HIDING PLACES

A Memoir from the Pirate Princess of Tybee Island

DEBORAH ELIZABETH MERRIMAN

MERRIMAN PUBLISHING, LLC.

"No matter what happens to me through all of life's mysteries, my little star will guide me back to the shores of Tybee."

— Deborah Elizabeth Merriman

CHAPTER ONE

— *Incoming Tides* —

Carried along the twilight shores of Tybee Island with invisible wings, my carefree spirit lifted me to a world of happiness far, far away from my real world—a world filled with uncertainties and confusion. Within the eerie nuances of darkness hovering over the ocean, my childish innocence and theatrical antics drew strangers into my world as they walked hand-in-hand along the shoreline.

Sadly, the strangers did not know that beneath this aura of happiness I silenced the horrors and torments that secretly plagued me. Alone, within the solitude of night, my consciousness filled with childhood innocence and I superimposed myself into a pixie-like pirate princess and entered into my fantasy world.

My happiness transcended into hope that one day I, too, would have someone to hold my hand as I walked along the shores of my beloved Tybee Island; and my quest for truly belonging would quiet as my fears flowed away with the outgoing tide into the depths of the sea.

Together we will go on many journeys as I reminisce about my childhood years. My name is Deborah Elizabeth. I was born in 1949 and I grew up in and around Savannah, Georgia. I experienced more in my first twelve years than most people experience in their lifetime.

With every story there is a beginning, but I experienced numerous beginnings as I transitioned in and out of many living arrangements. I find it difficult to merge my earliest beginnings into one unbiased series of truths. As with most stories, each family member claims their own interpretation of events as fact; mine is no different.

Listening to the versions of my beginnings is like listening to an orchestra warming up before a concert—each player concentrates on his own instrument and the result is melodic cacophony. I spent my childhood trying to find harmony within the discordant

homes and synchronization within the surrounding turmoil. My childhood was taken into the drones of lethargy where I wandered aimlessly between homes, desperately longing for parental acceptance.

However, constitutionally I couldn't dwell in such a place for long, so I'd quickly re-enter my special world where the senseless vibrations coming from the mouths of my persecutors muted; where human ears couldn't hear my songs, and human tongues could not critique my thoughts and actions with delusional misperceptions. Nature became my stage and all its creatures applauded me.

I've spent many years trying to bring some sort of sense and reason into the conflicting stories about my *kidnap* vs. *abandonment* scenarios. However, there's one fact I can conclusively affirm: I was born into a world where social classes and prejudices unfavorably altered my childhood.

Whether abandoned or kidnapped, the question hovered over much of my childhood. During these troublesome times filled with uncertainties, I found my own happiness within my hiding places, my adventurous capers, and most of all when I told my pirate princess stories to other lost children who listened attentively and marveled at my melodramatic antics.

Each new day brought forth new challenges, yet, even as a very scared little girl, I knew within my heart greater things awaited me—I just had to be patient. I never allowed my hopes to fall into the quicksand of despair.

I recently returned to Tybee, not as the little lost girl pretending to be a pirate princess, but as an adult who needed to find the core of self. There was a hush in the evening hours resting upon the ordeals of the day as I stood alone watching the last yellow-orange hues of a brilliant colored sunset drop behind the horizon. I was alone this night, just as many nights during my childhood visits to the shoreline. As I turned around to return to the mainland, the last waves from the incoming tide circled around my legs, as if to say, "Deborah Elizabeth, stay and sit within the salty waters that once soothed your childhood wounds".

I fixed my eyes on the familiar cottages situated just beyond the sand dunes. The dim lights easing through wooden blinds filtered through the sea oats swaying within the evening's gentle breeze and provided eerie shadows on the sand dunes. These visual images began a journey to my past and as I realized the dangers of such a journey, I pondered for a moment and thought, why is nature being so persistent in her pleas for me to remain on the darkened shores?

With a delicate balance, I brought my past into the present. Within this process, I concluded nature wanted me to bring to the surface the painful experiences of childhood and then for my heart to let the pain flow away with the outgoing tide.

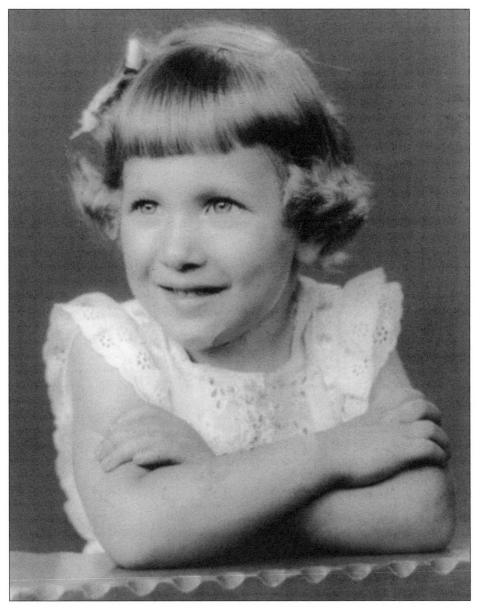

— Deborah Elizabeth at 3½ years-old —

Did Grandmother orchestrate a spurious kidnap in hopes Father's love for Mother would forever be purged from his heart if he believed Mother returned to the sailors in Virginia? Did Grandmother facilitate my various living accommodations with willing families in hopes Father's emotions for me would eventually disengage? Or did Mother return to Savannah where she herself took me from the nanny and fled to

Florida to escape Grandmother's mafia connections, or perhaps out of a spiteful rivalry, only to abandon me until my persistent cries summoned an elderly woman living next door?

I may never know the events which led to the 1951 letter from the American Red Cross which located me abandoned in Florida.

THE AMERICAN NATIONAL RED CROSS

PIERS OFFICE

RE: MERRIMEN, Robert S.
USS LIBRA AKA 12
BT-2 933 94 48

TO WHOM IT MAY CONCERN:

THE FOLLOWING INFORMATION HAS BEEN VERIFIED AND CHECKED INTO BY OUR HOME SERVICE CHAPTER IN NORFOLK, VA.

The above named Service man was in this office asking us to get verification to the fact that his wife had deserted him and his two year old child, Deborah Elizabeth.

The worker made a house visit to see just who was caring for the service man's child. The child was being cared for by a Mrs. Stagg, 9427 Hickory Street, Ocean View. kpxxx On talking with Mrs. Stagg the worker found out that Mrs. Merrimen just left the house on July 7th. without a word to anyone and went to Starke, Fla., which is the only address they have on her. When she arrived there she filed papers for a devorce and also stating that the service man could have full and complete care of the child. These papers are now in the hands of Mr. Merrimen's lawyer.

The lawyer who is in charge of the service man's case is Mr. Sam W. Nathan located at the Citizen's Bakk Building, Norfolk, Va. Mr. Nathan has made arrangements for the service man's case to come up aroung the last of September and that the service man's prexence is absolutely necessary.

There is no one else to care for the child or who could sign for the service man when his case come up. The service man's Mother who lives in Savannah, Ga. is unable to care for her due to the faxt she lives by herself and has to work to support herself.

According to Mrs Stagg the wife is an unfit mother and the service man has this same openion and and knows if he is sent out of the states for any length of time the wife will get a court order to get possession of the child.

Elmer L. Stout
ELMER L. STOUT
ASSISTANT FIELD DIRECTOR.
PIERS OFFICE BUILLDING #142

The above named Service man was in this office asking us to get verification to the fact that his wife had deserted him and his two year old child, Deborah Elizabeth.

The worker made a house visit to see just who was caring for the service man's child. The child was being cared for by a Mrs. Stagg, 9427 Hickory Street, Ocean View. On talking with Mrs. Stagg the worker found out that Mrs. Merriman just left the house on July 7th without a word to anyone and went to Starke, Fla., which is the only address they have on her. When she arrived there she filed papers for a divorce and also stated that the service man could have full and complete care of the child. These papers are now in the hands of Mr. Merriman's lawyer.

The lawyer who is in charge of the service man's case is Mr. Sam W. Nathan located at the Citizen's Building, Norfolk, Va. Mr. Nathan has made arrangements for the service man's case to come up around the last of September and that the service man's presence is absolutely necessary.

There is no one else to care for the child or who could sign for the service man when his case comes up. The service man's Mother, who lives in Savannah, Ga., is unable to care for her due to the fact she lives by herself and has to work to support herself.

According to Mrs. Stagg the wife is an unfit mother and the service man has this same opinion and knows if he is sent out of the states for any length of time the wife will get a court order to get possession of the child.

As you read my adventures, please do not assume or construe everything as factual. Instead, read and process my words with the same vigor as irreversible truth, as the unfolding events are my memories filled with fear, confusion, disturbing exploitations, and humor. *Oh, but of course my darlin's, there is just a tad of Southern embellishments— after all, my birthplace is Savannah, Georgia.*

Off to a journey we shall go.

WINTER...

The last rain of winter fell upon forbidden lovers with passionate desires unfurling in climax. A copious flow of wind scented from the heavens caressed the contours of their nude bodies

- bringing forth new life -

SPRING...

The earth's canopy of lace illuminated tapestries of subtle shades. Eros penetrated through the air and bestowed fanciful imaginations

- memories of a forbidden love -

SEARCHING...

Souls unyoked by emotional paralysis still linger aimlessly in the savannas hauntingly awaiting transformation in suspense

- hoping to recapture what was lost -

SILENCE...

Life will never be the same

- as it was during their last winter's rain -

Chapter Two

— *Unlovely Consequences* —

My first vivid memories begin with age four when my father remarried and my new stepmother became my primary care giver. Father returned to his Navy duties on board the U.S.S. Siboney leaving me behind once again with a family I did not know.

Skeleton and flesh, nature and religion; my normal childhood curiosities quickly became unfavorably labeled as *demonic* by my new stepmother. Stepmother Jo did not have the ability to differentiate between normal acceptable childhood behavior and abnormal sexual indignities.

A most frightening day, perhaps my first vivid childhood memory etched deeply in my mind was when Mama Jo yelled, "Deborah! The sins of your flesh are exposed. Get out of the water! Get out of the water! You're a spawn from the devil's workshop. No telling what lustful sins you have committed. Get out of the water this instant! *You* are the devil himself!"

What prompted this irrational exploitation of words? Why did Mama Jo act so hateful and upset with me? What had I done wrong—this time?

A little boy, maybe six years old, playing in his backyard noticed me swinging on a tire swing in my backyard. With a big smile stretching across his face, hoping to have a new playmate, he called; "Hey girl, what's your name?"

I turned my head to the direction of his voice, but the twirling swing turned my back away from his direction. Without receiving an answer to his first question, he ran along the chain-link fence and made a second attempt to gain my attention by calling out in a louder and more enthusiastic voice, "Hey girl, my name's Josh. What's yours?"

As the twirling swing slowed down to near stillness, the boy tried to get a response from me once again and called out, "Wanna play cars with me?"

I had to wait for my spinning brain to slow down before I could position myself taller in the swing. I clearly saw the boy standing on his side of the fence. I replied with a sad pout, "I'm not allowed to leave the yard. You can come over if you want."

With boyish vigor he threw his trucks and cars over the fence. Showing off, he bravely climbed over the fence in record-breaking time. We began playing with his cars and trucks and quickly tried to outdo each other's car crashing and emergency siren sounds. I couldn't make the sounds as well as he could; it seems boys possess a natural knack for making all sorts of noises.

Our playful competition became distracted when we simultaneously spotted a small vinyl pool decorated with colorful fish and filled with rain water. Like most normal children, we eagerly wanted to jump into the pool. However, being conscientious and foreknowing our parents' fits if we tracked water from our wet clothes into the house, we giggled as we peeled them off. Gleefully, we jumped into the pool and resumed playing cars.

A very curious boy, Josh asked a lot of questions while we played. "Where did you live before moving here?"

I proudly replied, "Somewhere near the ocean. Have you ever seen the ocean?"

"No," he answered, "but my cousins have. They really like collecting shells. I have some. Do you wanna see them?"

"Nope, I've seen zillions of shells," I replied nonchalantly and somewhat haughty.

Unbeknownst to us, our playful giggles and splashes attracted Mama Jo's attention as she peeled tomatoes for lunch and watched us occasionally from the kitchen window.

Suddenly, noise from the back screen door slamming shut startled us. The door hit against its frame so hard that it bounced back and slammed shut a second time.

Mama Jo ran from the back porch to the pool with a belt in her bloody-looking tomato juice hands. By the time she reached us in the pool, her face flushed and filled with rage, she repeatedly hit the water with the belt and screamed, "Get out! Get out! Get out the both of you!"

Snapping sounds filled the air each time Mama Jo pulled the belt away from the water, barely giving the last drop of water time to fall before it slapped the water again.

Mama Jo's verbal rampage sounded foreign to Josh. He'd never heard such cruelties and his wide eyes epitomized his fear. Unfortunately, I had grown to know the harsh sounds of her words and the crisp whipping sounds of the belt before it hit my flesh.

"How dare you show your privates!" she screamed at me, all the while thrashing the belt. "You are a demon child! I will *not* have you around other children—there's no telling *what* you will do to them. After this little episode, you are going to the mental institution, never to return to this house again."

Josh and I jumped out of the pool and grabbed our clothes. Looking scared and shivering he mumbled, "I'm sorry I got you into trouble."

Crying now, I then said, "No, I got you into trouble." Then I looked at Mama Jo and said, "I hate you, I hate you! You're a mean and hateful person!"

What had we done so wrong? What was so dirty about the water?

Mama Jo looked at Josh. He backed up instantly, tears in his eyes. "Go home," she spewed out her hurtful words, "and don't you ever return to my yard again. Deborah is not allowed to play with you or any other children for that matter. She is demonic and God will punish her." Pointing in the direction of his home, she once again eyed him sternly. "Go home!"

Josh tried as hard as he could to get his pants over his wet body. He saw Mama Jo becoming more impatient, gathered up his clothes and shoes and ran to our gate. He started yelling, "Mama, Mama." Just as he started to open the gate he looked at me and paused a few seconds. "I'm sorry. I'm sorry I have to leave you."

I looked at him with tears streaming down my face while Mama Jo continued beating my bare skin with the belt. I yelled, "Bye, Josh." Mama Jo became more infuriated when I started jumping around to avoid the belt and ran to the fence singing in an operatic voice, "I had fun playing. I had fun playing. No matter what she's saying, I had fun playing!" Then I yelled out to him, "I'll throw your toys over the fence."

The art of vengeance had already become part of my repertoire. I ran into the house pointing to my privates and lifted my butt high in the air. I ran around the house singing, "I have a butt hole; I have a pee pee, tee hee, hee, hee, hee; you can't catch me." Yes, a bit unlovely, but I had to find internal humor. This of course only fueled the situation and my punishment continued.

When I went to bed that night I wondered if the doctors at the mental institution would exorcise the demons out of me. Mama Jo said I needed an exorcism, but I didn't really know what that meant.

I finally drifted to sleep and in my dreams I saw Father standing on the prow of a mighty sailboat, gliding through an ocean filled with gold, yellow, and red hues displayed atop the water from a distant sunset. Massive white wind-filled sails bellowed within the beauty of the evening's gentle breeze and contrasted against the darkened skies, filled with twinkling stars. Father smiled as he stood on his tip toes to stretch his body over the side of the sailboat. His right arm extended upward, waving a piece of paper he held tightly in his hand. An amazingly beautiful seagull with keen senses and magical powers swooped downward and retrieved the letter. With trusting eyes, the seagull compassionately assured Father he understood the importance of the mission entrusted to him. I pretended the seagull carried messages back and forth between Father and me. Within the notes we kept our love for each other alive.

I woke up to the sounds of my own cries as my oozing opened flesh stuck to the sheets. Each time I moved my legs the pain jarred me from sleep. Does the Devil cry? I wondered for a while and then concluded, I don't think so. I felt comforted knowing the angels cried tears from heaven to help wash away my sins. I lay frightened the remainder of the night, knowing in my heart Mama Jo planned to take me to the mental institution to live among the other bad children whose parents didn't want them. I pulled my Gerber Doll closer to my chest and gently cried upon her heart.

Off to another journey we shall go...

UNDERWORLD

I came from the underworld, not from the womb of Persephone.
My intended destination secured eternal perdition with unified
emotions of indifference and loss of soul.

A whirlwind raged and forced the sea to surface my body and thrash
me amongst the swelling waves and pull me downward through the
forces of the undertows.

The depths of the sea swirled me upward amongst the whitecaps,
and my body became entangled within the ocean's seaweed as I drifted
in a trance.

Virile sounds from the underworld surfaced within each forceful swell,
assuring me tranquility would come within the turbulent seas.

I arose with the break of day in a subconscious state, abstractly beguiled
in nineteenth century lace with the sun resting upon my face.

Euphonious whispers awakened my senses whilst the incoming tide
gently touched my wounds from the underworld of childhood.

CHAPTER THREE

— *Oops Poop* —

After having experienced the belt as punishment for normal childhood behavior, I purposefully planned an unlovely retaliation. From time-to-time I didn't mind the consequences of the belt for you see, as unlovely as it may seem, the art of vengeance became my means of survival.

It so happened that the very next day after the demonic swimming pool incident, Mama Jo washed the family's white clothes. Her obsession with cleanliness echoed every day as she reminded us children how "cleanliness is next to godliness." She placed the delicate feminine apparel, such as panties, bras, and hosiery, on an expandable wooden drying rack inside the house, located out of view from male family members. Mama Joe sprayed the garments lightly with a mist of Clorox diluted with water. Female undergarments never hung on the outside clothesline for public view because Mama Jo feared there might be a perverted neighbor with sexual fantasies lurking in our neighborhood and the panties might lure him into our yard.

Deliberately and knowingly I became an unlovely child. I defiantly took Mama Jo's panties from the inside drying rack and attached them with wooden clothespins to the bottom of the white sheets hanging on the outside clothesline. After watching blue jays fly back and forth through the hanging clothes, my imagination peaked. I thought the birds might be hungry, so I quietly tiptoed inside the house like a skilled pirate princess, and quickly placed a small amount of parakeet seed in a cup. The seeds were carefully placed in the crotches of Mama Jo's panties. Within a few seconds the blue jays playfully flew in and out of the hanging clothes; then they securely placed themselves inside Mama Jo's panties and proceeded to enjoy their feast.

Oops! Poop! The birds pooped in her panties. A slight breeze swayed the panties back and forth with the birds perched inside, a hilarious sight to see. My continuous laughter caught Mama Jo's attention and summoned her to the backyard.

I had now acted out purposefully and with malice to gain humor from within. Words of fanatical ideologies stripped the innocent simplicities of my childhood play that day. While receiving my well-deserved spanking I said, "Oh, Mother, I'm so sorry. I just wanted the sunshine to bless your panties, and the birds seemed ever so hungry." Someone once said: Make the best out of a bad situation. Is this what I did? Or was I simply defiant? Simply defiant, I must admit.

Later that evening while I slept, Mama Jo woke me up when she tried to take my Gerber Doll from my arms. I sat up and yelled, "No, No, you can't take her, she's mine, you can't take her." I kicked her and screamed, "Leave us alone, leave us alone. Go away, I hate you!" My cries solicited her raging anger and our loud exchanges woke up my infant brother. Of course this just made things worse for me.

I watched helplessly as Mama Jo popped the head, arms, and legs from Gerber's torso. After giving me a look through her evil eyes, she threw all Gerber's doll parts out of the second story window. She turned around, looked directly at me and said coldly, "I can play games, too, little missy." She left the bedroom donning a cunning smile of victory.

I looked out my window for several rainy days and saw my dismembered doll parts getting muddied by the streams of water that flowed down our tiered backyard. Gerber felt afraid and I could do nothing for her. I knew at that moment I would need to hide my cherished Gerber, just like I hid myself in bad situations. Even though she was a doll and not a human, I felt saddened that I had failed to protect her, my little lost doll. Maybe my mother felt helpless, too. Maybe I was her little lost daughter.

Nature provided physical warning signs on Mama Jo's face as her displeasures began to unfold. Her facial muscles hardened and the shape of her eyes turned cold and hollow. I heard her talking on the phone to the Charlotte Mental Institution, making arrangements for my interview and possible long-term admission.

As soon as she hung up the telephone, I asked, "What did they say? What did they say?"

She simply replied, "You're going to the mental institution." Good riddance to the stepchild! This would soothe all her burdens, affording her a desired peaceful existence.

When the red belt marks vanished and the open flesh wounds healed, Mama Jo took me to the mental institution. I wondered if the psychiatric asylum would indeed become my new home, and if I would receive the same type of brutal spankings as I received from Mama Jo at my new home where I was supposed to be so happy.

As I followed close to her side, we began our brisk walk down the sterile psychiatric hallways filled with lingering smells from the prior evening's industrial cleaning products. By the time we reached the last long corridor, I complained about my painful heels. I couldn't walk anymore with my shoes on. My black shiny shoes kept moving

up and down. My socks pushed inside my shoes until my heels weren't covered. My exposed blistering heels became more and more painful with each step. Jo tugged at my dress, forcing my momentum to keep up with her stride. We finally reached the children's ward waiting room.

"Deborah Elizabeth," the receptionist called out, "Deborah Elizabeth, it's time to see the doctor."

After several hours of testing, a social worker took me on a tour of the facility. Before we entered the double-locked doors, sounds of cries and moans from the other side disturbed me. The doors opened up to a strong stench of bleach and urine. Children were placed in individual rooms with only a cot, a bucket, and no toys! I looked straight into the eyes of the social worker and asked, "Is this where I'm going to live?"

"*If you're not a good girl,*" she said in an unemotional voice.

Eventually the mental health halls became as familiar as my weekly counseling sessions, which became a stage for my theatrical embellishments. Sessions with Mama Jo merited no response from me. During one of our family sessions she blew up. She ranted and raved furiously at the doctors when they mentioned her own frail mental state as part of our problems. She told them she didn't bring me there to have them tell her that she had a problem. "You're crazy, not me!" she screamed, pointing her finger at the doctors, making a most unlovely scene. At this point the doctors, ready to take me into their care for my own safety, discovered Father had to sign the papers because Mama Jo was not my legal guardian.

Mama Jo started going to sessions without me. Once I started sessions without her in the room, I opened up to the counselors. One day I took off my tights and showed them the bruises from my spankings. Belt strap marks circled the backs of my legs.

The social workers contacted my father to arrange a dispatch reply request to return to the states.

OCT 55 – Action USS Siboney – Message – Robert Slater Merriman 933 94 48 BT2 request for hardship discharge of 2 SEP 55 approved x transfer Merriman nearest SEPCEN for discharge by reason of hardship citing ART C10308 BPM and this dispatch as authority.

The Navy granted father military leave to commence five days before my sixth birthday, 0900 17 OCT 55; leave to expire 0730 24 OCT 55, just two days after my birthday.

At last Father returned home! As soon as he walked through the front door, Sister and I felt a unique peacefulness. We immediately saw Mama Jo light up. She looked happy as the lines in her face softened. Pleasantries, uncommon in our household, gave way to curious glances between us girls.

The excitement of Father's arrival would soon take me to another place. Unbeknownst to me, Mama Jo had packed a suitcase for me sometime during the day.

Mama Jo prepared dinner while Sister and I set the table. We all sat down to eat—the first meal we enjoyed as a family with Father in many months. After dinner, Sister and I took our baths. We put our favorite nightgowns on and modestly covered ourselves with robes. We felt and smelt like little princesses, but of course I remained the pirate princess.

Sister and I sat on the living room couch snuggled up within Father's embracive arms. We listened enthusiastically to his adventurous stories of the high seas. He told us about his journeys to other countries, detailing the various landscapes, cultures, cuisines, and personalities of the people and places he visited.

I felt a sense of relief thinking Mama Jo would be kinder to me in Father's presence. Surely she wouldn't demonstrate her unpleasant and cruel side towards me while he was home.

All at once I felt a sadness overcome me as my senses took me back to reality. I started to fear an unpleasant event would soon take place. All at once Father's storytelling became whispers within my ears and my grim thoughts vanished when he told us his most exciting journey was coming home to his two little girls and baby boy. I remember remaining silent, but my eyes looked into his as if to say *I love you, Daddy,* terrified to speak these words out loud because Mama Jo said the devil knows no love.

Mama Jo told me I didn't know how to love. Sometimes I would tell my little brother, "I love you." Whenever she heard me speak these words she'd look straight into my eyes and say, "You don't know what love is. You only know how to put me through hell. You came from the devil's workshop! The devil doesn't know how to love. You don't have an ounce of love in you." Her anger swelled and stuck on autopilot.

Mama Jo rocked little Bobby to sleep and put him in his crib. She instructed us girls to go to our room and give the adults some alone time. We happily obeyed her instructions because we'd had our special time with Daddy and she deserved her special time. On my way to the bedroom I stopped by my baby brother's crib to kiss him and say goodnight. I touched his little head and whispered, "I love you." He peacefully sucked his thumb and slept soundly. I became worried Mama Jo would hear his sucking sounds and she might put hot pepper sauce on his fingers just like she did mine every time she saw me suck my thumb. I tried to gently take his thumb out of his mouth, thinking he would remain asleep. Instead, he woke up screaming at the top of his lungs. Mama Jo and Father ran into the bedroom. Father picked little Bobby up and his cries immediately calmed as he started sucking his thumb again. Mama Jo started yelling horrible names at me, and I remained unable to explain my honorable intentions to Father.

Bobby's screams validated Jo's sadistic feelings towards me. In her mind, I had once again violated my infant brother. I ran from his room with the belt popping against my legs. This was the first time Father witnessed Jo's physical wrath towards me. I ran into my room and slammed the door shut. I jumped into bed with Sister, pulled the sheets over our heads, and quickly explained to her why I took Bobby's thumb out of his mouth. She kindly acknowledged my good intentions. I feared Mama Jo would once again attempt to beat the demons out of me. Instead, she and Father's conversation became whispers in the night.

The whispers within their conversation broke when Sister and I heard Mama Jo yell, "I'm sick and tired of Deborah. I'm tired of caring for *your* child while *you* go out to sea, doing only God knows what!"

Her lengthy and repetitive ranting and raving lasted for hours. It didn't matter if all three of us children became upset and cried. Her threatening speech and agitated state of mind took precedence over everyone else's needs; nothing else mattered, just her words... the gospel according to Jo.

When the arguing stopped, Mama Jo came to the bedroom with our little brother in her arms. She stretched her arms outward to Sister and said, "Rock him back to sleep."

Turning towards me she said, "Deborah, get out of bed, now!" She took several steps closer to the bed and grabbed my arms, dragging me to the floor while yelling with saliva spraying from her mouth. "You are the devil himself. I won't tolerate the devil living in my home a moment longer. You've been nothing but trouble since the first day you got here. You are killing me."

Father came into the bedroom to abate the situation. He tried to pick me up from the floor but I was kicking and trying to avoid the belt. He turned his attention to Mama Jo and the belt and gently, but with a little noticeable force, took the belt from her, much to her displeasure. He bent down to the floor and lifted me until I felt secure in his arms. With his free hand he picked Gerber up from the floor and with the tiniest smile he handed me my doll. I felt like a *real* princess then, not just a pirate princess.

I remained in Father's arms as he walked over to the rocking chair in the master bedroom and gave my sister and brother kisses on their foreheads. He carried me into the kitchen where I saw my tattered suitcase placed next to the back door. In a whispered voice Father said, "I'll explain things to you in a few minutes; just stay quiet for now."

With his free hand, Father opened the squeaky back doors and then he picked up my suitcase. I was used to the screened porch door slamming, but this time it didn't. He carefully stepped down the back steps. With his eyes cast to the ground, he walked to the car. After he placed me in the front seat, I fearfully thought he was taking me to

the insane asylum where other demon children lived. I had already seen the children's ward during one of my therapy visits as an attempt to scare me into acting good or my fate would be just like theirs. I feared the children because some of them looked wild-eyed while having fits. Nervously, I began rubbing the satin trim on my pink blanket across my face and lips while Father returned to the house.

Shortly, Father returned to the car and turned the ignition. I moved across the front seat to sit as close to him as possible. His posture stiffened, like that of a military man ordered to sit up tall. He completely focused on the task at hand and remained silent. I wasn't sure if he still loved me or not, and I didn't know if he believed all the terrible stories Mama Jo told him about me.

Silently, I watched our home on 601 Woodlawn Road disappear into the midnight hour. Father's personification softened after he turned onto the highway going south. I felt loved once again. With his deep blue eyes looking sad, he gently said, "Sweetie, it's all right. One day we will be together. I'm taking you to my mother's home in Savannah, Georgia. Your grandmother will take care of you for a while until I can figure things out. Just remember, Daddy loves his little girl."

I felt overjoyed! I wasn't going to the insane asylum for bad children after all. Daddy loved me! I felt safe within his embrace and his voice quieted my fears.

Off to another journey we shall go...

CONTRADICTIONS

bordering between

right – wrong

forthright – manipulative

spiritual – demonic

love – hate

Survival

CHAPTER FOUR

— *Savannah, Georgia* —

Doorbell chimes echoed through the closed front door. Grandmother opened the door with sleepy eyes, appearing puzzled, as if she had no prior knowledge we would arrive at her doorstep. The usual pleasantries to greet someone remained on hold. Father took on his military attitude by standing erect with his shoulders held high and with his neck and jaws tightened as if preparing to salute her.

With no sleep, and in his military stance, he softly spoke. "I'm sorry, Mother. I didn't have anyone else to turn to."

Once again he turned to the only person he thought could take care of me on short notice. As Father spoke, a man appeared in his pajamas and slightly nudged himself in front of Grandmother.

"Good Morning, Robert. I'm Gibby, Gilbert Fraser." He extended his hand as a friendly gesture to Father.

Father's jaw relaxed and he appeared to release his military stance by having heard Mr. Fraser's kind introduction. Father spoke meagerly to Mr. Fraser, "Good morning, sir. I apologize for disturbing you at this early hour."

Grandmother stood at her new husband's side, somewhat flustered. Mr. Fraser opened the front door wider to allow us passageway into their home. "Do come in, and is this your little girl?"

Father, feeling a bit embarrassed said, "I know showing up with Deborah at your doorstep is an imposition. I had no one else to turn to and sorely feared for her safety."

Grandmother remained stand-offish. After all, she recently remarried and didn't need the complications surrounding my care. I remained silent and stood hidden behind Father's legs with my blanket over my head. Gerber's legs hung from underneath my blanket and Mr. Fraser touched her toes and said, "Now who do we have here?" He then turned his attention once again to Father. "How are you?"

"Could be better," Father said. "Trying to do the best I can. It's not easy when I'm away so much of the time."

"Don't beat yourself up," Mr. Fraser replied. "Some things just can't be helped. I'm a military man myself. I know how it is. How do you like the Navy?"

Each of the men shared his own military stories. Father spoke adamantly about his plans to make the Navy his career. Grandmother took in a deep sigh with an *Oh, my, here we go again* attitude. In a way, speaking of war seemed unfair, especially since Uncle Buddy was killed in WWII and Grandmother had just begun to move forward with her new life. Father made a quick glance towards his mother and noticed her disapproval of the conversation at hand. He respectfully changed the topic. He, too, missed his brother, more than anyone ever knew.

After the initial adult salutations and small talk, Father asked me to say hello to my grandparents. I pulled away from his legs and barely moved my blanket away from my face and saw my new grandfather's old ugly bare feet. I sort of remembered Grandmother, but I didn't remember the house. I thought she lived in a house near cobblestone streets. Mr. Fraser asked Father in a concerned voice, "Robert, what circumstances brought you to us in such haste and unannounced?"

Father replied in a sheepish voice, "Jo says she can no longer handle the strains of raising Deborah, especially since I'm away so much."

Oh great, everything is my fault, I thought to myself while squirming and holding an arrogant look on my hidden face.

Father continued talking while I began moving away from his legs. I pulled my blanket down away from my face to get a good look at my new grandfather. I wanted him to see my innocent, sweet, blue eyes, and at the same time gave him a fake-cake smile.

Father continued, "Jo's overburdened with the three children. Her doctor says she is having a mental breakdown. Jo called the Charlotte Mental Institution to see if they could admit Deborah to their residential facility as an emergency, but they didn't have an available bed."

Father, however, did say I acted fine while he was home and he couldn't be sure all of the stories he heard about me were in proper context. He felt, for the most part, everything had been exaggerated and blown out of proportion. He remained anxious to find out more details related to my mental illness from the social workers themselves. He had not had a chance to meet with anyone working on my case.

I really didn't want to hear them talking about my being the culprit to Jo's poor pitiful pearl problems. I darted from behind Father's legs into the dining room and sat on top of the bay window ledge. The window faced the front yard where a big tree

dropped acorns on top of Grandmother's car. I watched the blue jays and squirrels play within the tree branches and wanted to join them until I thought the blue jays looked directly at me said, Go away, go away, we don't want you here! You will hurt our babies, just like you hurt your baby brother.

My thoughts became distracted when I overheard Mr. Fraser raising his voice within my ear-shot. "Something doesn't sound right. How can one child have such a negative impact on so many lives? For Christ's sake, did you say she's already survived nineteen homes? Good God, who would put a child through something so terrible?"

I never heard someone speak on my behalf with such vigor as Mr. Fraser. He seemed disturbed and taken aback by my ordeals. I had an immediate mental connection with him but kept my physical distance. I sensed, given the opportunity, he would like me.

Mr. Fraser continued commenting, "Having never met Deborah before today, I would have believed her a stark raving mad child. Something is terribly wrong with this picture."

Not even acknowledging me as Deborah or her granddaughter, Grandmother chimed in. "Gibby, you have no idea how disturbed this child is. Jo called me the other day almost hysterical saying this child consumes every minute of her day. She drains all the energy out of Jo to the point she can barely take care of her young son. She also said Deborah was on a waiting list for a room in the children's ward."

Father was taken off guard as he tried to calm Grandmother's concerns. Jo had never mentioned her contact with his mother, nor had his mother mentioned anything to Mr. Fraser. He assured her I would not be staying for an extended time because Family Services, through the aide of the Navy, was looking for a suitable living arrangement for me. He asked if she would give him a few weeks to make the necessary arrangements.

"I'll be damned if I'll see this little girl go to a mental institution!" Mr. Fraser said.

I was surprised when I heard this stranger come to my defense. Mr. Fraser joined me in the dining room where I had buried my head between my knees drawn close to my chest. Once again he tried to introduce himself as my new grandfather. "Hi, I'm your Grandfather Fraser. I hear you've had a pretty rough time lately. Would you like to stay with us for awhile?"

I didn't respond to his kindness and kept my head bent downward in an attempt to ignore him. He continued his line of thought. "I realize you are afraid of new people and I don't want you to be afraid of me."

I quickly sat straight up with the airs only a pirate princess can possess and exclaimed, "I'm not afraid of you. I'm not afraid of anybody or anything. You don't even

21

know me, so how do you know if I'm afraid or not?" I turned my body towards the bay window and gazed outside with my lips poked out as if to say, so, there you have it.

An unlovely response for a six year old little girl, I looked up at him and immediately felt shameful for responding to his kindness with my abrupt retort. My troubled childhood and terse attitude became immediately obvious.

He smiled at me. "Yep, you are going to be my Little Darlin'. Why, you remind me of my pal, Margaret, Margaret Mitchell. Although Margaret's mother drilled Southern ladylike behavior into her girlishly shy ways, Margaret could change into a fearless young lady with an independent and irreverent spirit—just like you."

I wasn't anyone's Little Darlin'. For some reason he seemed sincere and, unlike most people, understood my reticence; he didn't ignore me after I spoke disrespectfully. He seemed genuinely kind.

Grandmother interrupted our conversation by entering the dining room. She was eager to show Father and me to the spare bedroom. The room contained twin beds separated by a kidney shaped vanity perfectly draped with Swiss white polka-dotted material. Matching porcelain lamps with George and Martha Washington figures sat on either side of the vanity. A beautiful antique brush and comb set, each encased in sterling silver adorned with swirling patterns and a large "M" engraved in the middle, sat on a delicate glass tray with sterling silver filigree sides. I imagined how nice it would be to have a mother comb my hair.

Oh well, I didn't, so I turned my attention to the rest of the room. A small writing desk with tiny little drawers and papers neatly placed in small slots sat in one corner. I opened the closet door and noticed all the clothes belonged to grandmother, but there was still plenty of space for Father to hang our few clothing articles; a perfect room set up for Father and me. I couldn't wait until bedtime to have Father all to myself. I knew he would tell adventurous stories until I drifted off to sleep.

Within a few minutes I overheard Mr. Fraser saying he would treat all of us to brunch. He went on and on about how wonderful the food tasted at Johnny Harris' Restaurant on Victory Drive. "It's time to eat some of Savannah's finest seafood and the best bar-b-q ribs in town," he said.

I joined everyone in the living room and stood next to my Father with sleepy eyes, wishing for nightfall. My father nudged me and stated I needed to change into a dress for the upcoming outing.

Reluctantly, I walked towards the bedroom without politely excusing myself from the living room. I'm sure a Southern princess would have utilized the proper Miss Manners before leaving the room, but I wasn't going to put on airs just to appease. Once I returned to the bedroom, I quickly changed my sulking attitude into excitement. I changed as quickly into my only dress, put on socks and my horrible

black Patent-leather shoes then returned to the living room with my dress unbuttoned and my sash untied. Mr. Fraser offered to tie my sash but I turned my back towards Father for him to do the honors. He tied a less than perfect bow, but I displayed it with pride.

The Frasers frequently dined at Johnny Harris' Restaurant. When we arrived the host greeted us royally then escorted us to the Frasers' favorite dining booth. Each booth had privacy curtains, but I liked the curtain open and so did Mr. Fraser.

Mr. Fraser pressed the service bell on the wall under the window, and his favorite colored waiter greeted our table. "Mista Fraser, it's mighty good to see you." He didn't address Grandmother, it being disrespectful for a colored man to address a white lady. The adults ordered cocktails and Father ordered me the freshly brewed sweet iced tea.

While the adults talked, I squirmed in my seat. My eyes wandered around the restaurant. The set-up included colorful booths aligned in a semi-circle around a large wooden dance floor. Grandmother said she and Gibby dined at Johnny Harris' every Friday and danced to the live music played by a five piece band. The ceiling above the dance floor twinkled with little star-like lights overhead.

Our lunch remained friendly and without unlovely comments about me. Grandmother ordered her favorite entrees, crab au gratin and tomato aspect salad. It was a rare occasion for me to see so much food.

Upon our return to Grandmother's house, Father immediately and unexpectedly announced he was returning to Charlotte, North Carolina, to help Jo for a few days before returning to the U.S.S. Siboney. Grandmother looked surprised and I pitched a Debby fit. I yelled at the top my lungs, "I hate you. I hate all of you."

I left the living room and returned to the bedroom, but in my rage I opened a door on the right side of the hall instead of the bedroom door on the left side of the hall. To my pleasant surprise, the door I opened had steps leading up to an attic. I stomped my feet as I climbed all the way to the top.

Father, with a stern voice, ordered me to come down the stairs. I ignored his summons and decided to guard my sadness by refusing the torments of an embracing final farewell.

Mr. Fraser took up for me by saying, "She's just a very hurt little girl. Let her be for awhile. She'll come back downstairs when she's ready." He was right; I felt very hurt Father would leave me once again.

In order for Father to say his goodbyes he had to join me in the attic. I looked out the small window that faced the Redmond's house, while in a somber voice he said; "I love you with my whole heart. I'm sorry I have to leave you again. Please give Daddy a hug and kiss."

I looked up at him with an ugly stare filled with tears. I threw my blanket over my head and said, "Bye, go away."

Father wrapped his arms tightly around the blanket, which still covered my head, and lifted me upward. Once he had me in his arms he began removing the blanket from my head. With my arms freed, I hugged him ever-so-tightly. I told him over and over again, "I love you, Daddy. I love you, Daddy." Now I didn't have to worry about Mama Jo screaming that I came from the devil's workshop and didn't have the capacity to love anyone or anything.

Sadly, Father looked into my eyes and into my heart. He did love me, he really did love me. "Give me a big hug before I have to leave. It's hard to say good-bye, sweetie. Listen to your grandparents and be the good girl I know you are."

He gave me a long embracive hug. As soon as he removed me from his loving embrace and my feet touched the floor, I sadly mumbled, "I love you, Daddy."

He walked downstairs to say his good-byes to his mother and Mr. Fraser. I smelt the lingering scent of Old Spice cologne on my blanket and hugged it. I wondered if he would be killed like Uncle Buddy. I wondered if I would ever see him again and turned my attention back to the window. When he left the house I could see his back as he walked to the car, alone and without me. He lifted his hand to his forehead a few times. I think he was crying.

I stayed in the attic until I smelled supper cooking. I made slow and cautious steps leaving the attic in an attempt to spy on my grandparents. Unbeknownst to me, the creaking noises reached above their conversation. When I peaked around the kitchen door, their eyes greeted me. "Dang-it," I thought to myself. Of course I entered the kitchen with a theatrical flair as if nothing in the world could hurt me. "Tada, it's me."

When I wasn't spending time with my grandparents I retreated to the unfinished garret where I spent many hours rummaging through mementos of times gone by. Also my time in the attic gave my grandparents time together, undaunted by my presence. The attic, like most grandparents' attics, held antiques such as cedar trunks which contained linens with hand embroidered initials and crocheted bed spreads made by my great-grandmother. I especially loved the hat boxes with foreign tableaus depicting journeys abroad and neatly stacked, one on top of the other, by shape and dimension. Great-grandmother's 1900 Singer sewing machine with cast iron peddles sat amongst old chairs and trunks along with Civil War swords. I found pictures of Margaret Mitchell and Mr. Fraser's Georgia Tech awards and sports medals. I also found the Fraser family bible and G.T.R. Fraser's diaries dating back to the 1800's.

I finally warmed up to my new living environment and I truly thought I had a permanent home with my grandparents. I forgot Father planned to work with Family Services for a more permanent placement for me. Grandfather and I drew plans for my

loft on his special drafting table we assembled in the attic. When Grandfather Fraser and I got together my world felt safe and calm. I seemed to adjust to life better while living with Grandfather Fraser. Even my first grade teachers sent moderately good progress reports home; however, I still exemplified emotional and social skill problems with other classmates and had difficulty staying in my seat.

Over the next few months the strains of caring for an emotionally disturbed child became too much of a burden for Grandmother—well, that's what I overheard her tell her friends while playing bridge in the living room. I think Grandmother resented me because Mr. Fraser spent so much time with me in his garage shop and less time with her. He enjoyed my antics and my eagerness to learn how to use his tools. I was his Little Darlin' and his side-kick.

The holidays approached and I asked Grandmother why she didn't put up a Christmas tree. I hoped Christmas would be happier than my past Christmases because I would be with my new grandfather whom I had begun to love ever-so-dearly. I thought maybe I would get my first bicycle.

Christmas with the Frasers didn't take place. Grandmother informed me that I would be staying with a family for three weeks while she and Mr. Fraser went on their annual holiday cruise with their friends. Devastated by the news, I retreated to my bedroom. Once again I was alone with Gerber, my one constant tangible love.

Off to another journey we shall go...

Dreams

My dreams are private as they weep
perhaps they are daydreams fading in the dark
perplexed by diverse and transitory themes

My dreams are private as they weep
without a corporeal friend to share
poetic thinking before I sleep

My dreams are private as they weep
how could life be trite with insignificance
while my soul is full of fertile imaginations

My dreams are private as they weep
I shall not allow varied metaphysics or theology
interfere with my inner self by compromising
the most powerful and intimate relationship I will ever know
that of which is with my soul

CHAPTER FIVE
— *The Killer Shower-Man* —

I entered my new home wearing Grandfather's red bandanna, pretending to be a gypsy. After all, gypsies traveled from one place to another, just like me. A boy with a pompous attitude approached me saying, "What's with the bandanna? Boys wear bandannas, not girls!"

"I'm a *real* gypsy and I have stories to tell about my family fighting off pirates who sailed along the Atlantic Ocean and who landed on the shores of Tybee Island, taking smarmy boys, just like you, away to sea, never to return." Perhaps the gypsy storytelling provided intrigue to my new brothers and sisters because my presence brought a refreshing influence to the home and the other children migrated to my energy as they lacked the imagination and survival skills I possessed so naturally.

As I did so many times before, I sought out a special hiding place. Untrustingly I never divulged or shared my secret hiding places with anyone. An outgoing and outspoken child, my inward quiet time became essential to regroup from the drones of the day. I became very nervous hearing loud parental voices, and seeing other children physically and mentally abused. Too young to help them, I couldn't cope with the injustices and retreated to my safe place.

For the most part all of us children living in the home suffered various injustices at the hands of our caregivers. In most instances the caregivers weren't interested in our individual well-being, nor did they nurture our young minds and bodies. Money drove their appeal for housing us; societies lost these children. Basically, we took care of ourselves and bonded together as we came face-to-face with dark moments. The current caregivers drank and fought most days and nights.

Clever and creative, I began organizing our daily chores into games with made up songs. Sometimes it became difficult for me to give the encouragement to others because I, too, needed external reinforcement, adding joy to my little life.

Just having turned six in October, with Christmas dreams and fantasies like most children my age, a most tragic Christmas Eve day began to unfold. The other children were placed amongst various families for the holidays. My grandparents traveled on their annual holiday cruise, Father journeyed out to sea, and I remained the only child in the house. I stayed quiet in my assigned bedroom in an effort to keep myself out of sight and with hopes I would not be available to complete all the daily chores by myself. I kept myself appeased by drawing, coloring, and cutting out paper dolls with changing outfits and, of course, accessories. I wanted to make enough paper dolls for everyone to have at least one, and together we would act out the stories I created in my mind.

Loud exchanges interrupted my imaginative thinking, words by and between the care givers and their guests. The day consisted of laughter and drinking, and by nightfall the levels of intoxication brought out the demons in their personalities. The men accused one another of cheating at cards. The women loudly voiced their opinions in support of their respective spouses. I heard glass breaking and furniture turning over. The sound of bodies slamming against the walls reminded me of my own experiences of being slung into walls and knocked into furniture at the hands of Mama Jo's rage. The cursing escalated.

Terror took over my Christmas dreams. I felt an immediate urgency to escape to my secret hiding place. I quickly placed the paper-dolls under my bed and grabbed my Gerber Doll sitting on top of her pillow. Cautiously I peeked out of my room towards the bathroom at the furthest end of the hallway. I felt confident I could reach the end of the hall unnoticed if fear didn't cause my footsteps to pause, even for a moment. I tip-toed into the hallway and slowly picked up my pace until I safely entered the bathroom. Once inside I gently closed the door, leaving it a tiny bit open so no one suspected anyone hiding inside.

A door led into the cabinets under the sink's vanity. A small door to the left of the inside cabinet led to the bathtub plumbing. I unlatched the door then quickly looked behind me to make sure I couldn't hear anyone coming down the hall. I lay down on my stomach with my legs facing the vanity and entered feet first, struggling to get my whole body inside the two cabinets. My feet and legs twisted through the pipes. The rest of my body filled the main cabinet. I had just enough space for Gerber. I would never let her be alone again, like she had been for days, dismembered in pools of muddy water.

I began shivering as the harsh words and the loud sounds became louder and louder. I began rocking from side to side in my small encasement. Suddenly, a terribly loud gunshot reverberated throughout the house. The house-mother began screaming my name. I could hear her running down the hall and through the house. "Deborah Elizabeth where are you? We have to get out of here, where are you; we've got to go, now!" I froze in my hiding place.

28

Chaos ensued the aftermath of the shooting. Suddenly everything became quiet. I wondered if anyone remained in the house, but I wasn't going to budge. No exit existed from the bathroom except through the door. Previously I had checked out the bathroom window, but sloppy paint glued it shut.

Someone pushed the bathroom door open with such force the door knob hit the wall. The intruder's quiet footsteps shuffled across the tiled floor. I then heard peeing noises made by a man. I anticipated he would hurry up and leave, but he didn't. Rustling sounds came from the shower curtain drawing closed. Next the pipes began knocking as water started to flow through them. The shower faucet turned to the hot position and the hot water flowing through pipes began burning my legs. My silent pain turned into a whimpering cry. I tried so hard to stay quiet, while trying to wiggle my legs free from the pipes. I finally cried out loudly from the scorching pain.

Hearing my cries over the sound of the water, the bather got out of the shower. The cabinet door opened and the man saw me struggling to free myself. Water dripped from his naked body while he grabbed both of my arms and pulled me until my trembling body met with the cold green and white tiled floor. The shower man kept saying; "What did you see? What did you hear?" I didn't say a word.

The shower man dropped my arms and placed a towel over his wet body. He told me to stay put until he returned. With my face still down on the floor, I hopelessly knew I didn't have an alternate escape route.

Within a few minutes the shower man came back to the bathroom partially dressed carrying a bucket of bleach water. I could smell the chemicals releasing from the bucket; the same odors I had become accustomed to in Mama Jo's house. He set the bucket down with force causing some of the water to splash out. He jerked my arm up and with his hand started to forcibly lead me to the living room. With my head still facing downward I saw bloody footprints on the hallway floor. I had to step on them with my bare feet. I didn't know if the blood belonged to the shower man or not. Maybe he was the only person left in the house and he wanted me to clean up the mess.

Repulsive odors lurked in the hallway, which became more pungent the closer we got to the living room. I tried to pull away from the man, but his strong grip pulled me harder. I tried to bite him but he jerked my hands higher, taking his hands out of my mouth's reach. I began kicking, and the shower man released my hands and pushed me into the living room. He slammed the door shut behind us. Then I saw a body dressed in men's clothing lying on the floor with a pool of blood surrounding his head.

Looking around the room I saw everything turned upside down. Spattered blood covered the remaining pictures on the wall. I saw hair and pieces of skin, and looked back at the man on the floor, his face almost gone. I started to bring my Gerber close to my chest, but realized she remained in the bathroom.

"Kid, keep your eyes straight—wash the wall. Don't look behind you. If you don't listen you might be next."

I knew from my past experiences with Mama Jo that if I even remotely tried to resist his instructions he would hurt me. Each time I dipped the sponge in the water, the water became bloodier. I could never clean this red pungent stuff off the walls with water and a sponge! It just smeared more. I became annoyed, yet I had seen the bloody footsteps leading to the bathroom and knew they remained from the killer-shower-man. I also knew to act very obediently or I might be the next one dead. Timidly speaking, without looking at the killer-shower-man and with a frightened voice, I asked, "Oh sir, would you please bring me my doll?" Surprisingly, and without a word, he retrieved my doll from the bathroom and placed her next to the bucket. Remaining silent, facing the wall, I continued my task and did not thank him. The room remained still with just me and my Gerber facing the wall with a dead man behind us; a man with his head blown off.

The killer-shower-man went outside and began talking to someone on the front porch. I heard someone say, "Let's get this over with." The commotion behind me did not distract my concentration on the wall, for I had learned many valuable lessons during my young years. Shortly, a third man arrived at the house to assist the killer and his friend. As soon as the third man entered the living room he sounded very upset when he saw me. "What the hell. Where did she come from? What are we going to do with the kid?" The three men argued as they rolled the bloody dead man's body into a sack and carried him out of the house. All the while I kept my position forward, staring at the wall of blood without a single whimper.

Emergency sirens in the distance approached closer and closer to the house. Suddenly, I heard a loud popping noise. Once again I stiffened because I thought someone else had been shot. Another loud boom sounded and I realized it was a car backfiring. I felt relief when the car sped off but remained frozen, looking at the wall. Flashing lights coming through the living room windows finally distracted me.

Quickly, I left the living room and ran back to my special hiding place. What purpose would anyone have to open the vanity cabinet doors again? I felt confident no one else would take a shower, infringing upon my sheltered domain a second time.

I heard the ringing of the front doorbell. Then I heard the creaking sounds of the rusty front screen door opening. People entered the house; I could barely hear their voices. Within a few seconds a thunderous sound came from the back door being kicked down. Even with all the commotion in the house, I suddenly realized I had forgotten my Gerber who remained seated next to the bucket of bleach water. Once again, within my hiding place the loneliness for my only family, my doll, procured my thoughts. Was this punishment? Perhaps I did come from the devil's workshop. Was I doomed to decay while alive, or would I emerge from the horrors of this childhood and

softly touch someone's life again as I had touched Grandfather Fraser's? Exhausted at this point, no amount of thinking eased my tired soul as I quivered with misgivings.

The sounds from the outside emergency sirens finally stopped. The muffled words I heard became more audible as people neared the bathroom. Before long the cabinet doors to my hiding place opened once again. How did they find me when I never uttered a sound? I didn't realize my small steps carried blood from the living room to the bathroom. My Gerber's presence was yet another indication a child was present during the heinous crime.

I didn't see who opened the cabinet because I kept my face covered by my hands. I rocked back and forth while trying to enter into my secret world without noise. I don't know how many times someone spoke to me or what they said. Someone touched my back and I flinched and drew tighter into my fold.

A man's voice spoke softly. "We are here to help you. I am a fireman. It's okay for you to come out now. I have a nice lady standing next to me, and she is going to take you to a safe place." I didn't respond until a woman's voice said, "I have your dolly. I think she misses you." Hesitantly, and at my own pace, I crawled out from my hiding place and sat on the floor. The lady handed me Gerber and I held my doll with both arms tightly clutched across my chest. I shrugged away from the lady when she tried to help me up from the floor and kicked my feet. I wanted to be left alone to crawl back into the cabinet.

However, I knew I must cooperate. The sooner I did so, the sooner I would know where I would be placed next. I followed the policeman out of the house, clutching Gerber ever-so-tightly. He lifted me into the backseat of his police car while the lady entered the backseat through the other side of the car. Then we left the scene of the killer-shower-man's bloody trails.

Off to another journey we shall go...

AFFECTION

Affection has tears and smiles
I am a lame soul creature
Who will give response, but
there is no heart throb

CHAPTER SIX

— *The Attic Fan* —

I was relocated to another home where new children came in and out every day or so. Authorities, unable to locate my guardians from the killer-shower-man's house, would now have to check with every cruise liner to locate Mr. and Mrs. Fraser. Even if my grandparents received the news of my unfortunate holiday, I felt sure they probably wouldn't come for me.

Christmas day, and the only people interested in me were the police and the nosey lady. The police asked a lot of questions, but I didn't provide many answers. I just wanted to be left alone and to sleep in Grandfather's hammock. I missed him and knew he would protect me. The day felt like an eternity. Anxiously, I awaited the other children's return from their church sponsored events and thought we would all be placed in the same home. At least we all experienced some of the same types of problems and rejections and therefore had already bonded within the short time we were together.

I was placed in a home with twenty-five other children. The immense building reminded me of the mental institution, but without the smells and locked doors. I longed for my grandparents' return, but I still had two weeks to wait. I never saw the other children from the killer-shower-man's house again.

Finally, I received word that my grandparents had returned from their trip, but also found out my grandparents weren't up to caring for me because of their work responsibilities. I would spend the winter months at a new group home. I don't think these new caregivers even knew all of our names. We were like a game of dice—we rolled in and out and the money kept coming.

Corporal punishment remained the norm in this new home, just as in most homes during the 1950's. If one child did something wrong, we all got the paddling as a lesson to be learned. It seemed like all the homes kept the same type of wooden paddles. The

paddle was long-handled with several holes in the main part of the paddle and hung by a leather strap on a nail near the refrigerator. If something contentious came up, one of us children had to step on a stool to retrieve the paddle and bring it to the house parent for our punishments. They demanded obedience while lining us up with our faces to the wall. Bending over, we each took our punishment and hoped to minimize our pain by cooperating. Oftentimes we had no idea what the spanking was for.

The summer months approached, and I anticipated staying at the beach with my grandparents since Grandmother would be taking time off from her job at the Corps of Engineers and Grandfather Fraser, I believed, was semi-retired and could take time off whenever he wanted.

The days became hotter and hotter. The home didn't have air conditioners, but I discovered it did have a huge attic fan and the area would make a perfect hiding place. The fan was huge. It had five blades, each expanding three feet. A louvered metal window opened up when the fan turned on. The fan's vibrations shook the louvered panels, soundproofing the resonance from my operatic aahhhs. My chest vibrated and my aahhhs fluctuated up and down.

The steep, narrow steps led up to the attic and remained off limits to us children. During the evening the darkness of the attic made my hiding place even safer. The attic did not have the interesting antiques and remembrances from times gone by like Grandmother's attic. The fan's encasement was about four feet deep, just large enough for me to set up housekeeping within its small boundaries. Behind the blades another two or three feet separated the fan's casing from the louvered window, another perfect hideaway; no one would ever think to look behind the fan!

Gradually and unnoticed, I finally had my hiding place all set up after diligently working on it for a few days. My essentials included: a big bowl in case nature called, toilet paper, a hand-held can opener, canned corn, peas, fruits, corned beef hash, beanie weenies, and spam. For my nocturnal comfort I had one sheet, two pillows, and two blankets. I used the blankets for a little mattress. The humming fan made me unable to hear voices downstairs, and its movements became lullabies. Its vibrations rocked me to sleep. The moon's light shined between the large fan blades casting unusual shadows, and the morning sun brought new rays of hope. I missed the ocean and the sand dunes, but when I closed my eyes I imagined I was a pirate princess in one of my forts overlooking the ocean, and I could hear my father's voice telling me one day we would be together again.

Migrating in and out of the downstairs home like Nancy Drew in a detective story, I joined the other children preparing for the church bus to pick us up to attend Vacation Bible School activities. Upon our return home I quickly retreated to my own humble abode, safe from the lower floors of confusion. Cleverly I avoided many of the spankings because I remained invisible while playing in the unfinished attic. From

time-to-time a child would be picked up by a church member and taken to supper, returning to the house the following day. I'm not sure what the special arrangements entailed, but it seemed like children rotated in and out all the time so if someone wasn't around it wasn't a big deal; no one really cared if one of us was missing unless it posed a real problem and the authorities were called.

Early one night I busily placed my supplies on the shelves between the window and the fan, and thought up new adventure stories. I felt calm and good in my own little fantasy world. Suddenly, and without warning, the window louvers began shaking and the fan blades began rotating, trapping me between the rotating blades and the louvered window. I knew the fan turned on at 8:00 p.m., but it was long before 8:00 p.m.! At first I felt really scared and suspected death-by-blades would prevail over my destiny. It seemed impossible for me to fit between the wall beams and the fan casing. Trapped like a mouse in a vice, I pressed my frail body close to the window to look at the stars and gain strength from the heavens. Sadly, I felt safer trapped behind the strength of the rotating blades than I did living downstairs—receiving punishment for things I didn't do. I could hear the other children's cries carried by the fan's wind currents and pulled through to the outside world. I tried to ease my situation by placing the purloined canned goods in a row between my body and the fan blades. I lay down as close to the outside wall as possible, and I eventually fell asleep, knowing if I moved too close to the fan the cans would be pushed into the path of the blades. The blades would hit the cans and alert me to the imminent danger.

In this way I survived the night, and when morning came I planned great adventures for the day. First I would do my chores and then sneak away just as the other children loaded the church bus for Vacation Bible School. If anyone asked why I wasn't getting on the bus I would say "I'm being picked up" and leave it at that. I planned to sneak around to the side yard and stay in the tool shed until the housemother left the house. I would find the necessary tools to cut a passageway in the fan's side frame. A few concerns presented themselves. I feared someone might see me going in and out of the tool shed, and worried someone might hear the noise from my reconstruction project. However, the most worrisome problem for me was the housemother coming home before I completed my project.

The housemother finally left the house to run her errands in town. I retrieved tools from the shed and ran upstairs to the attic. I began hammering, but the loud sounds almost convinced me to stop the project. I thought if I could hammer a small hole, then I could cut it to make a larger area. Finally, I split a small area of wood near the bottom. I sawed a ragged edged opening large enough for me to crawl through. I felt quite accomplished with my hiding place remodeling project. I would no longer have to squeeze between the blades. Now I could move freely back and forth, and I felt great pride in my cleverness.

Usually the evening hours quieted once we all went to bed. The house parents resumed their nightly rituals of listening to the radio, playing cards, smoking cigarettes, and drinking. We could hear the sounds from the talk radio but we couldn't understand what was said. Parentless, we children tossed and turned most nights before we eventually went to sleep. Some children cried themselves to sleep, but I didn't. Sometimes I made up fairy tale stories to help our imaginations float far away into a fantasy land, a land they could not create for themselves.

One day I picked zinnias from a neighbor's backyard and hid them in the attic until suppertime. I excused myself from the table to go to the restroom and snuck upstairs to retrieve the flowers. I quickly placed one flower inside each pillow case and carefully made sure the case wouldn't smother the bloom. I went back to the table and whispered, "I have a secret to tell you, promise you won't tell?

Heads nodded up and down.

"I saw fairies flying in our bedroom with flowers."

Everyone started wiggling like they wanted to leave the table. I gave everyone an evil look because I didn't want our caregivers to discover I had stolen flowers from the neighbor's yard. Everyone remained in their seat until we were given permission to get up and do our evening chores.

When we entered our room, disappointed eyes didn't see the flower until I told them to look inside their pillowcases. "See, I told you I saw fairies. Hurry up and hide them back under your pillowcase." After bath time we all hurried back and jumped into bed without resisting "lights out."

A CHILD'S FAIRY TALE

Fairy children with sparkling wings frolicked while playing in an enchanted garden filled with beautiful flowers and hummingbirds. The hummingbirds became very excited when they saw the fairy children and invited them to join in their merriment. Each fairy gently picked a unique beautiful flower from the enchanted garden and carefully placed it into their pinafore pocket.

The fairy children in a whispered voice asked the hummingbirds, "Would you please carry us across the vast blue sea to look for the lost children's daddies? Our wings are far too frail to withstand the evening's breeze."

The hummingbirds sang, "Although we are amongst the smallest of birds, our wings are very strong. We can ride atop the night's breeze. The breeze will carry us to the distant lands beyond the sea."

The hummingbirds were joyous, for you see, only the strongest and bravest could travel the hundreds of miles across the deep blue sea. Hovering above the enchanted garden with fluttering wings, the hummingbirds carried the fairy children high within the twilight stars. The fairy children gathered sparkles from the stars to help guide the hummingbirds through the darkness of the night.

Together the hummingbirds and fairy children found the lost children's daddies. They gently released the beautiful flowers from their tiny fairy hands and watched as the brilliant colors cascaded downward until the flowers were greeted by our daddies' hands.

Joyfully proclaiming our love, the fairy children told our daddies how we missed them ever-so-much. Each one of our daddies filled their special flower with kisses then gently placed the flower back into a tiny fairy hand. The fairy children and hummingbirds were guided across the sea by the sun's glorious morning rays peeking over the horizon bringing forth a glorious new day.

So now, little friends, you can sleep knowing you have a special flower filled with kisses from your very own daddy and how much we are loved on this special night.

Good night, fairy children. Good night, brave little hummingbirds.

Once all children had fallen asleep, the room once filled with loneliness overflowed with hope, even if the hope was only from a made-up fairytale. Now I could retreat to my own hiding place, knowing that in some small way I helped other lost children. Then I asked myself, *Who will help me forget the pain? Why can't anyone make me feel special?*

The time came for me to climb the dark stairs leading to the attic, placing me closer to the heavens. The moon's light glowed through the louvered windows and between the large fan blades, casting unusual shadows. I watched falling stars amongst thousands of twinkles in the sky, inspiring my creative musings. I asked for a safer world for all lost children as we felt tired of adapting to new beginnings, never knowing where we would be living in a month or two.

All of us craved to be loved individually. When loved, even tainted by bizarre motives, a calming aura penetrated us, if only for that moment. And we hopefully carried that affection and optimistic outlook into our external world.

Dawn presented itself with a few hungry baby birds waiting for their morning feeding. I quickly returned to my downstairs cot and watched the other children as they woke up with their special fairy flower. Later in the day I was told I would be leaving. The other children looked sad when I said good-bye. "We'll miss you, Deborah Elizabeth. We'll miss you, pirate princess." Some of the children cried and I quieted some of their fears by saying: "Just remember, when you see the twinkles in the stars, the children fairies are sprinkling happiness. Bye again. I'll miss you, too."

Off to another journey we shall go...

ODE TO THE OAK TREE

The oak's wide canopy casts century old shadowed corners atop its gnarled low bearing branches. Eerie nuances of mysteries and haunting legends interwoven within its massive structure become alive as the twilight hours approach.

Protruding majestic limbs lift the phantom half-child, half-fairy to its highest branches veiling her from human exposure and evil spirits. Her spiritual mystery is reconciled as she rests alone cradled within its curved arches.

Protected by the oak's masculine strength, faint images of her eloquent features are rarely exposed. Sanctioning the child-fairy's spirit, melodies of her song-filled whispers flow mysteriously producing symphonic poetry and harmony within its branches to yet another lost soul arriving beneath its canopy.

Channeling her calming aura to the lost soul arriving within a gust of wind on a windless night, distorting the oak's beautiful shadows in abstract patterns, only the most worthy of souls shall remain beneath its canopy of lace.

Should a visiting soul mock the manifestations of the child-fairy, the mighty oak will thrust the cynical soul deep into the Wilmington River. Hearing the soul's cries, malevolent spirits will rise from the marshes whaling with excitement, announcing that a new soul has entered into the eternal drones of desolation without hope for redemption. Desolation should not be a soul's destination.

CHAPTER SEVEN

— *The Mafia Man* —

Each day, as if I acted on a stage, I portrayed various characters in Shakespearian plays. Tales of woe and tragedy, searching for love and affection—my imagination guided me to unattainable places. Other players' souls withered with despair and animosity towards the lost girl placed within their guardianship.

Seemingly out of nowhere, I relocated to the care of a wonderful elderly couple, Redd and Marcella Donaldson. My imaginary parents came alive. Mr. Donaldson with his deep throaty voice from years of cigar smoking walked with a limp. The short Mrs. Donaldson with huge breasts looked like she might tip over any moment. Mr. and Mrs. Donaldson, both in their late seventies, looked like cartoon characters when they walked side-by-side, limping and wobbling.

Upon my arrival Mr. and Mrs. Donaldson wrote a list of their rules. Within the first hour Mr. Donaldson asked me to read the list aloud. "Do you have any questions about the rules?"

Before he completed his question Mrs. Donaldson chimed in, "Do you consider the rules fair and can you abide by them?"

I answered, "No Sir; yes Ma'am." I already knew I would break the fourth rule: Do not leave the yard without permission.

One morning after Sunday mass, Mrs. Donaldson asked if I would like to call them Papa and Nana. I told them Papa and Nana sounded fine to me. I customarily called guardians whatever they requested and did not take to heart any meaningful association to the true definition of the title. I would soon be placed with new guardians and they, too, would ask the same questions and my reply would be the same.

Acres of beautiful magnolia, dogwood, oak, and weeping willow trees surrounded their small home located on the banks of the Wilmington River. The Wilmington River's bend rounded to the back of the Donaldson property. A long dock extended

from their backyard to the marsh banks. Steps led from the main dock to a floating dock. Another platform with an aluminum roof structure housed a small boat hoisted up by an electric pulley, secured by huge chains and hooks. Instantly I fell in love with my new environment. It reminded me of past adventures Grandfather Fraser and I had on Tybee Island. I could show Mr. Donaldson just what a great crabber I was, not to mention how far I could throw a fish line!

A perfect nightly hideaway stood just down the road from Papa and Nana's house, The General Oglethorpe Hotel and Resort. Beautifully lit palm trees and shrubs lined the road leading to the main lobby's entrance. The meticulously groomed lawns and golf course were accentuated by moonlight streaming through oak trees which cast eerie shadows beneath their limbs and awakened my fabulist abilities for creating intriguing stories. I found sanctuary within this glorious milieu. But how would I go unnoticed, and what stories would I tell if questioned about my wanderings around at night without a parent?

A few days later I took my first nightly adventure. I had needed to familiarize myself with Nana and Papa's sleep patterns and nightly activities. After I felt comfortable in the new surroundings and established my exit and re-entry strategies, I prepared myself for some new adventuresome capers.

I migrated from our yard to the soft grassy manicured lawns of the General Oglethorpe Hotel, moving into and out of various settings. I remained undetected in a chameleon-like fashion. Reaching the darkest corner of the Hotel's swimming pool, I positioned myself next to two large fern planters. My frail whimsical frame remained unnoticed within the ferns' three foot long fronds swaying gently in the night's breeze. My playful engaging nature kept my mind active with anticipation of executing my next carefully orchestrated move; however, I remained stationary, intrigued by the secrecy displayed amongst a group of very well dressed men sitting around linen draped round tables.

Some of the men's behavior appeared quite odd, especially the men standing guard around the perimeter of the pool area. Curiously, I wondered what type of business kept words passed between them so secret and what caused the Negro waiters' obvious fear of them?

The Negro waiters wore formal attire for uniforms; black tuxedo long-tailed jackets, black pants, starched white pleated shirts with little black studs for buttons, black bow ties and white gloves. Each waiter stood at attention with his white gloved hands tucked behind his back in a military stance. Their eyes remained in a fixed position looking away from the group of men. However, without a forward look they seemed to know when one of the men waved for service. Although the white gloves looked nice, I knew the real reason the Negros wore them; so their dark skin did not make contact with a white man's skin nor with any table item a white man touched.

There was rank amongst the Negro waiters. If the Negro spoke with a broken dialogue—many slaves spoke a unique dialogue in the cotton fields—his assignment included tasks that prohibited him from speaking to the patrons—such as cleaning off tables and replenishing water. Negros who grew up in regions where proper English was the spoken dialogue, or who lived in regions where education was afforded them, received positions which allowed them to speak, but only with scripted words.

The senior Negro waiter with the very good diction was the only waiter who spoke to the captain, Captain Maggoni. The Captain's uniform resembled that of the Negro waiters', except his uniform bore embellishments denoting his superior rank. Even if the Captain wore the same uniform as the Negro wore, his white skin embodied his superiority within the colors of humans.

After watching the men for about ten minutes, I began to understand the various hand movements used to signal the waiters. Each hand movement represented a distinct action (service the tables, speak with a waiter, summon the captain), while a combination of movements represented multiple requests.

A waiter quickly responded to a hand motion; speak with waiter. Very few words exchanged between the two men, and with a final "Yes, Sir," the waiter quickly retreated. Once again, the men became engrossed in their conversation. Suddenly, my innocuous presence fell under suspicion when the waiter's leg brushed against the fern, exposing my cover. "Missis, please excuse me for the intrusion, but by whom are you accompanied?"

In response to his annoying question, with a lofty attitude I replied, "My daddy."

Continuing my dialogue, I pointed my index finger with a prissy authoritative gesture in the general direction of the tables. "And he's sitting over there, just across the pool with his friends. *My daddy* is the handsome man with the black and white shoes, holding a cigar in his hand."

All of the men wore black and white shoes and smoked cigars. With a whimsical plea, and in one long breath, I whispered, "I have to be real quiet because *my daddy* doesn't know I'm here. I miss him so much because he travels a lot; and Mama is crying in our room because they had a real big fight." Barely catching my breath I continued, "And we are staying over there in the first cottage. Please, please, don't tell Daddy I'm here."

Content with my dramatic pleas, the waiter hurriedly said, "Missis, you must be moving along before we are both greeted with displeasure by your daddy and his friends."

"Yes sir, I understand." I snuck away in a crouched position, moving between two large planters to the side of the service bar. As soon as I felt safe, I ran back to the river's edge.

I reached the oak tree out of breath. I bent my head down and placed my hands on my knees in an effort to regain even breathing patterns while still feeling woozy. I sat alongside the tree's gnarled trunk and continued to watch the curious group of men. It was impossible to hear them speaking from so far away and watching them felt monotonous. I really wanted to hear what they were saying—spying intrigued me.

Surveying the area, I saw a perfect spot to accommodate my curiosities. Dodging between trees and bushes, finally reaching the sprawling magnolia tree, I felt confident the magnolia leaves and large white fragrant flowers would camouflage me. I had to make sure the guards' eyes turned towards the road and the docks, and the men remained engaged in conversation before I began my ascent. While the waiters busily serviced the tables, the patrons critiqued them with unspoken words, imparting fear.

The first branch hung within arms reach, but I would have to scale the tree with my bare feet until I could wrap my legs around the branch. Feeling confident, I began maneuvering up. Having a bit of difficulty with my nightgown getting in the way, I dropped back down and started to tie the front and back together between my legs to make pants when I heard rustling leaves close by and froze. Startled, but still believing no one saw me, I curled up in a fetal position and remained stationary just in case I was mistaken. I heard a stern male voice restraining a ballistic outburst, "Hey kid, what are you doing? Get out of there before I have to rough you up."

Slowly I unfurled my body and began to stand. Turning around, I pushed a sourpuss expression on my face and placed my hands over my eyes. I knew I had to face this critical situation, but not this exact second. I had to think. Once the man saw that a girl stood in front of him, he subdued his harsh words just a tad. "What the hell is a little girl like you doing out here snooping around?"

Nervously I said the most stupid thing, "I'm a pirate princess." Realizing how ridiculous this sounded, I took my hands away from my face and kept my eyes tightly shut with my nose and mouth contorted.

"What is your name?"

I opened my eyes and before me stood a handsome man who reminded me of my daddy. Taking a few steps closer to my statue-rigid body, he squatted down until our eyes met. "Are you okay?"

After a pause I replied, "Yes sir."

"I'm Mr. Johnny. Are your parents nearby?"

"Yes sir."

Not getting very far with his interrogation he then said, "Come along. Let me take you back to the hotel."

43

Gently closing my eyes while releasing a trembling sigh, I imagined my daddy standing in his place as tears gently rolled down my cheeks.

The handsome man extended his hand to me. A portion of his white long sleeved shirt extended from his jacket revealing an ornate cluster of diamonds instead of a button. Accepting his hand, I started walking with him alongside the wrought iron fence leading to the pool's entrance gate. Before we got too close to the gate he loudly announced, "Look what I found wandering around in the night alone."

I pulled my hand from his before the other men had time to turn around. I knew running away would not be an option at that time. Trembling with fear, I hid behind his legs and tightly held onto his pants hoping he understood I didn't want to be seen.

He reiterated with emphasis on certain key words, "She is out here *all alone*. Her parents are staying at the hotel. I'll see to it the concierge reunites her with her parents. If business is complete, I'd like to retire for the evening."

A grumbling baritone voice said, "We're finished." As my protector turned I continued to cling onto his pant legs, gradually positioning myself along his right side and hoping to catch the grumbling man's last words. "Tomorrow, same time?" Hearing this pleased me because I wanted to make sure I came back to prove to myself that I could be a successful spy. I had failed twice tonight, and this really frustrated me. On previous nights, Papa conducted private meetings at his dock house and I thought I recognized some of the men. I wanted to verify my suspicions and listen in on their secretive conversations. I placed my hand into my protector's hand and asked him if he had a little girl.

"No, but if I ever do I hope she is as pretty as you."

My heart melted. I pretended *he* was my real daddy protecting me, his most precious little girl in the whole world. A doorman tipped his tall black hat. "Good evening, Mr. Johnny; good evening, miss," he said, while another doorman opened the doors of the grand lobby. Becoming apprehensive, I pulled my protector's hand back, afraid to enter. It would be obvious to everyone seeing me I was not the type of person staying in the General Oglethorpe Hotel. With my dirty nightgown, muddy feet, and messed up hair—in no way would I remotely blend into the grandeur. My protector nudged me forward until we were inside the atrium. The inside looked like a dream; a Southern paradise with beautiful lounges and luxurious furnishings, high ceilings with elaborate moldings, beautiful murals, and gilded gold mirrors. The atrium, adorned by large vases filled with fragrant colorful seasonal flowers, missed only one thing, my parents.

Thinking fast I executed the next escape before we reached the concierge's desk. Music filtered through the foyer from one of the grand ballrooms, and instantaneously a plan miraculously entered my mind. Happily I led my protector down the hallway

to an elegantly adorned arched doorway with sweetly scented magnolia blooms, pink roses, and baby's breath, all perfectly grouped within magnolia leaves intertwined and secured by pink and white ribbons. Trustingly, looking upwards with a confident smile, I let go of his hand and pointed to a small group of children standing at the punch bowl table.

Enthusiastically and without thinking about my disheveled appearance, I said, "Oh look! My cousins are over there." Quickly mingling amongst the wedding guests with my uncombed hair filled with oak leaves and small pieces of bark, I turned around and vigorously waved an enthusiastic final goodbye to the ever-so handsome man. Merrily cavorting with an uncanny air of playful confidence, I tried to reach the ballroom's back service door. A wedding guest became aghast and voiced his displeasure. "The nerve of that child! What sort of parent would allow such behavior? She's looks like an unkempt animal."

I quickly disappeared behind the white curtains lining the bottom of the stage—escaping anytime soon would be too risky. I remained under the stage listening to the band and dreaming about my own wedding with a fairy-tale spirit touching my heart. After the midnight hour's toasts celebrating the beginning of the bride and groom's first day as husband and wife, the guests began leaving the ballroom to take part in the traditional farewells and rice throwing. The band began dismantling their equipment and the clean-up crew began clearing the tables. Peeking out from under the curtained stage, I found an opportune time to dart out from the ballroom and make my way through the hotel. I didn't have time to pay attention to the startled and appalling comments made by society's pretentious sovereigns. I needed to make my way outside without anyone stopping me in my tracks. Pushing my way through the elegantly dressed guests, I escaped the halls of pretentiousness and snobbery. As I ran across the lawns with my white night gown trailing behind me, I felt a deep sense of relief when I looked back and saw that no one followed.

An ornate white carriage drawn by four white horses bejeweled in rhinestones and headpieces carried the newlyweds under the stars into the darkness of the night, just like in a fairy tale. I stopped by the roadside just long enough to wave, then without further hesitation, I returned to the house and snuck back into bed.

I woke up the next morning anticipating another nightly escape with hopes of seeing the handsome man again. I took a piece of paper from Nana's grocery list pad, and in my best penmanship wrote:

Dear Sir, I have something very important to tell you.

I will be waiting for you at the big oak tree by the river. Deborah Elizabeth

I folded the note in half and tucked it in my jumper dress pocket. It seemed that the day went by more slowly than most days, and I anxiously awaited nightfall so I

could take a bath. I wanted to have my hair washed, but Nana only washed my hair on Saturday for church on Sunday. I wanted to look like a real Little Lady, just like the girls at the wedding, not like a marsh bum or a pirate princess tramp.

With a plan already in my mind, I unpleasantly remembered the wooden paddle. Forging forward anyway, I went to the boathouse and looked for Papa's worm cans. He would use smelly worm bait or live crickets for fish bait.

I took worms from the can and squished them in my hair. Next, I took a handful of crickets and squished them in my hair, leaving behind little carcasses and leg remnants. I would surely receive punishment for these deliberate acts.

Wearing my nice gingham checked jumper with my new hairdo, I returned to the house. Nana heard the back porch screen door slam and turned away from the kitchen sink where she was washing her garden grown tomatoes. Wiping her hands on her apron she said; "Haven't I told you not to slam the door? How many times do I need to tell you the same thing? You startle me when you do that."

She was more startled than mad. The slam did sound like a gunshot. She greeted me in the mudroom and took a surprised second look. "Deborah Elizabeth, what have you done to yourself?"

I shrugged my shoulders with no verbal response. She looked at the wooden paddle and asked again, "What have you gotten into?"

"Are you going to tell Papa?"

"No, if you give me an honest answer."

I mumbled a few words with my head hanging low.

"Speak up, and speak up quickly before I change my mind."

"I wanted you to wash my hair so I would look like a little princess instead of a tomboy."

"Well, you sure didn't have to go to this extreme. Whatever possessed you to do this?"

"I don't know, I just thought you wouldn't wash my hair until Saturday. I wanted it washed and curled, and sit under your pink hair dryer. I thought maybe we could have some Nana and granddaughter time, just the two of us. Wouldn't that be lovely?"

The honey was flowing and Nana couldn't think of anything to say other than, "All right, hop into the bathtub. Next time just ask, okay?"

"Okay, Nana, I promise."

Papa and Nana went to bed at their usual hour. Nervously, I fiddled with the strings on my nightgown until the bow ripped off. The house quieted with only the sounds of Papa's snores and the chimes from the antique grandfather clock in the living room.

It was time to turn myself into a princess, not a pirate princess, but a real princess. I opened my curtains to fill my room with moonlight. I pulled a cotton slip over my head when I remembered I needed to wear a dress with buttons in the front. I thought of the pinafore and dress—only one problem, the pinafore tied in the back. Tying a perfect bow in the back was impossible, but no one would pay attention to my back in the darkness of night. I buckled my shiny black Sunday shoes and thought about wearing white gloves. Then, on second thought, it might look like I'm wearing waiters' gloves. I tied a pink ribbon in my neatly combed and curled hair then placed an olive seed necklace around my neck. I kissed a picture of Daddy and asked my Gerber Doll, "Do you think Daddy would think me ever-so-lovely?" Satisfied with my appearance, I dressed my doll in an equally beautiful ensemble. We both looked simply marvelous gazing in the mirror and seeing only a glimpse of our beautiful reflections. Almost forgetting, I placed the note in my pinafore pocket.

The sounds from my shoes making contact with the hardwood floors resonated as I migrated through the house to the mudroom, keeping each step as delicate and quiet as possible. When I closed the back porch door, I sighed with relief.

I stayed on the road leading to the General Oglethorpe Hotel until I reached the wrought iron fence surrounding the pool. I had to think of a way to walk past the entrance to reach the large fern planters without being seen, and this time avoid being caught. I also began to stiffen my composure because I began to feel stupid for devising this nonsensical plan to begin with.

Then, with an authoritative walk, I continued until I passed the entrance veering to the far side of the service bar. I quietly peeked around the corner to catch the attention of the service waiter.

"Pssst, oh sir, pssst."

He didn't even stir a muscle.

Repeating a little louder, I whispered,

"Pssst, oh sir, oh sir."

His eyes barely moved in my general direction. Positioning his eyes to their furthest corners, and without moving his head, he spotted me. Unobtrusively, he kept his stance forward while slowly moving one foot beside the other parallel to the small blue tiles lining the poolside. When he turned within earshot of my whispered summons, I solicited his help. "Oh sir, would you please give a note to Mr. Johnny, my daddy?"

With a hesitant pause, and most probably conflicted between curiosity, obeying the rules, and not knowing what to do, he mumbled, "How long yous bin hidin' der? Don't yous comin' an foolin' 'roun. Now move 'long befer we'n both sees the devil."

"Sir, it's a life or death matter, I promise."

Nervously obliging, his right gloved hand extended from his back far enough for me to place the note into it. While placing the note inside his left glove he mumbled, "Ya knows de Mafia men is worse den da devil himself. I's ain't gonna do it, no ma'am, I's sure ain't gonna if'n da other mens are a lookin'. Sump'in important, huh?"

Mafia—a word I never heard before. I rolled my eyes upward and sighed, "Yes sir." I had a feeling the word Mafia meant something like powerful, and dangerous, and maybe even killers—maybe members of the KKK, and that's why the waiters feared them so much.

Within a few minutes, a Mafia man waved his hand for multiple services. The two Negro waiters approached and one waiter began servicing the table while my messenger waited for his turn to proceed with his duties. The first waiter removed the crystal cocktail glasses and then the sterling silver monogrammed silverware. Methodically and quietly he then removed the china. Each piece of china, elegantly donned with gold edges and three monogrammed gold initials, depicted the finery and richness afforded only to the social elite. The Mafia men remained quiet as they observed the precision with which the waiter serviced their table. Their fixation afforded my messenger the opportunity to take a few steps closer to my daddy. Standing erect with his shoulders pushed back and his chest extended outward, and keeping his hands folded behind his back, the opportunity presented itself for my messenger to take my note from his left glove and hold it behind his back with his right hand.

Anticipating the worst, I suddenly became euphoric when my messenger took a few steps backward, aligning himself to the front left side of Mr. Johnny. He barely wiggled his fingers, bringing attention to the small piece of paper. Slowly bending forward, Mr. Johnny carefully took the note from the waiter's glove without bringing attention to the exchange. We had successfully accomplished our first mission!

As quickly as the note was retrieved, the men at the table looked over to my messenger, summoning him to begin his duties. With a degree of fear remaining on his face, he began artful wrist movements by gently swirling a sterling silver knife over the tablecloth and removing cigar ashes and food debris onto a silver platter. After he completed this task, and with the same wrist action flare, he pinched the corner of a folded napkin and with a gentle snap opened it and placed it respectfully on the lap of the eldest man, then commenced with the same ritual until each man received a clean napkin. Taking a few steps backward before making a forty-five degree turn, he began walking back to the service bar. Had he immediately turned his back to the guests, a blatant act of defiance to his white men superiors, an immediate blackball dismissal would take place. Being blackballed in Savannah was a serious infraction within any venue. My messenger reached his workstation with bent knees, trembling and sweating. I had no idea of the seriousness of my request and did not realize what he had sacrificed to help me. I will forever be indebted to him and grateful for his courage.

I made lip motions without sound, "Thank you, thank you so very much."

Leaving the pool area through the back gate, I ran to the largest oak tree by the river's edge and sat on the tree's long curved limb. Catching my breath, I stood tip-toed on the branch and watched the Mafia men exchange words with my daddy who then excused himself from the table. He walked down the grassy path towards the Wilmington River. As he approached the tree, I enthusiastically called out in a loud whisper, "Hello, Hello, I'm up here." Without giving him a chance to respond I continued, "I hope you won't scold me or send me away just yet. I have something very important to tell you."

Mr. Johnny extended his arms upward and lifted me down from the branch. I felt like I floated in the air in an ever-so-enchanting world filled with dancing lightning bugs. The strength from his firm, yet gentle, grip around my waist made me fee safe from all that was bad within my uncertain world.

As a true Southern lady with rightful English virtues, my eyes, gestures, and theatrical vocabulary spoke a unique language which intrigued this seemingly powerful man. His masculine embodiment softened the more I spoke. Somehow I felt compelled to be honest with him and told him my mother and grandparents abandoned me, and I was now staying with an elderly foster couple. I had feared telling him the truth the night before because I would rather die before Nana and Papa found out I had betrayed them. But fearing another unknown placement and punishment seemed too much to think about at this time. Skipping off to the ballroom certainly made much more sense to me.

For what seemed like hours, we exchanged similar nocturnal escapes and laughed about his boyhood capers. I felt comfortable with him and told him about the frightful killer-shower-man and my hiding places. He sensed I loved and missed Daddy more than anyone in the whole world. I told him I needed to know where my mother was because I felt she was alive. I could feel her presence around me every day and I knew she loved me.

He stared at the currents pulling the tides through the marshes for a long time without saying a word. With a quick snap-like motion, he turned his head towards me. "If I ever get word anyone harms you in any way, I will personally take care of the situation."

Deep down I knew he would never be around to protect me, but his words seemed heartfelt and I placed them in the fantasy-world-survival section within my heart and mind.

I agreed it would be a good idea for him to walk me back home to Papa and Nana's house. "Will you promise me if anyone stops us or asks who I am, you will tell them I am Mr. Cessaroni's granddaughter?" I once heard that name and thought it sounded

powerful. "Tell them we are looking for the pearl necklace my grandfather gave me for my seventh birthday."

Taking a few more steps down the shadowed grassy lawn he finally replied, "I will keep the promise only if you promise me you won't be outside after dark, and you won't be coming around our grownup conversations again. You must be respectful. I'm sure you agree, don't you?"

Obediently I answered, "Oh yes sir, of course I agree."

We walked holding hands, veering off the path just a little so we would not draw attention to ourselves. Distracted, we heard poolside chairs noisily scraping against the cement, clearing a passageway for a tall, large framed, dark-haired Italian man. He first spoke with authoritative hand gestures, and seconds later, he shouted in a loud raging voice. "Aren't you the girl staying with Redd Donaldson and his wife? What are you doing here? Where is Mr. Donaldson?"

The man furiously huffed out of breath, while pacing back and forth. He popped his knuckles as if preparing to break my neck. I trembled and hid behind Mr. Johnny, My Mafia Man, My Protector, My Daddy. He released my hand and the palm of his hand extended as if to say, "Stay put."

Mr. Johnny moved his head from side to side, making cracking noises in his neck. After realigning his neck and shoulders, he walked towards the angry man who now gnashed his teeth and sweated profusely. Mr. Johnny extended his arm over the three foot wrought iron fence and placed his hand firmly upon the angry man's shoulder, calming him down as they walked away to speak privately. I turned my back to the pool and stood motionless with my Gerber Doll, awaiting Mr. Johnny's return.

"Come along, we have to go right now. Don't dawdle. Keep moving," Mr. Johnny called out to me.

When we arrived at the house I asked Mr. Johnny if we could walk to the end of the dock for just a few short minutes. While he hesitated, I ran and didn't stop until I reached the end of the dock. I knew he felt obligated to make sure I returned safely to the house, so my strategy was right on target. I went down the few steps, stood on the floating dock, and waited for Mr. Johnny to catch up to me.

Papa and Nana would surely hear about the unfortunate event, and I wanted Mr. Johnny's advice on how I should handle the situation. While he looked down at me with piercing eyes, I asked, "Do you know Papa and Nana?"

"Your Papa is an old acquaintance of my business associates. You may have put Papa in grave danger by stepping out of bounds," he explained. "If I knew of your relationship with Mr. Donaldson, I wouldn't have put myself in jeopardy by associating with you, nor would I have been able to protect you if the situation got out of hand."

I was damn lucky things turned out favorably because I had walked on dangerous territory. I turned away and shuffled to the edge of the floating dock. The full moon's gravitational force was swiftly pulling the tidal creeks back into the ocean. Wrapping my arms tighter around my Gerber Doll and drawing her closer to my heart, I began crying. "I don't know what to do. Do you think I should run away? Maybe I should take an inner tube and drift away until I disappear into the marsh, or maybe I should just jump in the water and drown in an undertow. Everyone would be rid of me then."

Somewhat amused but unsure if I would do something drastic; Mr. Johnny followed me down the dock's steps. He shook his head saying, "Deborah Elizabeth. Indeed you are a curious girl."

In an effort to calm my gibberish threats, he suggested we sit down and dangle our feet in the water. I thought this was a marvelous idea and it would afford me the attention I so desired. We both took our shoes and socks off and dangled our feet in the water. We talked and talked until the evening events turned to exhaustion, and I just wanted to go to sleep and never wake up again.

While we put our shoes and socks back on, he sweetly said, "I'll remember you as my Midnight Miracle."

"Why is that?"

"You have a remarkable gift, Deborah Elizabeth. And you don't know it. Your wisdom is far beyond your young childhood years. You see the world with all its creatures, as if each one were the most important of its species. Wealth, position, and connections are very important within the family, but throughout troublesome years I have never met anyone with the courage you show in spite of adversities and your carefree enthusiasm."

He used some fancy, big words and some of them I figured out by its usage within the framework of his sentence.

"Never allow anyone to break your spirit, little lady. You will accomplish many great things and you will touch many lives, just as you have touched mine." He took my Gerber Doll and said to her, "You take care of Deborah Elizabeth. Even I can't take your place in her heart, nonetheless she will always remain in my heart." He then placed a kiss on my forehead.

We did not utter another word on the way back to the house. I opened the porch door and walked in. Peeking back out from a small opening I whispered, "I will miss you ever-so-much."

Mr. Johnny kissed two of his fingers and blew the kisses my way. I acknowledge him with the same kindness and closed the door.

51

Sensing his sadness, I ran to the front living room window to give him a final wave. He did not look back. I watched him walk through the entranceway to the General Oglethorpe Hotel until the road curved and he was no longer visible.

I went to my bedroom, looked out my window facing the river, and wondered what the next day would bring. After climbing into bed, I dreamt pleasant dreams about My Mafia Man as my fears of Papa finding out about my nightly capers vanished.

Two weeks passed and Papa's old friends began arriving as usual in big black cars with bodyguards escorting them to the house. Some of the younger men introduced to Papa for the first time possessed the same toughness and sweetness as Papa. The important men gave embracive welcomes to Nana as each took turns kissing her plump rosy cheeks. One man handed her a gift wrapped in gold paper with a big gold and black bow. Another man gave her a box of long stemmed red roses. Nana and I both sensed the men were pensive and more edgy than usual.

The next thing I knew, I received a beautiful bouquet of daisies tied together by pink and white flowing ribbons. Maybe this was a good sign that no one knew about the troubles I had caused several nights before, and maybe Mr. Johnny was able to smooth things over with the big Italian man.

I suddenly realized, *Oh my God, this is the same man sitting at the table the other night; the boss.* Afraid to look him in the eyes, I continued smelling the flowers while his elderly voice shook. "You will always be Johnny's Midnight Angel."

Stunned by his comment, I wondered how he knew about my conversation with Mr. Johnny, and why would this old man be giving me the flowers instead of Mr. Johnny himself?

For some reason I had a terrible premonition and thought if I ever needed to spy on someone, today was the day. More cars filled our driveway and front lawn. Several fancy small boats patrolled the nearby waters around our floating dock, which I thought very odd.

I could tell Papa and the other men joining him at the dock house appeared very upset about something—and something big. I resigned myself to helplessness and hated not knowing what was going on, but remembered Mr. Johnny's warning. I could cause Papa trouble if I spied on him or anyone for that matter. I kept a vigil lookout from the front bay window hoping Mr. Johnny might be joining the others. He never came.

By nightfall, all the cars in the driveway had left, and Papa remained in the dock house until Nana walked him back to the house. Without saying good night, he limped off to bed.

The next morning Papa remained aloof and did not engage in conversation with Nana. Later in the day Papa's silence finally broke. "Marcella, I'm on my way to a

meeting at the General Oglethorpe Hotel. There's no need to plan supper for me tonight. I'll be coming home late, so don't wait up and don't worry, everything will be fine."

This day seemed even more bizarre because now Nana was acting strangely. She nervously paced back and forth while listening to someone on the phone. Bursting out loudly without knowing I was within earshot, she said, "What! At the General Oglethorpe Hotel! Who all is coming? Johnny is... " She mumbled and I couldn't make out her words.

Did I just hear Johnny? Tonight! My Mr. Johnny? Here? With panic and a sense of urgency I ran over to the kitchen where Nana talked and boldly looked at her. Fuming, she said, "Go to your room and do something. Do not listen to my conversation and keep to your own business. Now scoot."

Immediately I sensed bad times coming, and I needed to obey her right that instant. She had never displayed this type of frustration and anger before and she scared me with the tones in her voice and her cutting words.

Respectfully, I returned to my bedroom and noticed car light beams hitting the entrance to the dock and disturbing the darkness of the night. My window did not have a view of the main road, but I could tell another long procession of cars was on its way to the hotel's entrance. Unusual lights began swaying throughout the sky and the marshes. *Helicopters! What are helicopters doing here?* Four helicopters beamed their bright lights over the rivers and creeks surrounding the marshes separating Savannah from Wilmington Island. Three helicopters remained in the air while the third one disappeared in the night as if it had suddenly dropped out of sight, hidden in the marsh grass. Within ten minutes, all four helicopters headed back towards Savannah, leaving behind the usual darkness over the rivers and marshes. The night became unusually quiet and the water looked like a sheet of glass.

Many hours later Papa came back home, went straight to his bedroom and joined Nana. Disappointingly, I couldn't hear their conversations. Sadly, and without any forewarning, Papa and Nana told me at breakfast that they were leaving for New York on business the next day, and they would not return for a few months. Once again, confused with everything seeming to fall apart, I placed myself in a survival mode and did not cry or express any emotional facial expressions. I continued to eat my breakfast without lifting my head up and refrained from making a response to their announcement.

Papa asked if I would help him secure all our wooden storage boxes on the deck.

Somewhat disrespectfully I said, "Sure." I thought the word "our" a bit much, knowing that I would be gone the next day and there wasn't anything that was mine, much less ours.

The next morning came quickly. Nana walked into my room with a new dress she made for me. Emotionless, but politely, I thanked her. A uniformed driver arrived at the house in a shiny black Pontiac. Papa greeted him and handed him my suitcases. After a brief conversation, the driver took my meager belongings and placed them in the trunk of the car.

As part of my survival readjustment, I avoided their hugs and kisses. As soon as I reached the car, the driver tried to take my doll while I positioned myself in the back seat. I yanked my body away from him and said, "I can do it all by myself. I don't need your help. I don't need anybody's help."

I watched Papa and Nana limping and wobbling in an effort to reach the car before the driver started the engine. In a deliberate voice without acknowledging their efforts, my last words came out curtly. "Good-bye; Mr. and Mrs. Donaldson."

I felt sad for them but I had to be strong to survive. I couldn't let my emotional sorrows get the best of me, and I became more impatient with each minute the car sat motionless. "Please, please, can we go now?"

As the car turned away from the Donaldson's house I watched the marshes fading in the distance from the back window.

Off to another journey we shall go...

THE ROLLIN' NANCY HANKS

The Nancy Hanks rollin' down the track
Quite fancy as a matter of fact
Miss Merriman stay in your seat
Is this an impossible feat?

Business men read their papers
Miss Merriman off on one of her capers
Connecting cars with accordion sides
Loud and hissing as we ride

Savannah to Atlanta riding on the rails
Yet to another family that may fail
Adventures are made in all situations
The kitchen was my favorite location

Skipping through the cocktail car
How do you do, have a good day
Goin' to the kitchen I'll be on my way

My stories and smiles kept the kitchen alive
Now Miss Merriman, yous better hide
Behind dat tater sack yonder der
The conductor is a comin', you best be aware

My travels became well known
I was the little girl who had no home

CHAPTER EIGHT

— *The Nancy Hanks* —

Everyone feared the killer-shower-man might be looking for me; everyone but me. If my mother couldn't find me, then he surely couldn't. I wanted to forget about the blood and the brains splattered on the wall. I just wanted to go to Great Aunt Margaret's house in Atlanta! I had never met her before, but Grandfather described her as the most talented pianist in the world. He said that my safety concerned her and she had opened her home to me.

I stayed with Great Aunt Margaret until she began her travels to Europe to play in a concert. Also I had to stay somewhere until my grandparents made arrangements for me to stay with them. They needed to find someone to care for me during the day while they worked. I don't remember any daycare facilities like we have today. I think most mothers stayed home and didn't work outside of the house.

The Nancy Hanks with her mighty engines arrived in Savannah on schedule, not a minute late. Riding the rails unaccompanied made me feel quite the important little traveler. The train's conductor called out, "All aboard." He put a small stepping stool in front of the boarding platform. When my time came to board he said, "Good morning, little lady" and gently guided me up the steps. A soft spoken colored porter led me to my seat. His uniform was neatly pressed with his white shirt collar firmly positioned close to his uniform coat lapel. He wore his name tag and years of service pin. His cap was firmly placed on his head, and his white gloves showed no stains or dirt smudges. The porter said, "Miss Merriman, now yous sit right here. The conductor is comin' by once all his passengers board. Now, you knows the rules. No gettin' up and runnin' 'round. The little ladies room is right over yonder near the front of the car. Good day, Ms. Merriman."

Attentively I watched passengers board, especially the stoic gentlemen who looked so businesslike. Some of the women wore fancy hats and carried pretentious airs. Other passengers appeared very well groomed, but did not have the expensive apparel. Very

few children boarded with their parents. I was the only child without guardians and I liked it that way. Independence made me happy.

After the porter and conductor completed their tasks of checking tickets and greeting passengers, an elite group of men proceeded to the smoking lounge car. I don't remember seeing any ladies in this car; maybe they weren't allowed. The remaining men passengers wore suits less stylish, but none the less very neat and clean. They remained in their seats and did not engage in conversation with the more refined gentlemen.

A curious traveler with an adventurous mind, I left my seat to mingle amongst all classes of passengers. Swirls of cigar and cigarette smoke filled the lounge car. The gentlemen talked of politics, war, manufacturing, and stocks, not to mention infidelity trysts. As I passed through the "off limits" lounge car, trying to reach yet another "off limits" kitchen car, I spoke to the male passengers on either side. "Good morning, kind sirs. I hope your travels are pleasant. Good morning, what a lovely day." I held an aristocratic posture by keeping dignified with my shoulders held back and my head held high. My most unexpected words elicited an inquisitive look and an occasional soft response, "Just fine, Little Lady."

"Now Ms. Merriman, I told you to stay sittin' in your seat. You disturbin' the passengers in the lounge. They's not likin' youngins comin' in der area."

"Yes sir," I replied, hiding my real intentions. Once past the lounge car, I came close to the happiest place on the train, the kitchen. Approaching the kitchen car, I discovered a small service counter and a coat cubby for storage. When the bartender left his station, I sat inside the cubby and listened to the adult conversations. I liked picking up big vocabulary words while hearing about business strategies and adventures to other countries. Most of all I liked the voices of the men and the authority with which they spoke.

Finally, arriving at my favorite location unnoticed, I heard the colored men working in the kitchen happily singing as if they didn't have a worry in the world.

At first the colored staff scorned my grand entrance. However, upon my friendly theatrical entry they couldn't resist kind words to greet me. I told them I was an unaccompanied castaway, but for them not to worry because they'd find me to be a friendly pirate princess. Some of the kitchen staff laughed while others seemed annoyed. One cook invited me to sit on a wooden crate in the corner next to the potato and rice bags. We laughed, and they enjoyed listening to my elaborate storytelling, mostly true adventures that seemed like a story to them. If the porter or the conductor came up to the door window, I hid behind the potato and rice bags until they left. Upon the conductors' or porters' entrance into the kitchen, I remained unseen and unheard. Some of the coloreds feared the consequences if I was caught. Sometimes the kitchen staff was

more serious and quiet. Maybe their supervisor mingled amongst them. When the workers weren't especially talkative, or their voices solemn, I would just stay for a little while and then quickly whisk away. "Oh my, I must be in the wrong car. I'll be on my way." Having a keen sense for danger, I never compromised the kitchen staffs' positions.

"Ms. Merriman, there you goes again out of yo seat. What'cha doin' now with yo head hangin' out da door? You gonna git hit by a big bug and it's gonna blind you. Why do I have to tell you over and over to stay put?"

When he left I stood on my tip toes, leaning over just enough for my head to tilt out of the opening of the entry platform, a half door with no window. My hair flew and the wind currents pushed the skin on my face in unnatural ways. I sang and sang until my throat became scratchy and sore. The sounds of wheels on the tracks and the hissings from pressure releasing seemed comforting, as the sounds pushed me forward to new adventures. The fast passing landscape inspired new feelings of life and escape.

Another fun place to sing aloud on the train was in the odd accordion-looking partitioned area that connected one train car to another. The loud noise rattled and didn't have the steadiness that the regular car provided. I liked to yell out aaaahhhhs and sing operatic sounds with made-up words.

Very seldom did I see young passengers. If children acted bored, they remained under the thumbs of their mothers. I couldn't understand why they weren't as excited as I was— going to the big city of Atlanta and traveling on such a prestigious train. Sometimes I would stick my tongue out just to get one of them in trouble; knowing that he, too, would do the same and his mother would catch him with her watchful eye. As for the girls on the train, I would act very adult-like by tossing my head with an air of sophistication and power. I went on a mission of independence by pretending to be a famous child born to a famous business powerhouse father like the men in the lounge car.

My pocketbook contained a pencil and paper, a clean cotton handkerchief with blue hand stitching around its edges, and some pocket change, perfectly accessorized for my business savvy appearance. As lunch time approached, the conductor escorted me to the dinner car. Performing with my usual theatrical self assuredness, I felt really important having his attention.

I sat with three other passengers at a table set for four, with starched, neatly pressed white napkins and table cloth. The little salt and pepper shakers stood next to the fresh cut flowers arranged in a short based etched vase. I wondered if the three passengers speculated about me. If so, they probably thought I held the innocence of a sweet child. They couldn't imagine the internal mechanics of my mind and heart; the horrid nightmares, the violations upon my childhood. Surely their illusions of me and my little world comforted them, as everyone wants to see a child and think of their own youthful fond memories.

The ladies sat next to their husbands in the diner car but didn't talk very much. Most of the tables filled with businessmen traveling without family. The men talked and acted politely, and of course children were seen and not heard. The women engaged in small talk, not as interesting as the men's banter.

I happily anticipated arriving in Atlanta. When I met Great Aunt Margaret, I liked her instantaneously and felt Grandfather described her perfectly. We went directly to her home by way of an electric trolley car. Auntie Margaret's home stood on the corner of Ponce de Leon and 14th Street. Ivy covered the front and side yard. The right side of the yard had a brick wall about six feet high. Collecting the liquor bottles thrown into the ivy from passersby became one of my daily chores.

Auntie Margaret, Grandfather Fraser's sister and a very talented pianist, played the piano in concerts all over the world. She also taught piano to blind students. Her home held several baby grand pianos and one grand piano. She usually ate all her meals at restaurants within walking distance of her home and introduced me to various types of food. I pretended to be grown up just like her. She socialized with Atlanta's elite, and therefore I always remained on my best behavior.

She would have made a perfect mother for me. We kept busy all day visiting art galleries, museums, going to the theatre, and playing duets. To this day, the smell of Crayola crayons takes me back to her home. She had a cigar box filled with broken fat crayons so her younger sighted students could color. She kept a supply of coloring books, some with boy themes and others with girls' interests.

Sometimes I sat for hours on her front porch and waived to the trolley car attendants, taxi cab drivers, motorists, and the people walking along the sidewalk. I never wanted to leave Auntie Margaret's house, but caring for a school aged child would be much too difficult because she traveled extensively and was only home part of the year.

My last visit to her house saddened me. Great Aunt Margaret lay in bed, dying of cancer, yet she still took the train ride back to Savannah with me to visit her brother. The trip was most enjoyable. We talked about the art galleries we visited together and the concert halls. Her wonderful friends always treated me kindly. I longed to be an opera singer, and they would play the music for me.

We talked of God and spiritual feelings. Auntie Margaret said I possessed the wisdom of an old soul wrapped up in a little girl's body. One day I would achieve great things and be an inspiration to the world. Her music and her kindness inspired me. We shared many of the same philosophies, even though there was a fifty year difference in our ages.

Great Aunt Margaret wasn't ready to die. Her illness terrified her and she remained in pain. I tried to comfort her by saying that all the good things about her would never die, and for her not to dread going to sleep because she feared never waking up again.

I tried to put myself within her fears and held her hand to say, "Auntie Margaret, when you wake up you will wake up to a new place, just like I do all the time, but your place will be in heaven with the angels. Did you know that you are one of my angels on earth? Even angels need to sleep."

We drifted to sleep with the sounds of The Nancy movin' down the track.

Off to another journey we shall go...

THE SEA

The music of the sea brings hope and joy to me
I dance with the sea gulls in their flight
Until their wings are folded for the night
Does my existence bring purpose to this life

I walk amongst the littlest footprints
Pelicans dip and sore, sand castles left upon the shore
The sea breeze carries my thoughts which flow
Amongst the dangers and the wind's bellows

Where does the sky begin, where does the sea begin
Where do I exist between these mighty forces

Little sand crab in such a hurry
Mussels and clams ashore
Star fish with radiating arms
Sea horses with bony plates
Silver dollars on the ocean's floor
Oh the sea life I so adore.

CHAPTER NINE
— *Tides of Tybee* —

Grandmother had a change of heart by agreeing for me to stay with them if I didn't cause her any problems. Prevailing winds from the northeast brought signs that a change of season was coming, and Grandfather geared up for his last few crabbing trips before he closed the boat shed for the winter.

"Hurry along," he said impatiently. "We best be goin' to catch the tide, there's no time to waste." It didn't matter if the sun had risen or not; we must leave immediately! Deliberately revving up his Ford F100 pickup truck, an impatient statement, brought Grandmother running from the kitchen to the back porch.

In a whispered shout she hollered, "Gibby, Gibby, Gibby," she always said his name three times in a certain little rhythmic pattern, "You'll wake up the neighbors!" Without sticking his head out of the truck window we could hear him say, "I don't give a damn if it wakes up the dead; it's time to go!" Five o'clock in the morning and the quiet neighborhood slept except for the sounds coming from the truck's engine and loud muffler.

If I didn't get in the truck right then, I must ride to Tybee with Grandmother later in the day and miss crabbing with Grandfather. Also, and most importantly, I was his sidekick and he needed his little buddy. But first I wanted to peek at the blue bird nest in our azalea bushes that Grandpa had shown me the day before.

"I'm coming, I'm coming." Now Grandmother gave me her look because I yelled my reply to Grandpa. Once again, before we even left Henry Street, I had disobeyed.

I peeked at the tiny blue bird eggs and couldn't resist stroking them with my finger. Once I realized what I had done, I almost froze. An alert signal popped into my head... don't touch baby bird eggs; the mother will kill them if she smells the scent of humans. Oh no! What had I done? Why didn't I think before touching them? I didn't want the mama bird to kill them. I cupped some of the nesting around the eggs with both of my hands and looked in all directions for any signs of their mother.

Suddenly Grandpa said, "All aboard to Tybee; last chance to board." Then he honked the horn three times. Holy cow, Grandmother lifted her white apron right off her waist and shook it vigorously, hushing Grandpa.

Without thinking I hurriedly placed the four bird eggs gently into my front pocket. They would be safe from their mama pecking them to death because of my human touch. I would keep them warm in my pocket and then I would find a way to care for them when they hatched.

Happily I jumped into the truck and said, "Let's get goin' Grandpa."

I felt a warm oozing sensation flowing on my leg and knew immediately the eggs had broken. I started to cry. I cried real tears, not crocodile tears. I killed the baby birds.

"What are those tears all about Little Darlin'? Now you dry them up. We're off to Tybee." He turned his head over his left shoulder looking down the driveway as he backed out onto Henry Street. I kept my full posture situated to the passenger window making sure my right side pocket remained as close to the door handle as possible.

"I'm just sad to leave Grandmother. I'm sad because, well, because I'm just sad because I want a mama just like the baby blue jays had." He didn't pick up on the past tense.

He drove silently and then said, "Well, birds only have their mamas for a very short time; and you have me forever. You're my Little Darlin'. Now scoot over beside me and take a nap. I'll wake you up when we get to Tybee."

I remained quiet and yawned. "I'll help you watch for the bridges. Tell me some stories about your adventures looking for the bomb in the marsh."

I knew I couldn't fall asleep for fear Grandpa might pat me on my side and feel the gooey wetness of the dead birds. I looked out the window and thought about what I did to the bird family. I will never, ever forget killing the baby birds; even if I destroyed them accidentally, I still selfishly killed them. Their mother wasn't protecting them, and if she had sat on her nest instead of flying off somewhere, well, then I wouldn't have touched the eggs and had to take them.

My thoughts grew into a vicious cycle of pain, sadness, hating myself, and hating my parents. My mother went away, never seeing me again. Maybe the same thing would have happened to the baby birds. They would wake up one morning all alone with no mama. I thought I could be a good mama to the little birds, but instead I killed them. I wanted to love the birds. A little piece of my heart died that day.

I sat frightened each time we approached the metal bridges expanding over the rivers leading to Tybee Island. Grandpa had poor vision and sometimes went way over the embankment a few yards before the bridge. We always carried a few bricks in the car in case he went off the road and we sat trapped inside the truck with the windows up and stuck.

As we drove through the arched bridges the shifting metal sounded like the bridge would fall all around us and we would die in the rubble underneath the water, crushed, and then we would be eaten by crabs and sharks. Two cars could barely travel side-by-side going opposite directions at the same time. In fear I pulled my knees close to my chest and buried my head, preparing to crash. My fears weren't unwonted as Grandfather on many occasions demanded the right of passage; someone had to yield and it wasn't going to be him. Sometimes he became a pretty scary ol' man.

Grandfather really became impatient when the draw bridge signal flashed red just as we approached the bridge. Sometimes he would step on the gas and beat the caution rails before they went all the way down. He'd then wave good-bye to the attendant and the attendant would raise his fist in anger. We would yell Whooo Hooo and high-five each other as both of us had a certain attraction to danger. One time he hit the wooden caution rail on the opposite side of the bridge. I think it scared him a little, but it didn't teach him to drive with full control, either.

Minutes after an incident like this, Grandfather would become serious once again and continued teaching to me using "prolific" words as if he read the explanations from a book. "The moon's powerful gravitational attraction generates semidiurnal tides—two high tides and two low tides every day." He looked at me to see if I listened to his lessons.

"I get it Grandpa. The tides go in and out with the help of the moon."

Turning his head back to the road he said, "Yep, you are right on target. Are you my smart little girl?"

In a dramatic voice I replied, "Oh, but of course my dear Grandpa, always and forever and ever."

As we drove along the road the debris from the last spring tide remained scattered upon the upper edges of the island's shorelines, the embankments of the marshlands, and alongside the old rail lines leading from Savannah to Tybee. Sometimes I became confused with my past experiences and wasn't sure if I had ever ridden the train to Tybee or not. My imagination oftentimes took me to events and places that seemed so real but really weren't; they were just events and pictures in my mind from stories I heard or read.

As soon as we arrived at the cottage we had to hurry up and get the johnboat hitched up and head to the landing before a boat line formed. Grandpa took special pride in being the first boat out and about. Everything went perfectly until we opened the shed and the boat trailer had two flat tires. Nothing made Grandpa madder than unexpected surprises, especially when he was on one of his missions. I knew he needed me to let him cool off and decide what he would do next. It became customary for him to stomp around and curse but he didn't usually throw things or slam doors. Today, however, he

slammed the shed door; I mean really slammed it hard. I thought the old wooden shed would fall apart. It was time for me to leave the situation alone and put the chicken necks in the refrigerator for another time; crabs are attracted to fresh tasting meat.

Since we weren't going crabbing I thought it would be a good idea to enjoy exploring the island. Like Grandpa said, "Alternating tides change the landscapes, and with each changing of the tides a newness of sea-life replenishes the shoreline and marshes." Yep, he had the long sentences and fancy words. I thought, *why not go to the shore and look for shells if we weren't going crabbing?* This made perfect sense to me. Then I thought again, *maybe I should just go by myself. I'll ask Grandpa if I can ride my bike, and give him time to cool off.*

"Better go before your Grandmother gets here. You know she doesn't like you wandering off by yourself. She thinks it makes her look bad to the community when you go traipsing off without supervision."

Without a reply I started peddling my bicycle before he could change his angry mind.

A little later I stood along the shore just thinking about having a birthday before too long. I wondered if my mother thought about me at all. Did she really abandon me and why didn't my father ever come to see me? I began remembering Mama Jo's harsh words, how disappointed everyone was in me, and what problems I'd caused since I was born. Movements from the unfolding waves of the incoming tide intercepted my thoughts, turning my focus to the beauty of the sunrise peeking above the horizon with its warm tones shimmering across the ocean. Each set of waves sprayed a salty mist touching me sweetly, and the sea's foam encircled my bare feet sunken deep within the wet sand.

I wished Grandfather could see all the jelly fish with their nearly transparent bodies, stranded from the outgoing tide. Grandfather warned me that their tentacles were lined with stingers, and if I stepped on one or picked one up they could still sting with "a significant poisonous reaction to the skin they touch." I usually just poked at them with a stick until I could flip them over to see their smiling mouths. All sorts of sea vegetation pulled up from the ocean's floor garnished the shoreline with colors of brown, green, yellow and purple. Little sea urchins with colorful shells adorned in pastel pink, blue, and beige tones, washed out of the sand then quickly burrowed themselves back into the sand leaving behind tiny bubbling holes. Conchs covered with fancy twirled shells in orange and beige tones along with a variety of snails moved slowly in their fancy shell-covered armor. Each little urchin, mollusk, bird and sea creature had its own distinctive survival cleverness. I too had to survive cleverly, though my body could not be shielded from the physical abuse and I couldn't put a shell over my heart.

As the new day began my heart remained safeguarded with the awakening of the coastal birds. The shore seemed massive when I was alone, and it wasn't until the morning walkers began collecting shells that I felt I had something in common with humans. Oftentimes I sang with an operatic voice "good morning, good morning, oh what a lovely morning it is" to all of nature's new arrivals. It's true; the morning is lovely with the newness of life waiting to be explored.

In my life, as at the seashore, simplicity and complexity existed side by side, and it was up to me how I would allow these dynamics to coexist in my life. My little girl dreams became mesmerized by nature's splendor while my heart longed for a real family. My emotions changed like the tides; however, they weren't as predictable as the synchronized gravitational pull from the moon. So many times I felt drawn in unfamiliar directions and the timing was unlike the systematic beat of the metronome's tap. Life would indeed be boring with unchanging and predictable cyclical events, yet, sometimes it is nice to simply have an unruffled day.

Off to another journey we shall go...

LITTLE CRICKET

Little Cricket, little cricket
Sing me a song tonight
I hear you speaking of life
One of which I take in strife.

Little cricket, little cricket
And your playmates, too
Praying mantis is that you
Sitting on a blade of grass
May I watch you as you pass?

Little cricket, little cricket
Sing me to sleep tonight
I hear your song with great delight
As I meditate under
The stars' bright light.

CHAPTER TEN

— *Sneaking Out of the Cottage* —

My nightly capers to the Tybee shoreline sustained my soul. The back river seemed one of the most peaceful places in the world. We lived on 5th Avenue, located maybe a five minute bicycle ride away. Sneaking out of the one bedroom cottage required skill.

The cottage had two doors: the screened porch door and the cottage door. I never understood why the screened porch door had locks because all it would take was a tear in the screen for someone to break in. At Grandmother's insistence, Grandfather installed a chain latch and a little hook and eye latch. The keys to the main door hung on a hook to the left side of the door. The hook looked like a crab and the claws held the keys.

I easily escaped because the window air conditioner in their room made a good bit of noise. The main challenge required keeping the back neighbor's dog from barking. This would usually wake Grandfather up and he would take his BB gun and shoot it up into air with some colorful words while Grandmother would say, "Gibby, Gibby, Gibby, stop that and get back into bed."

After successfully making my way out of the cottage I retrieved my bicycle out of the shed which, well, where do you think the shed sat? Yep, right next to the back neighbor's yard and the dog house. The best way I controlled this situation required canned spam, opened and ready to pass through the chain link fence.

With my hands on each handle bar, I quickly darted between the oleander bushes lining the side yard. I forgot I had attached playing cards to my spokes until the fluttering sounds became loud in the stillness of the night. I crouched behind the last bush and began taking the clothespins and cards off my spokes as I didn't want to make the slightest bit of noise and compromise my grand escape.

The sandy road to the back river, covered with crushed oyster shells, seemed like the smallest of sounds magnified, and I began peddling faster and faster, listening to

the oyster shells crush beneath my tires. The bell on my bike made a short ring each time I hit a little bump in the road, which annoyed me immensely.

As I made the right turn into the back dock entrance, I remembered a family once lived in a house that was now only charred ruins on the left side of the road; the chimney was all that remained. I parked my bicycle behind the chimney and began my pirate-like approach to the pier.

A beautiful white wooden home with a large wraparound porch stood majestically along the back river shoreline, across the street from the burned out home. The contrast between the two homes paralleled the contrasts in my life; something beautiful so close to something tragic.

When the tide receded I sat underneath the dock and made drip castles. At high tide I walked to the end of the dock and sat in the darkness of night looking at the stars and listening to the crickets. I also made small forts in the sand dunes along the back river and on the main beach. I made my forts out of old fences, boxes, inner tubes and bushel baskets. I loved the ocean and the back river at night and made up poems and songs.

I enjoyed the quiet hours alone. I put the world on mute or pause. I talked to Gerber as to a living talking friend. I used a large wooden palm branch for a bowl. I would place my snacks into it then pretend to dine in a fancy restaurant. I sat on my float and pretended to be a rich lady sitting on a green lawn atop a cliff in Greece, overlooking the ocean. I imagined surroundings of large granite columns with long soft white sheer material flowing with the gentle breeze.

I cleverly used bits and pieces of this and that to make my forts. I became upset when I returned another day to find some of the forts vandalized, but that would not dampen my fun. I just patched things up and hoped for the best.

During my visits to Tybee Island with my grandparents, I managed to take many bicycle capers to the Atlantic Ocean. I especially enjoyed leaving the cottage after I knew they slept soundly. If they ever questioned my empty bed, I would tell them I slept in the outside hammock.

The evening hours provided rest from the ordeals of the day, yet the ocean brought forth constant changes with its alternating tides. As I'd ride my bicycle to the sea, evening wind touched my flesh mysteriously, whereas the soft morning breeze carried hope that one day I would escape the people who unfavorably altered my life.

Certain sections of the beach were divided by wave breakers, and signs were posted to stay off the structures. DANGER! STAY OFF THE JETTIES; WARNING! NO SWIMMING. Jetties, once tamped into the Ocean's floor to protect the barrier island from erosion, jutted from the sea shore into the Atlantic. Over the years, tropical storms and hurricanes pelted the small island with prevailing winds, tides, and torrent currents,

disrupting the integrity of the jetties. However, the rickety wooden path leading to the end of one of the jetties became a passageway for my dangerous quest for solitude and unimaginable expressions of creative desires. Escaping to a safe place within the dangers of an approaching storm shielded me from the wrath of human cruelty by both words and corporal punishment.

On this particular night I watched as the night sky turned a deep blue grey while clouds formed over the shoreline. Fog horns with eerie baritone overtures gave warning that danger lurked within the foggy night. In the darkness lighted buoys guided boats through the rough seas on their charted destinations. The moon's light slowly disappeared behind the darkened clouds. Unencumbered by fear of the night's darkness, I needed the moon's light to guide me as I walked down one of the jetties. I began singing a song to the moon in hopes it would come out from behind a cloud.

Mr. Moon beam, Mr. Moon beam, Shine your light on me tonight. For now you see, for now you see, I'm all alone on this dark night.

Shadowed moon beams peered through the dark clouds and provided just enough light for me to step carefully to the next plank. A small gust of wind lifted my nightgown, momentarily obstructing my view. I needed my hands to hold my night gown in place and still remain balanced without the use of my arms. I drew important strength from the approaching storm. Returning back to the shore would prove that I surely eliminated all my fears.

I knew if my adrenaline took control over my body, my mind would not concentrate on executing my next step onto the jarred and broken planks. As I moved forward, the plank I stepped on cracked, I heard something splash, and wondered if my next step fell into the water. I remember waving my arms upward to the moon like a conductor leading his orchestra, singing to the moon, "Mr. Moon Beam, Mr. Moon Beam, shine your light on me tonight; for now you see, for now you see, I'm all alone on this dark night."

The moon heard my song and with its mighty beams shined its light on the missing planks until I safely reached the end of the jetty. Cautiously sitting down, I pulled my nightgown around my legs and tucked my knees under my chin, wrapping my arms around my legs, a little cocoon with the chilly mist from the waves hitting against the jetty touching me sweetly.

Harsh words from the adult world could not be heard. Waves breaking against the jetty and the oceans circulating forces around the crooked pilings became lullabies with rhythms of an imaginary mother's heart. The ocean's misty spray carried by the sea's breeze gently touched my body, replacing the sting from bamboo switches slicing into my flesh. Mama Jo's haunting words "You came from the devil's workshop" reverberated within my gentle spirit. Dim beams of light passed through small particles of water

within the thickening fog and recaptured my thoughts—reminding me of the immediate danger of the unfolding storm.

Sitting motionless at the deepest end of the jetty, once again I found sanctity within the loneliness and beauty of the night. Forming a unique combination of euphoria and fear, realizing the jetty could break apart at any moment and nature's forces would sweep me deep into the currents, I resisted the thought of perishing into the underworld of the sea. For a few moments I felt free from the aching sorrow and yearnings for a loving mother and father, brothers and sisters—seemingly unattainable dreams.

However, my imaginary world transported me to places with nonexistent sadness and where child fairies danced with me in a magical friendship. Unable to sort out the emotions of abandonment and longing for a family, I finally gave myself wholly to nature, allowing the absence of negative thoughts. Mesmerized in my own state of mind, I almost drifted off to sleep. The higher power looked over me and embraced my fears until I felt a profound peacefulness.

The whitecaps curled upward, splashing against the jetty's end, and the wind carried distinctive smells of the nearby marshes. The currents pulled the undertows deeper into the waters, and the waves built in strength—nature's warning signs that the storm brewed dangerously nearby; yet I remained motionless with an absence of fear.

The wind echoed from the deep darkness of the night with deliberation: *Deborah Elizabeth, Deborah Elizabeth! My lost little girl of the night; take heed of my warnings— be wary of the storm!*

THE WIND ECHOES

Be wary of the storm
the wind echoes

Why, I reply, when
the sounds are like cellos

Be wary of the storm
the wind echoes

Why, I reply, for I have but one request
Let the rain's mist and your gentle touch
peacefully put my worries to rest

71

Be wary of the storm
the wind echoes
Whitecaps shall swell and rise
with strength to carry you
between the tides

I shall give you my final reply
Nature's symphony and I are one
I dance amongst the whitecaps, for you see
dancing with death sets me free

I am mystery - I have no identity

I would rather challenge the storm in Truth or Dare than succumb to fear—fear of loneliness and fear of truly believing an unworthy creature like me lived amongst the beauty of nature. Would nature reject me too? Fear, one of the worst emotions, and unkindness brought fear to my soul every single day. Belittlement and degradation became the lullabies of the human tongue. Beatings became the physical contacts instead of endearing hugs and kisses. I feared each beating would be my last; I would die from the next attack. Thin and frail, my weary body had so much to live for. My heart and soul listened to the sea which told me greatness stood ahead. Psychiatrists would label me rebellious, uncontrollable, and seeking attention, but in truth I only sought serenity and peacefulness within the abandoned beaches. Perhaps the educated never personally experienced my terrors, and therefore why should my every thought be examined and dissected with assorted interpretations.

Emerging from the fantasies of the sea into an earthly state of mind, the time arrived for me to listen to the winds' echoes. My feet became immobilized by a thick, numb feeling which prevented me from standing. I looked at the dim lights cascading through wooden shutters of cottages facing the ocean and wondered if warmth and kindness hid behind those shutters. I began imagining families playing board games and making up theatrical plays and little girls giggling, tickled by their fathers. Families eating watermelon, sitting in rocking chairs, clustered together on a large wraparound porch built high above the ground on stilts, providing a glorious view of the ocean's majestic glory.

Suddenly, a gust of wind blew so hard I almost felt pushed off the unstable planks. Remembering that thousands of razor sharp barnacles lined the sides of the jetties, a

slip away from death, I had to wait a few more minutes for the blood to flow within my limbs so I could begin my journey back to the shore. If I fell from the jetty I would be unable to climb back up, and unable to swim away because the waves would push my body back against the jetty edges, attaching my skin to the flesh-ripping barnacles. Realizing salvation never came from my cries of pain during the storms of darkness at home, why should I succumb to fear and cry aloud this night? Anyway, the pain would be excruciating and no cries would be heard over the crashing waves and thunder.

I felt lonely and scared in the world of people, yet so loved and secure in the storm's darkness while trusting nature to protect me. It's true, nature protected me with her echoes, and her supernatural touch brought dexterity to my feet. I sang in an operatic voice with overtures of made up words and sounds, thanking nature and the sea for shielding me from the storm's wrath. During my lonely times, my heart wanted nothing more than the peace of knowing my mother was alive, and I would see my father again. Living amongst so many homes almost took me to the drones of despair, yet I would never truly let this happen. My witty antics and thirst for adventure could never be compromised by the ignorance of the world I was born into.

The ocean's floor became alive with the approaching storm stirring abundant sea life and vegetation from its depths. Plankton pulled from the ocean's floor floated atop waves. The wind carried melodious notes played from a viola in a nearby cottage and intermingled with the sounds from fog horns in the distant ocean. The prolonged resonance provided a disturbing atmosphere to the night's aura. *Be wary of the storm*, the wind echoed.

While I concentrated on every step, occasionally the shoreline, brightened by the lightning, illuminated the image of lovers walking hand in hand along the sand. Sheets of rain in the far distance traveled quickly towards the shoreline with only a few minutes left before the sprinkles would turn into a deluge.

I imagined the lovers' romantic desires becoming excited from the thrill of danger just as my fascination with the sea and the dangers of the approaching storm heightened my senses. Lightning lit the sky, and with my presence no longer camouflaged by the veil of darkness, my eerie, ghost-like silhouette moving atop the dangerous jetties had been compromised. The lovers paused just as they began to climb onto the jetty. I suppose they gave serious attention to the warning signs and with a sense of urgency ran to the nearest cottage for help. I could barely see them standing underneath the cottage porch, frantically knocking on the door for help. The outside porch light turned on and the cottage door opened. I could see the lovers nervously turning their heads several times towards the jetties and then they pointed in my direction. Within a minute of their pleas for help, the door closed and the porch light turned off. Filled with self-doubt, the lovers could no longer see the ghostly images they enigmatically had seen when the moon's light filtered through the slow-moving fog.

Did the darkness play games with their imaginations? Did they see an apparition of a child from one of the haunting tales as told by local lore? I couldn't focus my thoughts on them; I had to reach the shore before being swept away by the storm's mighty forces.

During this stormy night I felt the power of evil spirits pushing me to the edges of the jetty. Malevolent spirits lifted the sea upward, thrashing the waves through the broken planks and spraying the salty water into my eyes. In retaliation, the clouds became darker and with anger swirled counterclockwise to the forces of the evil spirits. Infuriated with the clouds' intervention, the evil spirits amplified their efforts in hopes the pilings would become unstable and I would lose my footing and fall into the rough waters.

Suddenly a bloody image flashed into my mind which jarred my memory of a painful gash I received to the bottom of my foot the first time I barely brushed it against a cluster of barnacles. I realized if I fell into the water I would have to struggle to free my flesh from the clutches of the sharp demon barnacles. I envisioned the rip currents pulling my flesh-torn, bloody, lifeless body into the depths of the sea.

Be wary of the storm, the wind echoes.

Constitutionally I did not allow the swirling forces beneath the jetties to destroy me with their greed for power and control over me, thus making the forces unable to pull me downward into the torrent currents. Perhaps my illuminating spirit safely guided me across the jetties and overpowered the same forces which tried to take my childhood innocence into the depths of despair.

Off to another journey we shall go...

LACEY MICHELLE

Dearest Lacey Michelle
with your strawberry hair and brown eyes
so much confusion in our young lives
I cherish the laughter upon your face
your friendship I shall always embrace

Off on our journeys with nature to see
butterflies and bumble bees
playing amongst the flowers and trees
we gave our troubles to the sea

Careful, careful as our bare feet step
meeting some of nature's surprised little pets
Mr. Earthworm going underground
Mr. Bull frog hopping around
a tiny, silly roly-poly becoming round
a chameleon changing colors not to be found

Oh, isn't summer so lovely and special
let's hold hands and explore some more
collecting treasures from the ocean's floor
for you see tomorrow I leave
off I go, yet to another family

CHAPTER ELEVEN

— *The Fresh Air Home* —

Grandmother and Grandfather enrolled me in a summer retreat for children on Tybee Island, very close to Savannah. Upon entering the home, hundreds of colorful prisms cascading downward from the second story balcony greeted me. I immediately felt comfortable and anxious to meet the other children.

Naturally bonded by silent fears, pensively listening to the housemothers explaining the rules and the consequences for breaking the rules, each of us children felt alone in our confused worlds, but unified and happy to stay at the Fresh Air Home. Turning my attention to the morning sun shining through the beveled glass window just above the upstairs balcony, I became spellbound watching the dancing prism rainbows filtering throughout the atrium.

Impassive words transformed into feelings of hope that my confused life would be safe in the Fresh Air Home. All of the lost children lived in dark shadows of hurt and discord within our assortment of homes. We all communicated unspoken words with our wide eyes looking at each new child entering the halls of the Fresh Air Home. We barricaded our hurts, as they felt much too painful to explore and process. Our young minds had not developed enough for such a task. We all felt anxious for our summer experiences to begin.

Orderly and in single file, we began our ascent to the dormitories. Holding onto the wide banister rail, occasionally reaching over to catch a sparkling ray, our small feet padded up the winding steps to the balcony. Standing on tip toes, peering through the stained glass window ornately framed with beveled edges, we caught a glimpse of the ocean in the not so far distance.

Individual cots with metal springs and thin mattresses with fresh Ivory scented linens lined the dormitory walls. A large walk-in closet with shelves containing communal clothing sorted by size and item divided the girls' and boys' dorms. The first day is always

the hardest in a new home, and we anxiously awaited our upcoming activity—going to the beach. Unlike the other children, I had spent many hours on Tybee Island's shores.

Barefooted, running as quickly as we could, jumping over sticker bushes along the hot sand, rippled pools of water left from the receding tide cooled our feet. We reached the small foam-topped waves breaking at the shores edge. Giggling and splashing each other, we jumped over the waves and began swimming until almost waist deep. Our toes squiggled through the ocean's floor, feeling for sea treasures; fuzzy round sand dollars. If the waters calmed we could balance on one foot and bring our treasure to the surface with our toes. If the currents flowed and we were unable to balance, we would dive into the water and retrieve our sea creature with our hands, then quickly place our treasure into a bucket on the beach.

On one particular day we noticed a lot of jelly fish along the shore. I explained to the others that jelly fish had tentacles covered with stingers. We took sticks and poked at their thick jelly-like bodies.

The housemothers allowed us to swim that day, even though we should have engaged in other activities out of the water. Just as I began placing our sand dollars into the bucket, I suddenly heard one of the girls scream. "Deborah Elizabeth, Deborah Elizabeth!"

Quickly placing the sand dollars in the bucket, I turned toward the screams. At first I thought the girls were warning me that Anna, the cottage snoop and tattle tale, tried to take their sand dollars and boast that she found the most; but the cries came from my best friend, Lacey Michelle—the first one to encounter the stinging wrath of the jelly fish. The other girls frantically struggled as the school of jelly fish began floating towards them. The girls kept stumbling as they tried to get out of the water. Poisonous tentacles brushed against their flesh, leaving behind unbearable stings and louder and louder horrible screams—crying screams. The frantic housemothers with anxious voices screamed, "Get out! Get out of the water, quickly!"

I felt so bad thinking Anna had betrayed the girls because now she tried so hard to help the younger girls and pushed away the jelly fish with her hands and arms. Obviously, the housemothers possessed no clever survival skills. They stood still, acting helpless in their efforts to help the girls to safety. The currents pulled everyone closer to the razor-sharp barnacle-lined jetties. It seemed the more everyone fought the currents, the less progress they made to return to shore. The housemothers would not enter the water. They just kept yelling and waving their arms and hands, like that would do any good rescuing anyone!

I threw a beach towel like a shrimp net on top of the school of jelly fish. Entering the water, I began using towels to help Anna scoop the jellies away from the girls. Finally everyone reached the shore, but their continued cries helped warn other bathers to get

out of the water. The housemothers, acting like they saved everyone with their words, covered the girls with towels and quickly led them to the infirmary. Soon thereafter I heard the emergency sirens approaching the cottage. Some of the girls went to the hospital that night. If the housemothers had listened to me, I think the stinging would have minimized if they used meat tenderizer like I said; but no, they ignored me.

A fortunate day for the boys, they fished from the Tybee pier with their Big Brother sponsors. Word quickly traveled to the pier, and shortly thereafter their concerns brought them back to the Home. A strong bond had developed between each of us children, and we rarely competed against each other. We seldom mocked or ridiculed others' shortcomings, but sometimes I did. Especially if a boy feared the fuzzy caterpillars that dropped out of trees or if a sand crab dashed out of the sand dunes. I truly can't stand a squealing boy. I could outdo most of the boys with clever antics.

The girls wailed throughout the night hours over their pain and stinging. The housemothers, with special exception to the rules, finally gave in to some of our pleas and our promises to be extremely quiet if allowed to make surprise dove-star necklaces from our sand dollars. A tiny little white porous sea creature that looked like a group of tiny doves lived in the center of each sand dollar. The brownish outside of the sand dollar left a yellowish stain on our fingers. We baked the sand dollar in the oven so it wouldn't stink as it died and decayed. Then we bleached it so that it became pretty and white.

First we carefully broke the outer shell exposing the little dove-star sea creature. Even though we worked very carefully, we became very frustrated each time a star broke during the retrieval process because we wanted to make sure everyone had a star necklace. After we successfully created more than enough dove-stars, we baked them for about five minutes. We received permission to use the clear fingernail polish, usually in reserve for red bug and chigger bites, to lightly coat the dove-stars and give them a special shine. The next step challenged us also: placing a very thin threaded needle in the center of the dove-star and bringing the needle and thread through the other side without breaking our treasure. We used ribbons from the craft box and tied the star to a ribbon. We connected the boys' stars to thick string. The boys had a problem with patience during the project, but they managed to pay special attention to all the details and worked slowly and steadily. During this night I had them truly believing I had escaped from the underground dungeons leading from the Pirate's House to River Street, and that I had jumped onto the caboose of a train as it went down River Street to Savannah's Port Authority. Having spent my whole childhood in my made up world, my stories were very compelling.

After orchestrating a most wonderful plan for yet another night to come and after having completed our surprise necklaces, the boys and I happily returned to our respective dorms.

On previous nights, our lights-out time had filled with girlish giggles. The boys snuck past the housemothers' room, through the dark closet, and then into the girls'

dorm. Pretending to be afraid, we pulled sheets over our heads and squealed, but never loud enough for the housemothers to hear. We never wanted the boys to leave because they exaggerated their stories with amazing creativity.

Their young eyes became bright with excitement as they told tall tales about pirates coming ashore at night to unscrupulously shanghai girls, taking them out to sea never to return. I knew this to be untrue; pirates only wanted boys, as girls brought bad luck on the high seas. The girls coiled in fear, believing every word. Of course the boys extrapolated their stories from my true adventures. But still, having boys around somehow made us feel safer because they presented themselves as courageous, willing to throw themselves into the perils of the night as brave swordsmen, sacrificing their own young lives to protect fair maidens in distress. I would never be in distress, but of course I would pretend to be so.

Finally, the perfect night with a full moon and twinkling stars arrived—the time to execute our previously orchestrated plan. As I gently awakened everyone from their slumber, boys and girls with sleepy eyes began to fill their curiosity with cautious anticipation. After they followed behind me through the shadows of the night, we then sat closely together beneath the stained glass window. The millions of twinkling stars and bright moon beams provided just enough light for our very special assemblage. The time had come to unveil the ocean treasures, the dove-star necklaces. I had wrapped each surprise in lavender paper with an oleander flower glued on top. The anticipation of opening a secret present began to escalate as everyone waited until all treasures were presented.

With gleeful excitement, we now all had our special treasure from the sea. We found it difficult to stay very quiet, but from time-to-time we could hear one of the housemother's snores—a good sign we remained safe.

We recited our special Ode to Tybee Island. Everyone held their dove-star upward towards the moon and stars. With my lead, the others repeated my words;

"No matter what happens to me."

"No matter what happens to me."

"Through all of life's mysteries,"

"Through all of life's mysteries,"

"My little star will guide me,"

"My little star will guide me,"

"Back to the shores of Tybee."

"Back to the shores of Tybee."

Off to another journey we shall go...

CHAPTER TWELVE

— *Wishes and Miracles* —

"Now, make a silent wish," I whispered. One of the boys said that wishes never came true, and for the most part most of us had no real reason to believe in miracles or wishes coming true. I touched his hand and said, "If you give up on your dreams and wishes, then you will never have a dream or wish come true because it's not part of your heart and soul." I think the girls were more into the wishing and dreaming than the boys. But, oh well, they followed our lead anyway and acted like they were wishing really hard by squinting their eyes and quietly making a few boy noises.

Someone's wish did come true the very next morning! And guess who? Yep, you are right, the boy. The water now safe from the jelly fish, once again our playful adventures commenced.

Notwithstanding the boundary rules, I suggested to three of the more adventurous boys that I knew how to get to the colored beach. At first they looked skeptical, but then with a little persuasion and a good full-proof plan, they were "in." First we had to tell the housemothers that we needed to return to the cottage to finish a Bible School project. The cooks and housekeepers were always on duty during the day, so it wasn't unusual for some of the children to stay at the cottage. We began our walk on the usual path to the cottage and then crouched within the sand dunes' tall grasses. Now we four little pirates chartered our course very carefully so that none of the locals would see us. Sometimes it seemed hard to stay on course as we became easily distracted by the happenings along the beach. We watched some of society's elite enjoying cocktails at the DeSota Hotel and occasionally a couple would dance to the music on the outside veranda. We watched the local children run up to the ice cream truck and wished we had money for an ice cone, or better yet, cotton candy. Teenagers would drive in shiny convertibles up and down the main street, and we pretended we already attended high school and put on airs like teenagers do. We didn't have a care in the world; we felt so

excited about our adventurous escapade. It took about thirty minutes to finally reach the colored beach.

Beautiful bright colored blankets with picnic baskets holding the edges down lined the beach; a most welcoming feeling for the next arriving family. Each new family acted as if they knew everyone already there; maybe having a family reunion. The colored boys that looked our age dug holes next to the water's edge and placed large watermelons in them to keep them cool. The colored girls carried white baby dolls and wore the same stupid rubber bathing caps we girls on the white beach wore. Although the beaches were separated by color, one thing we girls had in common—we all resisted wearing the rubber beach caps with bright colored flowers. The chin straps fit so tightly that we usually pulled them off, not without a scolding however. Whoever invented them probably never had to wear one.

Just as we got settled into our spy-viewing positions, the ocean's breeze picked up one of the beach balls, blowing it just past the edge of our hiding place. I eagerly jumped from the dune's grassy shield to catch up to it. Everyone's attention drew in my direction as my boney white long legs ran faster and faster trying to retrieve the ball. With every stride I made, the wet seat portion of my too-large bathing suit hung way below my bottom and began hitting the upper portions of my legs. Although embarrassed by my sagging bathing suit, I gained control of the beach ball and excitedly ran towards the colored children with a big smile.

As I approached the edge of a brilliant colored blanket, a buxom woman laboriously wiggled out of her lounge chair. Repositioning her bathing suit, strategically placing her large parts into their proper compartments, she began walking towards me, all the while waving her church fan. Nervously, I questioned myself without speaking; *Oh, I hope I haven't gotten myself in another predicament.*

With the sweetest little voice she said to me, "Now what'cha doin' on this side of the beach? You best be goin' to the other side where you belong." Soon more of the family members joined and I looked to my friends in the sand dune and saw them fleeing from the tall grass. The coloreds remained very curious about my being out of place, so to speak. I talked to the elders for a little while, telling them some of my courageous capers. Of course, I didn't embellish one single thing.

Praising God in uneven chants, "You is the child of Jesus Christ, Yes Jesus! And color, well it don't matter to the Lord Jesus. Praise God, Yes Jesus! We knows she's a confused little girl with no mama or daddy but we'z all God's children. Praise God, Praise Jesus." The women vigorously waved their church fans to cool off after having experienced the spirit of Jesus. Out of breath, one of the women said again, "You best be goin' to the other side where yous belong."

Respecting their praises, I said, "I shall therefore go henceforth back to the drones of the other world where I shall perish in the sea, for no one loves me." Crying internally, already knowing what fate awaited, I left sadly and returned to the Fresh Air Home.

Hearing the housemothers talking amongst themselves during their nightly meetings, I felt the need to return to the shore. Maybe it would be my last time that season; maybe I would never see the ocean again.

That night, while everyone slept, I left through the side door which led to the sandy crushed oyster shell road. The road went only a few hundred feet before it met with the sand dunes, and the path leading to the ocean. Once again I returned to the jetty's edge. I just cried. I didn't understand the adult world and the adult rules of color. I held onto my star-dove necklace and recited the lost children's oath.

"No matter what happens to me, through all of life's mysteries, my little star will guide me back to shores of Tybee."

Just as I turned around to walk the hazardous planks, I saw one of the housemothers at the foot of the jetty. Startled by her presence, I lost my footing and began falling towards the jetty's edge. With quick dexterity I maneuvered back to safety; however, my necklace caught on the edge of a loose plank and fell into the ocean. The evening hours went without incident; I was tucked into bed and told, "Good night, my little troubled one."

The next morning as I slowly walked down the steps from the upstairs dormitory to the downstairs atrium, all the while catching the morning's dancing rainbows, the consequence for leaving the white boundaries for the world of color came to pass, just as I knew it would.

"It's my Grandpa! It's my Grandpa! I can hear his truck!"

"Now you just stay put where I told you and don't you get up again! Do you understand me?"

With a snooty turned up nose I sat back down on the bench inside the atrium as I was so rudely instructed to do.

The groundskeeper who swept sand from the sidewalk leading to the Fresh Air Home's entrance greeted Grandfather Fraser. I could only make out the pleasantries of the normal hello, how are you, fine...

Grandpa entered the atrium with his head tilted away from me. He saw me all right. He ignored my existence. He cleared his throat and then made a terse grumbling mumbling sound. I couldn't tell if he said words or just grumbled.

He turned his head towards me and without saying hello, he instructed me to wait outside in the truck.

"Pick up your things and go sit in the truck."

"Yes sir."

I tried to further my dialogue with him but he cut my words off. "Grandpa, how..."

"I told you to get in the truck. No time for you to get all sweet with me. Now get going before I... " He didn't finish his sentence. He never raised his hand to me before, but then there was that chance that he would; just like so many others.

I repeated to myself, *he didn't even hug me; he didn't even hug me.*

I walked slowly to the truck, kicking sand back onto the neatly swept surface. I felt dejected as I struggled to climb into the truck. I sat in the front seat with my head resting on my folded arms and stared towards the ocean. I could hear the waves folding onto the shore. I wanted to run away to one of my forts.

I became very annoyed and impatient waiting in the stifling hot truck for what seemed a very long time. I wanted my time with Grandfather because I missed him so very much. Disrespecting his authority, I jumped out of the truck and looked through the glass front door where I could see him engaged in conversation. I began tapping repeatedly on the window until the taps became an annoyance. He gave me the look; the look of dissatisfaction. I knew I disrespected my elders, but stubbornly I didn't care. I was already in trouble with him for leaving the home's grounds without permission and I was already in trouble for various other minor infractions of the Home's rules. I went back to the truck fearing the worst.

I started singing loudly; "Grandpa hates me, yes he does. And why does he hate me? Because, because everyone else does." I figured I wasn't his Little Darlin' anymore. Oh well, I'll talk to the crickets on the back river and the seagulls, too. I don't need him anyway, now there.

Grandfather looked away from me when he began walking towards the truck. I got out of the truck and ran up to him with my arms extended towards his waist and with excitement said, "Grandpa! Grandpa! I missed you ever-so-much."

I gave him a big hug around his waist. His body remained stiff and unresponsive. Looking ever-so-sad and with an extended lower pouting lip, I said, "Grandpa, don't you love me?"

He responded by tilting his head upward to the sky and said, "Not right now, little missis. Not right now. I'm very disappointed in your lack of respect and disregard of authority."

With a smirk I said, "I'm sorry, but you don't... "

"Quiet! You and I both know you aren't sorry for anything."

He knew by the tone of my voice I wasn't sincere, nevertheless he helped me get into the truck by guiding my arm as he said, "Get into the truck."

"Yes Sir."

As we backed out of the driveway, I noticed Gerber had fallen out of the truck when we opened the door for me to get inside. I screamed "Gerber, Gerber" at the top of my lungs. Without hesitation I opened the door while the truck headed down the road. Grandpa grabbed my trousers at the waist and pulled me back inside.

"What the hell do you think you're doing yelling like that? Scared the tar out of me. I thought I ran over a child or something."

He changed the truck gear into park and repeatedly pressed the gas pedal as a reminder of his anger towards the events of the morning while I ran back to pick up my doll.

"Oh Gerber, I'm so sorry. Grandpa is sorry, too. Now, let's pretty you all up and forget about this place. We are going to our real home now; isn't that right Grandpa?"

I knew I wasn't in his good graces and that he felt hurt and embarrassed by me. Oh well, I knew he would forget about it when we could be alone and having our fun times. I also knew that he would probably talk to me about respecting my elders. I expected these talks. I knew the rules and for the most part abided by them, but oh well; things do happen and today was just one of those times. I just didn't feel like acting the perfect little girl role.

I thought perfection boring and only dull unimaginative children seemed perfect. They all would probably grow up with serious mental problems anyway. All of their thoughts pinned up on being perfect, and for what? No one took the time to know their thoughts and hearts. They looked sad all the time, or they had some fake smile that looked like they just passed gas.

What if Grandfather truly didn't care about me anymore? Does this mean forgiveness is mute? I could never do to others what had been done to me. Even my biggest sin could not compare to the sins brought against me. I stood in everyone's way, everyone's burden to bear or be rid of. I longed for wings to fly away. I thought that in my own way I could manipulate Grandfather, and sometimes I knew he allowed me to. I just wanted to go back to the beach cottage on 5th Avenue.

Grandfather broke the silence when he said, "We are heading back to Savannah. Your Grandmother is back there already waiting on us." He was taking me back to Gordonston! I kept my face turned to the right the whole drive down Victory Drive because I didn't want to see the sadness in Grandfather's face, nor did I want him to see me cry. I thought to myself, *I bet Margaret Mitchell never cried because she was*

adventurous and independent and Grandpa always said she was the bravest girl he ever knew. I wanted to be the bravest, not some dead girl from the 1920's.

I tried to rectify my own wrongful actions by turning my thoughts to what other families had done to me. People hurt me far more than I could ever hurt them with my words or with my actions. I respected Grandfather, but at the same time I didn't like how he was acting towards me. I thought his actions appeared as deliberate as mine. He was stubborn and should have at least talked to me. He felt cold towards me and, well, I'd have to make him feel guilty for his cold heartedness. I wanted total forgiveness. Let bygones be bygones.

For some reason, that day seemed different. I wanted the feelings of rejection to stop and I most assuredly wasn't blaming any of the transgression towards me as any wrongdoing I may have done, of course not! I just didn't understand all the hoopla about black and white beaches, drinking fountains, public bathrooms, and assigned seats on buses. I just didn't get it.

One time in a public restroom with a colored woman, I saw she didn't have change to put into the coin collector attached to the toilet stall door. Now, the white peoples' toilet stall doors didn't have coin collectors, but our stall doors displayed signs denoting Whites Only. I opened one of the Whites Only stall doors and told the family of female coloreds with several children they could use my stall. Timidly they accepted my generous offer. However, just as the last colored was entering the stall, a white lady entered. Aghast at what she saw, she quickly blurted out hurtful words. "You impudent child, what do you think you are doing? Where are your parents? I wish to speak to them immediately."

With a quick wit and a little attitude I replied, "You can't take the joy out of my day because I have Jesus in my heart. This poor lady was doing the pee pee dance and accidentally dropped her coin and it rolled into the drain. See the drain over there? Well, that's where her coin is. So, technically, she did pay for the use of a toilet, just not this particular stall."

"The fact of the matter is, little back talker, she is a Negro and Negroes can't use our facilities—that's why the stalls have specific instructions. If I used the toilet after a Negro, I might pick up some sort of dreadful disease. Now, once again, where are your parents?"

After washing their hands, the coloreds quietly left the restroom with their heads tilted towards the floor and looked saddened by the scolding I received. I had seen more kindness in Negro strangers' eyes than I had received from the starchy white folks' eyes. All prim and proper, they strutted along acting so high and almighty.

Bringing myself back to my present troubles, I bent my head downward until it rested on Grandpa's leg and pretended to fall asleep. I knew everything was all right

once he stroked my hair with his hand. He faintly whispered; "My Little Darlin'." I must have fallen asleep shortly after I felt his affection because we were back to our Gordonston home which seemed like minutes from his touch. Once in the driveway I asked, "Grandpa, are you going to send me away?" He didn't answer.

Off to another journey we shall go...

LET ME DIE

Let me die, as I can no longer evaluate
 and act upon the needs of others
I feel my words are only vibrations and
 my thoughts lack depth in meaning

Let me die, as I search for the outgoing tide
 to cleanse away the soiled self I am
Let the ocean's spray glisten with sunbeams
 as I express myself in my misty state

Let me die with the salt from the sea
 resting in the wounds of my life
And for the currents to pull me to the ocean's floor
 so I will exist no more

Let me die without dispiriting my friends
 Dear sea gulls,
 I can no longer dance with you
 Sweet sea creatures
 I can no longer watch you play
 Little crickets
 I can no longer sing your songs at night

For my soul is searching for its next life

CHAPTER THIRTEEN

— *The Secret Room* —

With summer over, Grandmother dutifully enrolled me into Christ Church's Sunday school. Before my first Sunday school experience, she instilled daily the importance of good, appropriate behavior, and most importantly she reminded me to represent the family name with the utmost honorable display of words and actions.

The Sunday school classes were housed in a building separate from the church. One of the upstairs rooms invited my curiosity. The door looked as if it had remained unopened for many years. I had to be careful who I told about this secret room, because someone might squeal and get me into trouble. I only trusted one boy, so that made it easy and less threatening. Each Sunday we checked the door, hoping to find it unlocked. The dirty outside door edges flaunted spider webs connecting from the ceiling to the upper door frame. The room appeared closed-up for years. Just standing outside the door gave an eerie feeling of a haunted chamber or that something really bad had happened inside.

Each Sunday we checked the door's lock but faced the same rejection; it remained locked. Finally on one Sunday the classrooms doubled up to allow the church men access to paint the rooms and install new shelving for supplies.

I had faith that I would find an opportunity to retrieve the keys from Grandfather, but I would have to closely orchestrate my plans. *Finally*, I thought, *I've got it!* I'll pretend one of the church ladies needed the keys to open the pantry for snacks and the pre-service coffee and cookie station. I waited until I saw one of the church ladies go down the hall towards the kitchen and eagerly asked Grandfather if I could take the keys to Ms. Hulin. It worked! I ran to the pantry with the keys and eagerly gave them to Mrs. Hulin and waited for her to unlock the door. I, of course, cheerfully offered her my gracious assistance to return the keys to Grandfather so he could lock up after the services. I helped gather up the paper plates, napkins and cups, with a gleeful smile of

course. I then acted like I was taking the keys promptly back to Grandfather, but I made a beeline to the prohibited door. I started to get scared and almost retreated, but nope, I couldn't do that, I had waited too long to do this and I didn't want to hear "Deborah Elizabeth is afraid to go inside."

When I opened the door, dust and cobwebs clung to my face. A weird smell like something had died permeated the darkened room. Scared stiff, I decided not to enter alone. I would wait for my friend just in case something really dead lay in there. I closed the door, but left it unlocked. Very carefully I ran back down the stairs, while making sure I didn't pounce on the steps. Taking a quick glance from side-to-side, I entered the hallway and back into the classroom where Grandfather stood painting. "Here you go, Grandpa." He slid the keys safely back into his pocket.

My friend and I had already planned how we would ask to be excused from our Sunday school class. Since the classrooms were divided during the cleanup, we decided we'd attend separate classes. We watched the clock in each of our classrooms. When 9:15 displayed, we raised our hands to go to the restroom. Our plan worked. On our way down the hallway, we knew within a few minutes we would climb up the stairs and sneak inside the room.

Entering the room seemed the most frightening part. Once we got in, we saw dusty jars filled with all sorts of pickled little animals. Sick. The whole room looked like an old abandoned library. The shelves contained unorganized dusty books and papers. Several jars contained tarantula spiders. We almost took one with us, but decided not to. What if the huge spider was alive? Even though we didn't know what happened in that room, we both felt something eerie and ghost-like sail through us at the same time. Whatever went through us produced a weird odor and made our stomachs turn upside down. Nonetheless, we accomplished our quest and now had a frightening true story to tell. It's true, Savannah has a lot of mysteries and ghost stories, and we truly know we felt spirits breeze right through us!

Reverend Tucker, a pleasant, soft spoken man, couldn't hold the attention of an eight-year-old during his sermons. He needed to have more animation. After the church service, everyone stood in line until it was their turn to shake his hand and compliment him on his sermon. It seemed important for congregants to leave the church in this ritualistic style. I thought the women, in particular, just wanted his attention and to be seen and receive his approval for having made it to church. I thought it sort of fake, but I did the same thing, though sometimes I would whisper the truth in his ear.

"Reverend Tucker, you gave a good sermon but it was too long and I wanted to sing more songs."

Of course he was humored by my sentiments and usually had a clever comment like, "Just hope the Lord didn't get bored and fall asleep."

Reverend and Mrs. Tucker invited Grandmother and me to their home, a row house near one of the squares. Reverend and Mrs. Tucker talked with Grandmother about the troubling problems attacking Episcopal churches. Some wanted to change the doctrine since General Oglethorpe and George Whitfield's time. The upcoming changes would certainly split the Diocese. Some people even wanted to change the hymnal because they didn't like some of the words. Changing times in the Episcopal diocese existed, and not all of the changes settled well with the older generation.

Grandmother felt very comfortable with the service and the choir book unchanged. Everyone embraced before and after services with the usual how-do-you-do's and small talk. Most of the talk remained polite, but sometimes when heads turned, the women would scrunch up their noses with disapproval of a particular lady approaching them. Savannah always maintained social classes, much like the English.

Many unspoken works and soulful eye exchanges met between the church women who lost sons to WWII, for they shared a mother's sorrow; an inexpressible sorrow that has no words. A small metal plate affixed to a pew rail held our family surname, Merriman, printed on it. I'm not sure it resulted from Uncle Buddy's death in the war or not, but the Merriman family pew remains located on the main floor to the left front section of the church, near a column. Since Grandmother sang in the Christ Church choir and Grandfather usually went to St. John's Episcopal, I frequently sat alone in the front pew at Christ Church during the 11:00 service. Once in awhile a few other girls would sit with me if both of their parents sang in the choir. Sometimes we all planned to wear our red dresses on the same Sunday. I always felt uncomfortable in my red dress and coat. Stepmother Jo said the color red belonged to the devil, but Grandmother liked red and bought the outfit for me, so I supposed it lacked Satan's influence—especially when I wore it to church.

Reverend Tucker liked red, also. He would make a special proclamation from the pulpit when he saw us girls all dressed-up in red: "Good morning and God bless you. I see my little red birds are lined up all in a row, just ready to be good listeners. Today's sermon... " Our white gloves covered our mouths as we giggled and our attentiveness to the sermon became short-lived. We folded our bulletins in all sorts of shapes to stay awake and passed notes back and forth to each other.

Sometimes Grandmother seemed sad when she went to church. She participated on the altar guild and was very much loved by all the volunteer ladies and deacons. Grandfather Fraser treated Grandmother so kindly. I suppose the memories of her dear loved ones surfaced more at Christ Church, where they had all worshiped as a family during better times.

90

After the 11:00 o'clock service the old Negro bellman would ring the Church's bells by hand, startling pigeons in the trees in Johnson Square. The bellman was one of the only people in town who knew how to play the chimes by hand; most of the church bells in town were sounded by an automated player. Tourist buses and horse drawn carriages stopped as worshippers walked the broad steps leading up to the church. The tourist drivers would tell their passengers about Christ Church's history through their hand-held speaker: "Christ Church is the mother church of the colony."

Off to another journey we shall go...

FRIENDSHIP

In life friendship is gained

In death friendship shall remain

CHAPTER FOURTEEN

— Annie Ruth —

Grandmother and Grandfather Fraser agreed to care for me the remainder of the school year and maybe through the summer months if I remained very well behaved. Mr. and Mrs. Donaldson wrote a nice letter to my grandparents reflecting upon their good times with me, and how sorry they felt that they had to go to New York for business in such a hurry. I still knew, even with kind words and wishes sent my way, I was an unwelcome responsibility for Grandmother to take upon herself once again, but Grandfather Fraser and I remained ever-so-happy being reunited.

Grandmother hired a maid to care for me after school hours until she arrived home from work. My fourth grade school year and my report card average remained basically uneventful. The "needs improvement" boxes under the social skills category contained all check marks.

The maid walked me to the city bus stop every Wednesday at 3:30 p.m. I rode the bus alone from the East Henry Street and Skidaway Road stop to Broughton and Abercorn Street to attend my weekly piano lesson. I placed a coin in the coin slot, anticipating my change. The bus driver checked the fare and pressed the appropriate lever on the metal cylinder containing chambers for nickels, dimes and quarters. Coins released from the cylinder into his hand as he said, "Here's your change, missis." One day I sat in my usual seat in the front of the bus, holding my piano music and lesson pad in my lap when I noticed an elderly lady at the back of the bus having difficulty getting situated in her seat.

In the eyes of a child she looked around seventy years old. She untied her white uniform apron, revealing a pretty dress with tiny pastel flowers loosely fitting her thin, framed body. She placed her apron, along with the daily newspaper given to her by the lady of the house, in a brown paper bag with a paper corded handle. She carried a black shiny pocketbook and wore blue pop beads. Her teeth appeared a little big for her thin aged face and her grey hair was pulled back into a tight bun. An unspoken sweetness

surrounded her; the kind of sweetness you feel when you don't know someone but you just sense their goodness. Her eyes looked very tired and would hold a long closed pause until the bus hit a bump.

On this particular Wednesday, the passengers sat silently. The 101 degree August heat took everyone's energy away. Several of the small metal framed windows remained partially opened and jammed. The hot humid air barely managed to pass through the windows and did not provide enough ventilation to the passengers seated in the back.

A new passenger boarded the bus, paid his fare, got off the bus, and then reentered through the back door to sit in the colored section. Being curious and always using any opportunity to voice my opinion, I openly expressed my opinion of the ridiculous parade required of the Negro man: board, un-board, re-board.

On this particular August day, Annie Ruth, as I later learned her name was, had unusual difficulty breathing and her tired facial expressions turned to fear. We exchanged eye contact and I felt her pleading to me, "I need air. I am sick, so tired and weak." I left my front seat and walked to the back of the bus. Immediately the bus driver with his strong voice said, "Missis, yous better get back in yo seat before I's stop da bus."

I continued walking to the back of the bus to offer the little old lady my seat. In her very weak voice she said, "Missis, I's can't. I's not allowed. Now yous go back where's yous belong. I's gonna be all right."

She looked like she was dying. I had already seen death by that age, and she looked close to dying. I kept insisting she take my place, just as her resistance kept insisting she stay put. I placed her brown paper bag and shiny black pocketbook in my left hand. I put my right arm around her thin waste, lifting her up gently. The bus joggled over bumps, but I knew the other passengers would be compassionate and help us along. Each passenger moved their feet and personal belongings closer to their seat and extended their hands to steady Annie Ruth.

Humming sounds escalated throughout the bus—*Mmm C h i l d, Mmm L o r d, Mmm Mmm, Mmm Praises, Mmm J e s u s.*

Returning back to my seat in the front of the bus with Annie Ruth, the white passengers acted embrace, unlike the bus driver who stopped at an unmarked corner and told me, "You needn't bring that old woman up in da front of dah bus; she can't be up here, 'gainst the rules and I's not gonna get in no trouble 'cause of it." How I remember these words! Some of the cruelest words I had ever heard. Well, as the unlovely child I was always accused of being, I refused to take Annie Ruth back to her original seat and proceeded to give the driver my two-cent's worth.

A feisty talker, my voice didn't match my skinny, fragile stature. I told the bus driver, "You will go to hell if she dies because you won't let her get air. You will be haunted by the devil for your evil ways. You came from the devil's workshop."

Knowing how religious the local coloreds were, I tried to use a little religious persuasion, but of course it didn't work. I lacked the understanding of the real consequences of my actions, and acting terse and haughty to the bus driver didn't win any favors with him.

The driver stopped the bus just as he had said he would. He opened the front door with the lever next to his seat. After the door opened he gently took Annie Ruth by her arm and helped her down the steps to the sidewalk curb. I followed close behind, talkin' away: "You are a mean man. You don't care about a sick old lady. I hate you; you're goin' to hell." Other passengers, feeling helpless, looked on. They had paid their fare and didn't want to get kicked off along with us.

"What will we do now," I asked the old lady. "Look at the trouble I caused."

"Child, don't yous worry, he's a nice man just doin' his job. He means no harm." She understood what I didn't. For a little girl who never lived in one place very long, witnessing wrongful acts imposed on all types of people would became part of my daily life.

Annie Ruth and I slowly walked a few blocks to Tanner's Sandwich Shop. Tanner's served the best fresh squeezed orange juice in the world. White customers filled the counter; they sat on stools, ate, and listened to the radio. As soon as Annie Ruth and I entered the diner, all heads turned our way in unison. Being colored, Annie Ruth's look on her face said she didn't think we should go inside. "Come along," she said.

We walked hand-in-hand down the Broughton Street sidewalk. In her sweet soft voice she said, "See da Globe Shoe Company down da street... another block or so? Da elevator operator is a friend of mine from church. I'll ask her if I can use da pay phone."

Upon our entrance we saw Annie Ruth's friend standing in front of the elevator waiting to take her next customer to the second floor. The elevator, with a small chamber and an ornate expandable black metal door, required an operator to manually open and close it. The kind store manager listened to my grandioso rendition of our unfortunate travels. Hearing the commotion coming from the front of the shoe store, a nice man walked from the back of the store through a curtained doorway, and with small unassuming steps came up to me with a quizzical smile. Curious, he wanted to hear the whole story from start to finish. He owned the Globe Shoe Company. This particular shoe company carries some of the most expensive shoes in Savannah, and the prettiest, too, with matching purses. He told me I did the right thing and how more people should respect their elders.

Annie Ruth called her son without giving him many details about our adventures. He arrived at the Globe Shoe Company and parked his old black, beat up Ford truck on Broughton Street just long enough to help Annie Ruth into the truck. She looked so tiny against his muscular frame and her hands so small against his. His bibbed denim overalls and brown tattered hat gave the impression of a hard working laborer.

"Mama, yous needn't be goin' out on dat bus no more," he said. "Runnin' aroun' helpin' folks wid der houses. You let 'em do der own cleanin'. You's hear me, Mama? You's need be stayin' at home. I'll get ya to the doctor in the mornin', unless you's needin' to go right now."

"No, son, I's be all right, da heat just got to me. We needs to take my little friend to the Christ Church. She's almost late for her piano lesson. She's a brave little girl, son. Her name is Deborah Elizabeth, mighty big a name for such a little girl, don't ya think?"

He hesitantly offered his hand to help me into the truck. I don't think he really liked the idea of taking me somewhere, but at his mother's insistence he obliged.

Annie Ruth wanted to tell him our story but she felt too sick and exhausted from the heat. She told me she had noticed me on other occasions riding the bus alone. I told her I had piano lessons every Wednesday, and I would try to catch an earlier bus and come by her house before piano lessons. She promised her son she wouldn't do housework anymore.

Annie Ruth's home stood a few squares from Christ Episcopal Church. I always had a lot of nervous energy and ran everywhere instead of quickly walking from one place to another. Annie Ruth and I had a lot of wonderful talks. I took her my school picture which she placed underneath her glass top coffee table in the living room next to her children and grandchildren. I don't remember meeting any of her other children, just the one son and her sister. Her son thanked me on several occasions for helping his mother. He seemed almost afraid to talk to me. Maybe it was the times and any friendly hug from a man of color to a white little girl would be wrongly perceived. I wanted to feel his hugs, but never did.

Annie Ruth had a snack waiting for me every Wednesday, until the time I didn't come back because I was kicked out of music class. My music teacher, Addie Mae Jackson, wanted me to learn theory and read notes. Instead of being prepared for class with my completed assignments, I sat in front of the piano with perfect posture and hand positioning, and began playing the Blue Danube Waltz—the music I heard from the student in the last class, and which I picked out on Grandmother's piano. I had been warned previously that the ruler would slap my palms if I did not come to class prepared, and if I played the lesson by ear. I loved the freedom of playing the piano with my eager spirit but lacked discipline in my studies. The consequences saddened me, but I was saddened even more because my weekly visits with Annie Ruth ended. She had a calming soul, which I needed so much in my upside down life.

Off to another journey we shall go...

BURIAL GROUNDS

Whispering souls linger in Bonaventure
reliving stories both told and untold

The assemblage: innocent, condemned, embattled, virtuous
death becomes the bonds of the unknown

Dust, disconnected bodies lay beneath the
unyielding stone statues portraying life
providing frigid warmth within the nigh
sorrowful remembrance within a sigh

Visiting the 18th century burial grounds
envisioning life within the isolation of death
awaken the silenced mysteries within the moss draped oaks
casting haunting images within eerie shadows

Winds on a windless night stir within the savannas
along the riverbanks of the Wilmington River
as bewailing spirits rise with from their prolonged isolation
greeting visiting souls with calming auras

Solace

CHAPTER FIFTEEN

— *Bonaventure Cemetery* —

Whenever I became bored, I'd ask my grandparents' permission to ride my bicycle in the neighborhood. I was, of course, reminded of my limited parameters, and if I stopped at a friend's house to play I must call to let them know my whereabouts. I agreed, but I knew exactly where I wanted to go and it was not in the neighborhood. Bonaventure Cemetery felt calm and inviting. I needed to tell the statues all about my summer at Tybee.

Bonaventure Cemetery, with its mossy oaks, became one of my favorite places for a bicycle caper. Musical notes of Amazing Grace, carried by the breeze from the Thunderbolt River, cascaded over the beautiful statues. The unpaved sandy roads provided passage between sections of rows which gave way to a unique feeling of reverence. I walked the sandy roads alongside my bicycle with reverence in hopes the dearly departed souls would guide and protect me from any evil lurking within the boundaries.

I spoke with the statues and felt both warmth and sadness. I imagined the dead as my mentors, my sane family. I hoped to be sitting on a wooden bench facing the river, listening to my playmates—the crickets and sea gulls—when I died, and my free spirit would join my family of statues and headstones. I envisioned myself as a guardian angel roaming through Bonaventure, helping the arriving lost souls. I'd emanate the same peacefulness I experienced each time I walked the sandy roads.

Sometimes I stopped to talk to the grave diggers before climbing a tree or sitting on the Wilmington River's banks. I liked talking to the diggers. My kind of folks, down to earth and hard workers, they didn't mind my stopping by and loved my theatrical antics.

"Well, Miss Deborah Elizabeth, where's you be hidin' yurssef. Been awhile since yus be visitin' yo frens."

"Yes, it has been a long time, but I'm here now just to ask—how do you do?"

I loved talking to the coloreds because they were people with personality in their eyes and deep down caring souls. Yep, I was a sight for sore eyes, they used to say.

"Missis, yous not afraid to be comin' 'round here by yurssef?"

"Oh, no sir. I'm brave and I have a good pull on my slingshot. Butch, my friend, taught me how to use a sling shot and now I am almost better than he is. I can shoot an acorn right into the eye of an intruder. Wanna see?" I would show off my good aim and usually missed my intended target. Of course, I never divulged the actual target.

Butch, truly the champion shooter, couldn't compete with my tree climbing. Well, that's not nice to say because he had polio and wore braces on his legs. But truthfully, I did climb the trees faster and I climbed higher, too.

The coloreds made me promise not to come to the cemetery at nightfall because the spirits roused themselves out of the graves. I really didn't fear the spirits, but I knew if I saw one I wouldn't be such a talker.

Off to another journey we shall go...

UNSPOKEN WEBS OF THOUGHTS

Unspoken words become haunting webs of thoughts
 Trapping emotions in the nigh
Unspoken words reserved with fear
 Placed within a pen afraid of a reply.

Do lost children need to spend their lives
 Searching for the truth amongst the lies
Or should the child be apprised
 Of the situations that led to their demise.

Waiting until the time is right
 is only right for the one who is waiting
 not for the one who is searching

CHAPTER SIXTEEN

— *Tree Houses* —

My tree houses weren't ordinary tree houses with uneven wooden planks for steps leading up to a little clubhouse. My tree houses hid within the branches of old oak trees draped in moss or in large magnolia trees whose white blossoms fragranced the evenings' breezes. With cat-like movements I climbed the twisted and curved low bearing branches until I reached the upper smaller branches. I felt protected and unthreatened from human annoyances while sheltered between two branches extending from a large hollow gap. My adventurous climbs did pose a certain amount of uncertainty and danger, yet cautiously and with respect to the authority of the tree's guiding branches, I knew when to stop climbing upward and view the world from its caring arms.

Hidden within the tree's canopy, I looked at life and the world differently than I did when I sat on the jetty's edge. Yet the happenings of daily life posed unique similarities between the two distinctive settings. All of nature's creatures kept my curiosity alive as my eyes observed the comings and goings of my winged friends, squirrels, and insects. Interestingly, their daily comings and goings oftentimes provided new survival skills for me to draw upon.

I remember watching a dog chase a squirrel up a tree. Smart enough to know its enemy, the squirrel quickly executed his escape plan. Once the squirrel safely escaped from the jumping dog, he turned around and looked downward realizing the danger he avoided. He wiggled his fluffy tail as if to say, "Ha. Ha. Stupid dog, you can't even climb a tree." In merriment, the squirrel jumped from one tree to another, like an aerialist, leaving his antagonist behind.

I had to learn how to disengage my fears, yet live daily amongst the verbal and physical dangers. Of course I couldn't wiggle my behind with an air of retaliation like the squirrel, but I could surely look into someone's eyes to show them I wasn't going

to allow my fear of them to control my happy thoughts, nor would I allow them to enter my pirate princess fairy world of imaginary capers and dreams. I had to return to the treetops when such incidents occurred in order to find myself again and to like myself again; the same balance we all need as we travel through life.

My grandparents were invited to attend a weekend gala on Jekyll Island. I was so happy to learn I would be joining them. The oak trees lining the coastal waters of the Jekyll Island Club were the most beautiful trees I had ever seen. Breathtaking views of the marshlands and river greeted us as we entered the glorious resort. My grandparents visited the island every year and always requested to stay in the Crane Cottage. The suite depicted the décor of times gone by. Tall, double wide windows opened up to a beautiful courtyard garden lined with manicured evergreens and flowers. A water fountain, surrounded by sculptured marble benches, provided the gentle sounds of serenity and calmness.

Politely and of course well-mannered, I joined my grandparents and their friends for an evening of piano music and fine dining. Remembering *children are to be seen and not to be heard*, I obeyed the rules of dining etiquette. I thought of Great Aunt Margaret and how pleased she would be if she could see me so eloquently polite. After I finished my dessert, of course in a proper lady-like manner, I neatly folded my linen napkin and placed it to the left side of my plate. Waiting for the appropriate time to speak, when the guests unengaged their conversation I sheepishly asked in a soft voice, "Dearest Grandmother, would you mind if I excused myself from the table?"

Grandmother seemed a bit taken back with the sound of my voice as my silence had been broken.

I continued, "With your approval, I would like to sit in the piano alcove."

Grandmother took her napkin from her lap, gently patted her lips, and before she could answer, I spoke once again, "I promised I'll behave, and I promise I won't disturb the piano player, nor will I disturb other guests."

In unison both grandparents nodded with approval. Grandfather, showing off his Southern gentleman style, excused himself from the table. He gently pulled my chair a little bit from the table and extended his guiding hand to me as I lifted myself out of the chair. "Little Darlin'," he said, "be my sweet girl."

As I looked towards their friends sitting at the table, with a sappy sweet voice I said, "Oh, but of course, Grandfather, I most certainly will." I stood on my tip toes to give him a delicate, but appropriate, kiss on the cheek. The kiss wasn't a sincere kiss, just a theatrical kiss in hopes to further win the affections of their friends.

Unobtrusively, I positioned myself in an overstuffed chair grouped with an ensemble of other comfy chairs and couches. The piano player winked with approval and said, "Hello, it's so lovely to see such a refined young lady. And your name is Miss... ?"

I replied with an exaggerated Southern drawl, "Oh Sir, how kind of you to ask. My name is Deborah Elizabeth."

Without missing a note as he played the piano, he continued, "Miss Deborah Elizabeth, what a lovely name. I hope you are enjoying this lovely evening. Do you have any special requests for me to play for you?"

Without answering his first question, I jumped to the second question. "Oh, yes sir, I would love to hear something from Carmen, you know, the opera Carmen."

Astounded by my answer, he quickly transitioned the musical notes and began playing my beloved opera, the first opera Great Aunt Margaret took me to see in Atlanta. Sinking further into the overstuffed chair, I closed my eyes pretending I was an opera singer. From time to time I waved my right hand as if I held a baton conducting the orchestra. My fantasy world was disrupted when Grandfather's hand patted my knee. It was time to go back to the cottage.

Strolling back to Crane Cottage, Grandfather took my hand and praised me for my respectful behavior. Grandmother seemed a bit distant. She had spent much of her evening worrying about how I might embarrass her in front of her socially acceptable friends. I sort of felt she had justifications to worry and quickly slipped my hand away from Grandfather's. I placed his hand next to her hand as a peace making effort. All her tension turned to smiles as their hands locked together.

Once inside the cottage, we prepared ourselves for sleep. I felt very fortunate because my pull-out bed was next to large windows with a beautiful view. A pastel peach colored goose feathered Duvall lay folded neatly across the foot of my bed; my bed looked just as beautiful as my grandparents' large canopy bed with the same linens. The freshly scented sheets, pulled back with a perfect angular crease, summoned me to slip underneath its folds for a luxurious slumber. Grandfather tucked the sheets under my chin and gave me a kiss on the forehead.

"Sleep well, my Little Darlin'. Grandpa loves you."

"I love you, too, Grandpa, truly I do. Was I good for you tonight?"

He replied with concern in his voice. "Of course you were; you were no problem at all, and don't you worry so much. You know Grandmother frets about everything. Now off to sleep you go."

As he started back towards the master bedroom he turned his head towards me to say, "And continue to be a good girl." I knew exactly what he meant by "continue." Perhaps my nocturnal adventures were unsanctioned by Grandmother; however, more times than not, I shared my capers with Grandfather. He never expressed his disapproval of the actual caper itself. Needless to say, he frowned upon their taking place during the evening hours, mostly because of my young age, but my being a girl played a factor, I'm sure.

Grandfather's snores floated underneath the master bedroom door. Although I felt like a real princess in my bed, I couldn't miss an opportunity to climb the most beautiful trees I had ever seen. With renewed excitement, I took the throw blanket from the side chair and quietly climbed out of the door-sized window. With caution, I ran barefooted from the Crane Cottage to the nearest oak tree. Free from the inside world, I walked the banks of the marshlands as my nocturnal friends awakened. Each beckoned his own call of order. I sat on a bench facing the vast marshlands and wondered *what will nature bring my way tonight?*

Century old oak and magnolia trees adorned the plush green lawns and edged marshlands and river banks of the Island. I found the perfect tree! Low branches offered its masculine arms for me to embark upon. The evening breezes carried spine thrilling ghostly images within the shadows of the moss-draped oaks. Of course, a pirate princess would never show her fears if approached by malevolent spirits as local lore proclaimed existed within the marshes and the oaks. The creaking sounds from the oaks' branches and the rustling sounds of the palms heightened my adventurous curiosities. However, I was in uncharted territory, and I didn't feel much like a pirate; I was vulnerable to fear. I felt child-like, girlish and sweet. Perhaps the oak's masculinity took away my need to be strong, releasing the demands placed upon me to survive. *Maybe this is what a little girl should feel.* I liked the feeling and with a sigh found a comfortable place within the oak to sit.

Nature once again endorsed my existence by sending me a spider. I watched a lizard cross the top of a spider's dew-covered web. The spider quickly escaped down its drag line blending within the tree's bark. Although I didn't have a drag line, my intuitions, like the spider's keen senses, warned me when danger lurked. I had never before seen such intricate details entrenched into a spider's beautifully designed web. Its web expanded more than fifteen feet between two branches and went upward as far as I could see.

The spider had attached pieces of Spanish moss to the branches, securing its well-constructed web as it swayed back and forth with the wind. Only the spider knew how to navigate within the web's complex patterns. I wished I could navigate through life on a course to which only I knew the entrance and exit. Like the spider, I must always have an escape route; an escape from humans.

I started my climb very carefully, avoiding the web's delicate structure. Stopping along the way I said, "How do you do little spider? We can be friends, you and I." Continuing in a hushed voice I whispered, "Little spider, little spider, hiding in your web, all dressed up in black and white; may I join you on this windy night?"

He replied hesitantly, "What brings you to the branches I have built my home upon?"

In a soft sigh I said, "I'm looking for a home to call my own."

The spider cautiously paused as he stopped his drag line descent, deliberating his next strategy. While holding tightly onto his web, which was moving vigorously from strengthening winds, the spider stretched all of his legs as far as they could stretch in an effort to extend his body higher than the web's fancy configuration. I'm sure he was trying to impress me with his strength. Joyfully I said, "Oh, little spider, how glad I am you didn't abandon your web, for you see, I can catch you if the wind pulls you downward."

The spider seemed amused at my eagerness to save him; however, he knew his web's strength would survive the winds of this night, just as it had survived gales brought forth by tropical storms in the past.

Each of us in our own world had the power to destroy one another; he with his poisonous venom and me with my ability to squish him. Yet, we simply felt content just being ourselves. We both possessed the art of avoidance; neither one of us needed to engage in conflict. We both just wanted to enjoy a night in the tree with the marshland breezes captivating our moods.

I remained silent with my thoughts a little while longer. The cooling wind lifted the blanket, once secured around my legs, as a warning for me to return to the cottage—where I could sleep without concern that I might fall out of the tree. The salty breeze has a way of mesmerizing ones thoughts, bringing forth a slumberous night filled with dreams.

"Good night, little spider."

"Good night, little girl."

Off to another journey we shall go...

CHAPTER SEVENTEEN

— *Hammocks and Spider Webs* —

The next morning Grandfather and I woke up about the same time while Grandmother remained asleep. Hand-in-hand, I took him through the tall windows into the magical garden.

"Grandfather," I said, "I know I promised I will continue to be a good girl, and I am."

Grandfather shifted his weight while releasing his hand from mine and said, "Little Darlin', I'm sure you are, and you won't disappoint me, will you?"

Quickly I replied, "Oh, no sir, I won't disappoint you in the least, but . . . well, there is just one thing I want to show you. Can we go right now? We have to go right now or the spider will be gone."

"The spider," he said. "What spider? Is it in the garden?"

I pointed in the direction of the oak tree where the spider's delicate web had eloquently swayed within the twilight breeze the previous night. The parameter of the tree and spider were too far for me to show Grandfather, who still wore his pajamas.

Grandfather, foreknowing something brewing inside of me could burst at any time said, "From the looks of you, you must have some story to tell. Why, your smile is going to stretch from ear-to-ear if you don't hurry up and spill it out."

"Well," I said, pointing to the tree, "There is this spider living in the tree. Well, we had a friendly chat last night—oh, I meant to say yesterday. As I was saying, we had a chat. I was wondering; why can't colored people and white people go to the same beaches? If a poisonous spider and a person, well, like me, can sit in a tree together and talk, why can't people do the same?"

Grandfather merely replied, "Some things are just that way right now. Hopefully, times will change."

I thought he responded poorly to a question I felt very important to me, especially since I received punishments for kindnesses shown to the coloreds.

Changing the subject, Grandfather took us back to the spider, and said, "What else can you tell me about the spider?"

I continued my story, described the web, and how afraid I became when I almost dozed off and fell out of the tree. Somewhat doubtful, and assuming I exaggerated the size of the spider's web, Grandfather promised me we would walk past the tree on our way to breakfast. He also promised he wouldn't tell Grandmother, and when we approached the tree he must act surprised to have spotted such a magnificently structured web. Grandfather, a Georgia Tech engineer graduate, paid special attention to lines and dimensions, and I knew he would share my fascination.

After having seen the heights I climbed the night before, Grandfather genuinely expressed concerns for my safety. Of course, and not within the ear-shot of Grandmother, we discussed how we could construct a hammock-like device for me to use in such instances. *What a neat idea*, I thought, and Grandfather Fraser held true to his promise.

Within the next few days, after we returned to Savannah, he and I went to the local ACE Hardware store, our favorite place to get all sorts of gadgets. Grandfather picked out a wide piece of canvas fabric with metal rings along the edges. He took his time selecting just the right width of rope, and clamps looking like humongous necklace latches.

Our next stop took us to a dilapidated smelly store located near the Thunderbolt River Bridge. The store smelled like dead fish. I suppose this made sense because most of the supplies were for fishermen and shrimpers coming in to shop before and after going to work on the local rigs. All sorts of nets hung on the walls and down from the upper rafters. If you needed any type of net for crabbing, fishing, or to shrimp, you could find it there. Some of the netting had been made to hold hundreds upon hundreds of pounds of sea life; so my pixie-pirate princess frame would be held just fine.

While Grandfather pondered whether he should use canvas or netting for the hammock, I, of course, needed to express my opinions. "Grandfather," I said with a voice much older than my current years, "I need something strong, yet not too heavy for me to carry; I need a canteen, a back-pack; oh, and I need a real sling shot, a… "

Interrupting my shopping list tangent, Grandfather chuckled and said, "Now Little Darln', don't you think you are getting carried away?" Together he and the storekeeper laughed and laughed much to my displeasure. I knew they were minimizing my needs. After all, a pirate princess must accessorize her tree house. I suppose the gentlemen found humor as they remembered their days as young boys in similar situations as mine.

A store clerk held netting behind me while Grandfather determined the amount needed for our project. Next the storekeeper used a small metal curved tool to weave the edges of the netting in and around the metal rings, running the weaving process along the edges of the canvas strips. The process took a long time, much to my surprise. I was ready to go and try out my new hammock.

Seeing my impatience, the storekeeper invited Grandfather and me to the back room where an old commercial sewing machine sat on top of a makeshift wooden table. The storekeeper pressed his dirty scarred left fingers tightly against the fabric, and with his equally dirty and scarred right hand, moved the cast iron sewing machine wheel forward. *ZZZzzzZZZzzz*, the sound of the sewing machine zoomed as he quickly guided the fabric through the double needles moving rapidly up and down the band of fabric. He sewed so fast I was surprised he didn't sew a finger onto my hammock. His weathered facial expressions indicated he felt pleased with his work.

"What a marvelous contraption this turned out to be," he said proudly. "I'll have to make my grandson one, he's about your age; nine-ish I suppose."

"Yes, sir," I replied and stood taller.

Grandfather shook the storekeeper's hand while saying thank you. Grandfather's facial expressions motioned me to say thank you, also.

"Thank you, kind sir. You did a superb job." I walked up to shake his hand; however, the smell of dead fish became more repulsive and I almost gagged. Quickly turning my attention to the hammock in Grandfather's hand, I said, "Oh, Grandfather, please let me carry my hammock to the check-out counter. I'll see you there." Anxiously I placed my hammock on the check-out counter, hurried to the entranceway door, took in a deep breath of fresh air, and returned inside as if nothing had happened. I didn't want to hurt the man's feelings, but honestly he really did stink like dead fish.

Grandfather loaded the hammock in his truck bed along with other items he had purchased for his garage shop. He never resisted buying all sorts of gadgets, many never used, yet I was denied the items most necessary for my tree house.

Earlier in the day Grandfather had made arrangements to join some friends for afternoon cocktails at the club. However, due to the length of time our project had dominated, now he didn't have time to take me home in the opposite direction.

Grandfather drove about ten miles eastward to Wilmington Island's prestigious General Oglethorpe Club. Immediately he noticed the change in my mood. The color in my face changed from olive to chalky-white. I became unapproachable while turning my face, staring out of the window towards the river banks. I hadn't known Grandfather participated as a notable member of the elite club, the same establishment as the Mafia man, Mr. Johnny. I started to re-live many hurtful feelings. I didn't want to have these feelings in the midst of all the joy we had shared that day. *The Killer-Shower-Man; Mr.*

Johnny; Mama Jo; Little Spider; Gerber... Oh my, why must my little mind hold vexing preponderances over the past on this ever-so-special day?

Fortunately, our early arrival afforded us time to test out the new hammock device together. The oak branches along the Wilmington River weren't nearly as impressive as the sprawling oak branches adorning the Jekyll Island club's river banks; however, a huge magnolia tree provided the perfect branch configurations we needed. Unbeknownst to me, Grandfather had purchased the back-pack from the netting store.

"Grandfather, Grandfather, you got me my very own back-pack. Thank you. Thank you." My attention, now focused on the hammock, took over my sadness. Poor, pitiful, Pearl transformed into the brave and adventurous pirate princess! Together we stuffed my hammock into my back-pack. I couldn't wait to wear my pack and climb the tree.

Grandfather said, "Okay Little Darlin', let's see how this fits over your shoulders. We need to make sure it doesn't shift too much or you will lose your balance when you climb."

Yep, I thought, *he wouldn't want a building to shift or a bridge to sway.* After he checked the shoulder straps and the waist belt several times, he felt comfortable I would be safe.

His next words were, "Come on now, let's get you up on this branch and see how you do." He lifted me up to the first limb and patted my behind for encouragement. My excitement grew as I made my way up the tree to a comfortable height.

"I did it, I did it. See, it wasn't hard at all, Grandpa."

I looked down at Grandfather and gave him thumbs up. I straddled my legs over a large branch and alternated my grip until I removed my back-pack. I hung it on a branch just a bit higher than my position. I strategically braced myself in a position allowing me the ability to pull my hammock out of the bag. I had a bit of difficulty maneuvering the netting in the tree; it was easier in the car. Seeing my struggles Grandfather showed signs of concern then said, "How's it going? Now listen to me, remember to follow the same clamping techniques you practiced in the car. You hear me?"

Frustrated I replied, "Okay, okay, I know what I'm doing. Don't worry about a thing."

Cautiously I placed the first set of ropes over branches and secured the clamps in their respective holes. Studying the limb structures and figuring out which combination of limbs was best suited to wrap the other ropes around took more time. Allowing for uneven distances between the limbs, and taking into consideration the individual branch circumferences—terminology Grandfather would use—the process took longer than either of us expected. Both of us became impatient. Grandfather wanted to join his friends for cocktails, and I wanted to lie down in my hammock.

I think Grandfather and I became equally excited as the last clamp latched into the metal rings. "Looks great, now try it out. I'm here if you fall."

How stupid, me fall! I thought. *I've been climbing trees all my life!*

With caution I placed all my weight within the hammock. Instantly taking my newfound freedom for granted, I began rocking until the hammock swayed vigorously back and forth. I knew I had crossed my limits when I saw Grandfather's scornful frown of disapproval.

With a forceful, angry scolding he said, "Deborah Elizabeth, come down this very instant. Do you hear me? And I do mean right now. And, leave the hammock in the tree. I want you down here now!"

As soon as my foot reached the ground he jerked my arm causing me to lose balance. I fell backwards and began to cry, not because I hurt but because Grandfather looked so disappointed and angry with me. He yelled louder and louder reiterating terse words.

"I know now why you can't stay in one place for long. I know now why everyone is so put out with you. You don't give a damn about anyone but yourself. All you think about is me, me, me." After having his tyrannical rage, and after realizing how harshly he had spoken to such an adorable child, a pirate princess, he lowered his voice.

In a much calmer tone, he said, "Do you remember the purpose for having the hammock?"

"Uh, huh," I whimpered in a pout.

"That's 'yes sir' to me. Is this correct?"

"Uh, huh... I mean, yes sir."

"If I ever see or hear of you misusing your hammock like that again, I will take it from you. I'll put it in the leaf barrel and you will watch it burn. Deborah Elizabeth, do you understand me!"

Without a verbal reply I nodded my head up and down as if saying, uh huh, uh huh; yes, sir! Anytime I heard the word "fire," I thought of Mama Jo. She had told me many times I would burn in hell for my sins.

After hearing the gospel according to Grandfather Fraser and upon his direction, I climbed back up the tree, disassembled my hammock while taking my own sweet time of course, climbed back down the tree and handed him my backpack.

Grandfather spent about an hour or so with his friends in the cocktail lounge. I sat in the atrium, very bored, until we left to go back home.

Grandfather seemed less interested in me after our return home, and he looked extremely happy to spend more time with Grandmother. Regardless of Grandmother's mood, which in a way I understood and felt sorry for her, I enjoyed watching the excitement as they opened all the brochures depicting the various ports they would visit on their next cruise. Grandfather spun the globe next to his desk with an exaggerated touch. He wiggled his finger above the spinning globe, placed his finger on the continent their travels would take them, so I'd know where they were going.

As they packed, I packed. To my pleasant surprise, Grandfather presented me with my back-pack, along with a little survival kit he had assembled for me. The kit included a few of the necessities a pirate princess surely needed for her capers.

He placed a small tin of tobacco for me to use if stung by a wasp or bee. He even wrote instructions for the application, but I already knew the technique because Mary Ann and I were stung by wasps when we were in a tree together. Instructions:

1. Place a large pinch of tobacco in the palm of your hand.

2. Spit as much spit as you can produce on the tobacco. Make sure the loose tobacco leaves bond into a paste-like composite.

3. Press the tobacco wad on the sting and hold it in place for a few minutes.

4. As the poison neutralizes, the sting lessens. It really works.

Grandfather also packed clear fingernail polish to brush over chigger, red bug, and ant bites. The fingernail polish smothers the bite and helps stop the painful itching.

He entrusted me with his very own pocket knife his father had given him when he turned twelve. I knew I was going to stay with another family while they vacationed and now, with Grandfather's knife in my possession, I knew they would come back for me.

The front doorbell rang and Grandmother greeted the driver. "Hello, Cirus. It's so good to see you. How is your family? Good, I trust?"

Cirus didn't have time to answer before Grandmother handed him my old tattered suitcase. He took my meager belongings to the car while Grandmother fumbled for words to say to me. Grandfather stood quietly, waiting for me to say something. By the time Cirus returned to the front porch, my survival mode had kicked in. I didn't say good-bye, see-ya, have a good trip... nothing. I focused on the unknown, yet the unknown is the known... I'm going to another home.

Cirus, Grandmother's personal colored driver, extended his white gloved hand, gesturing for me to take hold. He guided me down the steps to the curbside and placed me in the back seat. He started talking in his fancy dialogue. "Well, Miss Deborah Elizabeth, I suppose it's time to be takin' you over to Mrs. Hulin's place of work; you

knows her place pretty well by now, don'tcha Miss Deborah Elizabeth? How long you thinkin' you'll be stayin' away this time?"

Shrugging my shoulders upward I replied with a mumble, "I don't know." Continuing in a whimpering voice, I stammered, "I guess until my grandparents return home from their cruise, but I'm not sure about that either; they didn't say."

Cirus' facial appearance became expressionless. With saddened eyes he watched my teary eyes wander off in the distance just before we left East Henry Avenue circling the Gordonston Park; a much too familiar scene of events.

Cirus mumbled, "I don't understand them high society folks and their ways about town and all; just don't make sense puttin' a little child thru all this movin' around." He began with his Mmm Mmm Mmm sounds then once again said, "I's just don't understand them folks." He remained silent the rest of the trip. Once in a while I noticed him glancing at his rear view mirror, watching me hold my Gerber Doll close to the window as if she, too, were looking out and talking to her about our new journey together; just the two of us, as usual.

Off to another journey we shall go...

ANOTHER DAY

I rise and fall with the tides
 Always in motion
Until I'm exhausted and
 House no emotion

CHAPTER EIGHTEEN

— *The Colored's Summertime Revival* —

Winter and spring saw its seasons, and summer approached once again. Only three more months stood before my first double-digit birthday—ten. I felt so pleased I'd be staying at Tybee with Grandmother and Grandfather Fraser. Every summer Tybee Island hosted a revival attended by coloreds from all over Georgia and maybe South Carolina, too.

One day I heard the music from the ice-cream truck all the way from Butler Avenue to our cottage on 5th Avenue. Grandfather gave me two nickels for helping him carry palm branches to the road. He trimmed the palms from the bottom of the trees because he worried a spark would fly from the ground pit where we steamed oysters and boiled crabs. He saw my excitement and permitted me to ride my bicycle to the main street.

Frantically peddling, a loud flittering noise followed me from the playing cards I had re-attached with clothespins to the spokes. I finally reached the back of the ice-cream truck, but not in clear view of the driver. I began singing in an operatic voice, "Oh sirrrr, oh sirrrr."

The ice-cream man laughed at my antics. "What would you like today; a snow cone or cotton candy?"

I replied by using a deep Southern drawl, and lingering the vowels. "Ooooh kiiiind sir, I would looooove to haaaave a red snooooow cooooone with extra syyyyruuuup."

"Deborah Elizabeth, you are something else, little lady." While handing me the snow cone he added, "You best be careful steering with one hand; lots of traffic out there today. Folks are comin' to the Island for the big revival this weekend. The cone is a little top heavy so be careful it doesn't drop off."

"Yes, sir. If it does will you fix me another one FREE?"

He just gave me a silly look for I knew the answer already. I rang my bicycle bell as a way of saying, "see ya soon and good-bye." Then I sang once again in my operatic voice, "Gooood byeeeee, goood byeeeee."

On my way back to the cottage, I noticed workers tying down a big white tent. A large sign posted near the roadside said: REVIVAL, FRIDAY 12 NOON to SUNDAY 3 PM. JESUS WANTS YOU! Three days of praying; now that's a lot of praying.

Yellow flags dotted the shoreline, warning bathers of the dangerous currents and to swim with caution. Grandfather listened to his short-wave radio and heard the weather man announce a tropical storm brewing in the Atlantic. The storm would bring mild winds and showers, but would be too weak for us to worry about a hurricane. I hoped it wouldn't rain because the revival would be cancelled or moved into a big church in Savannah.

Yep, I would most assuredly come back on Friday to see what a revival was all about. I didn't even know what the word meant, but I knew it had to do with Jesus and praying because of all the signs along the road: Jesus Saves - Jesus is Powerful - Jesus is Our Savior - Come Pray with Jesus. The signs made me wonder if I would be ousted and shunned as I had been in Vacation Bible School. Nope, I would just be a fly on the wall and observe. I would keep a low profile and wouldn't bring attention to myself. That was the plan.

Friday, 12:00 noon finally arrived. At least ten buses, if not more, parked on the side streets. Cars filled all the parking lots, and all the parking areas with meters filled up, too. Tybee's Sheriff's department would make a lot of money that day. First Baptist Church and Zion Baptist Church, the two most prestigious colored churches in Savannah, sent the most buses, filled with accepting souls. I began peddling faster in hopes that I could still get inside the tent. To my surprise, the only white people I saw were policemen directing traffic and keeping the traffic flow orderly. I had never seen so many colored people before in my life, dressed in their Sunday best. Some of the women wore vibrant hats with large brims, while others carried fancy parasols. Fashion, but of course darlin's, is a Southern pastime. The clouds shielded the sun. The breeze from the ocean felt warm, but it still helped to cool down the July heat. Thank goodness it didn't rain. Obviously I did not blend in, nor did I go unnoticed. Nevertheless, I would join in on the festivities and didn't care if I seemed an oddity.

I felt a difference between the teachings within the Bible School environment and the teachings within the revival setting although both exclaimed similar words about Jesus and the need to be saved. The coloreds looked so passionate and moved joyously around instead of sitting stoically. I liked the exciting aspects although sometimes the preacher talked so fast and loud the only words I understood were "Yes Jesus" and "Praise the Lord" voiced in uneven patterns. In the Catholic Church, all responses were spoken in unison. I liked the spontaneity of this congregation.

It wasn't important for me to understand what the preacher preached; I felt I was a part of something good. The tent filled to capacity, holding as many people inside as outside the enclosure. That didn't stop the preaching! Gatherers stacked cinderblocks throughout the outside perimeter. Visiting preachers stood on the blocks with their heads barely visible over the crowds.

The preaching started with glory hallelujahs and praises to the Lord, everyone excited. The preachers said, "Jesus is God; Jesus is a powerful teacher; Jesus loves all of his children." Now, if the white people and the colored people said the same things, why couldn't they swim together at the beach or eat together at the restaurants? It just didn't make sense to me. Suddenly I felt sad within the high spirits surrounding me.

I was growing up hearing slanderous and degrading comments about colored people. I had heard the same hurtful things about me. Having been kicked off the city bus for helping a colored lady, hurtful memories flashed before me. The next thing I knew, a colored boy gave me a church fan with an image of Jesus printed on it. "Jesus loves you, too," he said.

For some reason I gave back a snooty reply. "I know that. I'm one of his angels." After I walked away I felt ashamed of my haughty response. I turned back and walked quickly to catch up to him. "Thank you for the fan."

On our way to the beverage table he asked, "Do you know how to play the harmonica?"

"Nope, but I make up songs and sing like an opera star."

He pulled out his silver harmonica and began playing. It wasn't long before a crowd gathered around to listen. Gatherers began humming and gently clapping their hands together while soulful rhythms lifted towards the heavens.

Some of the preaching confused me. If I don't believe in Jesus, I will burn in hell. The Jews are going to hell. The Catholics are going to hell. *How could so many people go to hell or limbo just because they attended different churches? Why not focus on teaching compassion and understanding instead of teaching—if you don't do this or that, or believe in this or that? Why talk about other churches and their doctrine? Just keep it simple and talk about how all people should treat each other with kindness and gentleness.*

I heard many good sermons that day. I enjoyed seeing people happy and hugging each other. Several worshippers asked me where I came from. "I'm just a curious Island girl and love Jesus Christ. Praise the Lord."

Later, Grandmother enrolled me into the All Saints Episcopal Church Vacation Bible School on Tybee Island. Most of the teachers looked like old fuddy-duddies with the exception of one teacher, a college student named Miss Sandy. I remember her name because it reminded me of the seashore.

Upon meeting, we felt an immediate fondness towards each other. I impressed her with my answers to the questions the elder teachers asked of the students, and therefore enthusiastically raised my hand to every question—even if I didn't know the answer. Finally, when she selected me to answer a question, Miss Sandy quizzically lifted her eyebrows. After I completed my answer, her lips returned to a half smile-like smirk. Her body remained in an unfretted stance, making sure her facial expressions went undetected by the elder teachers. She didn't challenge my answer like the other teachers might have. The other teachers possessed strong by-the-book answers. If our answers deviated whatsoever they interjected disapproval with authoritative starkness. The other children laughed and eagerly responded with the memorized answers. I slumped into my wooden desk chair, not with embarrassment but with rejection. I would never belittle another person like they belittled me. I wasn't trying to debase their teachings; I simply provided answers drawn from my own experiences. Just because Jesus said to *act* good wasn't enough, in my opinion, for a person to *be* good. Goodness and honor comes from the heart. It shouldn't be an act.

Miss Sandy asked the class, "How do you know Jesus loves you?"

"I know because when I am all alone walking on the jetties late at night, and a storm is coming to shore and the sky becomes dark, He guides me to safety. I can feel him and I can hear his words whispering through the wind that I am loved. You don't know Jesus until you can feel him enter your spirit when you are all alone and scared."

All of my classmates laughed.

One of the other teachers asked the class to give the correct answer. Proudly and in unison they provided the canned-answer. "For the Bible tells us so." With more giggles the class repeated, "For the Bible tells us so."

I didn't know the Bible stories or the canned answers most of the children had learned over the years, and I wasn't allowed to weave my thinking into the actual bible lessons without offending the sappy sweet teachers.

What did they know in their happy protected lives? Maybe they faked happiness to cover up their own sadness. Acting good and being good seemed two different things. It's more important to be good from within your heart. In my readings of bible stories, I never read where Jesus yelled and screamed and forced people to believe his teachings. The stories portrayed him as a teacher with wisdom beyond his young years, just as I had. I don't think Jesus stood on a rock and said, "Look at me, I'm Jesus the Great." I think he knew that many great teachers from all faiths existed. In his travels he met many scholars as well as evil people. I don't think he judged anyone.

As vacation bible school drew to a close Miss Sandy asked permission to spend some time with me. I overheard her discussing with the other teachers that she studied "Deborah's types of behaviors" in college and it made "good material." Since I

previously had my share of psychiatrists digging into my actions, I welcomed the opportunity for her to analyze me. In any event, she promised to buy me cotton candy. We walked on the boardwalk towards T.C. Chu's and sat down on the wooden benches facing the ocean. We watched two little girls making drip castles. Miss Sandy warmed up to me before the serious questions began, trying too hard to act nonchalant.

After our initial chit-chat she began asking specific questions about the answers I gave in bible class. Her curiosity peaked with each answer I gave and she eagerly asked more and more questions. My insight and wisdom, with an uncharacteristic awareness of God, appeared far more advanced than her own. Enthusiastically, I told her I had acquired my teachings by watching nature and by drawing answers from deep within myself. The fairy children and my guardian angels always provided me hope. I told her how exposed and distracted I felt by unfamiliar and unimaginable events.

In my heart, I believed nature protected me. If nature wasn't there for me, I might have already died from the beatings or fell off the jetties and attached to the barnacles until I bled to death.

She asked why I didn't hate the people who hurt me.

"It's like this, Miss Sandy, sometimes I sort of hate them, but most of the time I don't. I'm too busy thinking about good things, like my adventures. Thinking about the hurtful people just makes me sad. I'm sad when I get into so much trouble. So, when I'm not sad I don't want to think about sad things."

"That makes sense."

"Maybe the people who hurt me most had bad childhoods, too, or maybe they don't know how to deal with children like me. Annie Ruth told me if someone treats me wrongfully, I must treat them nicely with twice the amount of sugar. Miss Sandy, I sure know how to put on the sweetness even when I don't mean it—that's called fake-cake. Lord have mercy, Miss Sandy. The teachers say you have to love yourself before you can love another. If that is true, wouldn't you have to hate yourself before you can hate another? Ta dah! As you know, I simply love myself—kiss, kiss."

Miss Sandy thought my animated speech and my use of words a bit comical. I told her when I became nervous my theatrical antics just popped out. My hands, my body, my facial expressions, just everything got all happy-nervous. My imagination always held steadfast and easily accessible during unpromising times, and sometimes I just acted downright silly to cover up the hurt.

Sometimes I wanted to die because death would stop all the role-playing needed to please everyone, or I longed to survive another day without ridicule or punishment. I wanted to live with Grandfather Fraser forever and Grandmother Fraser to love me with a mother's love. I wanted my daddy to rescue me and take me to a place far, far away and never leave me again. I wanted to stop thinking and just play.

Miss Sandy turned somber. She asked if we could talk again one day. I quickly jumped up and gave her an embracive hug. "Oh yes! Can we, can we? I would love to have a friend like you."

I felt I could talk openly with her. I had mastered the art of doing and saying what was expected of me to avoid conflict and abuse. I suppose Miss Sandy got too busy with work and college, as she never returned. That's okay. She needed me more than I needed her. I'm sure she made an A+ on her thesis because I was the best material she could ever come across.

Off to another journey we shall go...

WHISPERING NOTES

Musical wind escapes from the oboe
Rhythmic chimes echo in the distance as
Vibrations from beating drums open
the chambers of my soul.

A single lingering note
Becomes a whisper of hope
to draw upon within myself
when I feel alone

Whispering notes harmonize
Neutralizing the ordeals of the day
Giving way to pleasantries
Waiting to come my way

With a peaceful awareness
Uncluttered by woes
A playful happiness transcends
The constitution of the mind itself
Providing a passageway to
An imaginary world filled with dandelions
To wish upon.

CHAPTER NINETEEN
— *Back River Crabbing* —

Several hours into the day, Grandfather asked me to come along with him to welcome the new neighbors to the Island. He seemed more curious than friendly and wanted to make sure they were desirable neighbors. No sooner had he knocked on the door than twin boys about fifteen years old greeted us. Now I had two boys to outwit! The grown-ups began their salutations while the boys were ordered by their mother to remain in the sunroom. The boys had no choice other than to be polite to me because their mother kept an eye on their behavior. Grandfather and I were their guests, first and foremost, and Southern manners must be practiced when guests arrive—a lack of manners was worse than a mortal sin to a Southern mother.

At first the boys ignored me, engaging in twin brother conversations with words and secret gestures privy only to them. Becoming bored I asked them, "Have you ever explored the marshes?" Before they could answer I said, "The tidal creeks and marshes are perfect hideaways and great places for pirate princesses like me to explore all by myself."

Enthusiastically sharing some of my Island wisdom, all the while receiving smirks and off-the-wall comments, it became obvious the new boys didn't have a clue about island adventures. They retaliated pompously, talking as if they knew all of everything; typical boys. They believed they could never get lost in the creeks and the tides would never be swift enough to take them off their charted course. Seeing I wasn't going to get anywhere with our initial conversation, I geared my mind to challenge them in a navigational marshland game of truth or dare; then we would see just who needed help.

When we were leaving, as Grandfather and I walked down the steps from the stilted home, I turned around and with a soft cunning voice said, "Huge marsh rats ate the last peoples' cats; that's why they moved."

121

"Yeah, right," they said in unrehearsed unison. Then one of the boys pushed their cat back inside the house with his foot while looking to Grandfather for some sort of reassurance that my statement wasn't true.

Continuing down the steps Grandfather said, "Come along, Little Darlin', we've got to get ready for crabbing."

It surprised me he didn't assure the boys their cat would be okay and that I only bluffed them, but he knew they hadn't treated me very nicely. This was his way of saying that I made a great comeback.

The twins, after several hours of boredom at home, decided to appease their curiosity and walked over to watch Grandfather and me prepare our johnboat for our bi-weekly crabbing expedition. Surprisingly, they didn't roam freely about the Island; from what they told Grandfather, they weren't allowed to go anywhere without their parents, and their parents spent a lot of time in Savannah working on real estate deals. They didn't even have bicycles, an essential mode of transportation when living on an island. I couldn't believe their parents denied them the freedom to explore and thought them whooshes for not having the balls to go on adventures anyway. Of course I really didn't have a lot of freedom with open permission, but Grandfather knew I longed for such capers and he knew my survival skills extended far beyond my young years.

I didn't like the twins invading my special times with Grandfather. He, on the other hand, felt compassion towards their inquisitiveness. Grandfather hurried along, placing our boat on the trailer and hitching it to the back of his '47 Ford truck. With a lofty attitude, I climbed into the johnboat instead of the truck and began waving good-bye. This time the boys shouted out in retaliation, each saying his own insensitive words that went into my heart as one hurtful sentence: "You're nothing but a dumb, stupid, ugly skinny girl and nobody likes you."

Maybe I deserved some sort of comment since I was a bit pretentious, but I didn't say personal hurtful things to them that cut into the core of their existence. The Island boys never spoke to me ugly that way; they remained my back river buddies. I wasn't going to let these city boys have the last word. I decided, instead of saying something hurtful back to them, I would find a way to prove them stupid. *I would make them beg for my help! I would set them up somehow and get them into a lot of trouble with their parents. Yes indeed, I now had the challenge to concoct the perfect adventure that would surely set them up for failure.* Before they went out of sight, I yelled, "You'll see who is the smartest." And then with my operatic voice I sang out a series of notes as Grandfather and I drove away.

After a short ride we arrived at the boat landing. Grandfather quickly got out of the truck and before helping me out of the boat he made sure my tennis shoes were tied tightly with double knots. It was a good idea to wear shoes when boating in case we

had to push off from the mud flats where sharp shells could make some pretty deep gashes in bare feet. Grandfather and I placed our usual items in the johnboat: two paddles, a bushel basket, chicken necks, crab cages and a long handled net to scoop up the crabs that tried to get away. There wasn't enough space in the small boat to put my big inner tube, so we secured it to the side of the boat. A perfect floatation device, the inner tube got me around the creeks and marshes, but of course only under Grandfather's supervision. Grandfather made a special seat for the tube's large opening to accommodate my small size. He weaved nylon strips from a discarded lounge chair and tied the nylon seat around two sides of the tube. He worried I would slip through the tube and be swept away by a swift current. He always attended to my safety, yet he appreciated my self-sufficient attitude and my fearless capers.

It was my job to keep our boat close to the shore until Grandfather returned from parking the truck, a serious task because the currents from the outgoing tides could force the boat to drift rapidly downstream. Grandfather would be furious if I disregarded my assigned responsibility. He taught me how to notice the inconspicuous landmarks within the marshes—it was very easy to get lost, and before long every turn begins to look alike. He also taught me about the dangers of following the creeks to the rivers leading into the ocean, and how storms brewed quickly over the Atlantic and our small craft could not survive a big storm. Over the years he placed various man-made landmarks along the creeks he traveled most frequently. He and I were the only two people that knew where he placed those markers. He took two-by-four planks and painted them a greenish-brownish blend of tones like the natural colors of the marsh. Then he burned large letters into the wood; GR (go right); GL (go left); GS (go straight); OB (oyster bed); SB (sandbar); GC (good crabbing; he knew just the right spots); GO (good place to get off and walk around), QS (quick sand). The art of crabbing could be tricky, but between the two of us we always accomplished our goal— bringing home a full bushel basket of big blue crabs! He taught me to always put the female crabs with eggs back into the water to replenish the crops.

Grandfather and I spent many hours riding through the marshes. He was determined to find the accidently released nuclear bomb in the marshes along Warsaw Sound. If anyone could find it, he sure could. I loved our adventures but sometimes Grandfather would become so angered at the incompetence of the military. That would take the fun out of our exploratory searches. Sometimes he just wouldn't stop going on and on about government cover-ups, the Soviet Union beating the United States with man-made objects—like launching Sputnik into space, communism, on and on. Once he started ranting, he wouldn't stop for hours. I didn't like him when he drank and acted this way. I never tried to calm him down, nor did I ever respond to his tirades. I kept my back to him as he steered the boat and wished we were home so I could leave and explore alone.

Grandmother rarely crabbed with us except on the back river's edge. She didn't like the idea of sitting in a small boat because Grandfather would horse around and act like they were tipping over. In a terse tone she would draw out his name, G i b b y, then pause and say his name three times in a row rapidly, "Gibby, Gibby, Gibby," followed by "Now you stop that right now!"

Of course he and I would laugh and then he would put his hand on her knee and say, "Yes, Dear," and I would say, "Be nice to Grandmother. She's afraid, but I'm not."

Mary Ann, my best friend on Tybee Island, lived across the street from my grandparents' cottage. Mary Ann's mother seemed to be the perfect mother. I never heard her raise her voice nor say cruel words to her children. Like all mothers, she had her rules; however, for the most part her children freely roamed the Island. Growing up around the water provided a second sense of caution, and nature instinctively guided us even when we went off-course into unsanctioned areas.

Mary Ann and I spent many times crabbing on the back river. We carried a woven wooden bushel basket and a small styrofoam cooler. The basket contained our long handled crab nets. Our styrofoam cooler contained chicken necks already tied to lines, plus extra necks to replace the meat when it became less than tasty to the crabs.

The walk along the sandy crushed-oyster-shell road leading to the back river usually took us about ten minutes. The sand dunes along the shores of the back river weren't as high as the dunes on the main beach shorelines, nevertheless the dunes presented us with the prettiest blossoming morning glories. Oddly, within the beauty of this perfect setting, hidden sand spurs became a nuisance. The needles in the sand spurs resembled needles in a cactus except thicker. Pulling a spur from your foot didn't mean the problem was solved. The spur then became embedded into the fingers used to pull it out. Life's spurs were far harder to pull out from my heart than the sand spurs piercing my feet.

Once Mary Ann and I settled alongside the back river dock, we each took out two pre-strung chicken necks and threw them into the water. We anxiously awaited our blue crabs to catch the scent of the chicken. Before long, three or four big blue crabs began feeding on our chicken necks. The real challenges now began.

There is a real art to hand crabbing. If the crab feels vibration from the string being pulled, it will release its claws from the chicken skin. Carefully, with the greatest amount of ease, the tips of our fingers barely pulled the string towards us. Pausing, we watched as the crabs continued eating before we began pulling the string again. You may think crabs are dumb, but they aren't. Even our shadows or the shadows from the crab net could spook them away.

Once the crab net became positioned over the water, scooping the crabs into the net had to be swift and accurate. If the net hit the river's bottom, stirring up the sand,

it would take minutes before the murky waters settled down from the escaping crabs. Since we were, as Grandfather considered, the best crabbers on the Island, very seldom did we make such a stir. The hardest part in crabbing is getting the crabs to detach their claws from the chicken or the crab net. This skill is one learned after suffering many claw pinches from past crabbing adventures. After carefully holding the crabs by their middle torsos and avoiding the front big claws, we shook and wiggled the crabs free from the netting and placed them in the basket. We secured the basket in the wet sand along the water's edge, keeping the crabs alive until they hit the boiling water waiting for them back at the cottage.

By the time we arrived home, the coals in the ground pit were all fired up, and the water in the large black kettle sitting on top of a make-shift grill had reached its boiling point. Grandfather was in charge of taking the crabs from the basket to the fire. Grandmother was in charge of setting up the card tables in the screened porch area. She usually draped one table with Great Aunt Lu's green and yellow gingham checkered table cloth, along with matching cloth napkins. She placed a large pitcher of sweet tea with floating lemon slices on this table, along with the side dishes.

Grandmother covered the second table with newspapers for Grandfather to place the boiled crabs on, along with small bowls for warm butter to dip the crab meat and a pair of pliers to crack the crabs. Oh, I almost forgot; she put flowers in the little duck vase in the center of the table, although Grandfather always grunted with disapproval. He thought it unreasonable to have flowers placed in the center of the table where the crabs were dumped. *What stupidity* he simmered inwardly. Grumbling with undertones, he asked Grandmother to put the ridiculous duck on the side table, off of the crab table. They engaged in their ritualistic exchange of words, and Grandmother gave in every time. She would then place the little duck with the hole in its blue hat for flowers on the side table next to her.

Grandfather's eyes rolled around in his head when Grandmother started talking to the ceramic duck like a pet. "Now come along, little ducky, it's time to put you right here next to me; now how's that?" She then returned to her seat, placed a napkin in her lap and said, "Now, where were we? Oh, Gibby, would you please be a doll and bring the butter to the table? It's on the stove."

They exchanged looks as Grandfather's non-verbal displeasure, caused by her deliberate request, reached its peak. You could tell by his expression he felt she herself could have gotten the butter when she was up from the table moving the damn duck. Needless to say, he retrieved the butter from the kitchen and poured it into our bowls. The crab pickin' and eatin' began without further ado.

Dripping with butter, Grandfather wiped his chin while he sucked the meat out of a crab leg; of course slurping and smacking out of plain annoyance.

"Mighty good eatin'. Mmm, Little Darlin', you pulled in some good tasting crabs."

He left the table after eating a few more crabs and hush puppies. It was Johnny Walker Red and water time, another daily ritual of his which didn't make him a very nice man. No sooner had he opened the screened porch door than a mosquito landed on his arm. Laughing, he said, "I've got more liquor than blood flowin' through these old veins. Even the skeeters won't bite me." He slapped his arm. "Swoosh!"

"Oh, Grandfather, you are just so silly. Enjoy your nap in the hammock. I'll help Grandmother clean up." Grandfather needed his nap, especially after drinking, to avoid confrontations with Grandmother or the neighbors.

The twins saw Grandfather napping in the hammock. Instead of shooing them away, I said, "Would you like to come inside and eat some leftover crabs I caught all by myself?"

"No, not really," they replied.

"Well then, do you want to go crabbing with Grandfather if I don't go along? I'm sure he'll take you."

Of course they enthusiastically and in unison chimed, "Yes!"

"I'm just teasing you; he'd never go crabbing without me." They were about to leave when I turned my head to make sure Grandmother was out of earshot before I asked my next question. "Would you like to go to the marsh with me and float on inner tubes, alone, and without parental supervision or permission—or are you chickens?"

Pausing, they looked at each other and said; "Oh, we've already done that! We don't need some dumb girl showing us around."

"You two are liars! You don't even have a boat, much less inner tubes. You wouldn't even know how to navigate the marshes anyway. Even your parents don't know how to get around the marshes like my Grandpa does."

With a deliberate cruelty, Ben added, "You don't even have parents! At least we do."

I ignored their comment. "So, are we going or not?"

Off to another journey we shall go...

TRUISM

Undoubtable, self-evident truth
Yet, when blinded by fear
Mirages of truth appear

Mysterious forces within the
Assembly of utterances to deceive fabrications
Lacking coherence as destructive words swarm

Reliance upon reason
By reason of inherent qualities entitled to respect
Religious in nature and pure in thought
A child's voice is silenced

Within the silenced echoes of reasoning
Within the simplicity of harmonious thoughts
Within the obstacles of human frailty
The inner-child emerges
Not lost forever, as once feared.

Chapter Twenty

— *Stranded in the Marshes* —

Several days passed before the boys came over to say their parents had gone to Savannah for the whole day and how it would be a perfect time to go to the marshes; that is if I wasn't too afraid to go without my old grandfather. I thought it strange that they asked me since they had previously told me they canvassed the marshes all alone. I didn't press the issue because I knew I surely would make their adventure thrilling, and I would find a way to get even with them for having said hurtful words.

I made up an elaborate story asking Grandmother's permission to join the Spahos family for Bessie's birthday party. "Oh, Grandmother, it's going to be so much fun! We're going to grill hotdogs and play volley ball on the beach. If it's windy enough we might even fly kites! Won't that be fun? Please, Grandmother, oh please, can I go? It's only for a couple of hours. Ben and Benji are going, too."

"Well, we don't have a birthday present for Bessie. I suppose I can run to T.S. Chu's and pick up a little something for her. I'll bring it to the back river."

"Oh Grandmother, don't worry about a present. Bessie said I'm her best friend ever. She wants me there. Don't worry. We can get a present for her later. Just keep an eye on Grandfather."

It wasn't customary for me to deliberately and boldly lie to my grandparents. Usually I would just do things without permission to avoid the "No" word. I'd just say, "I'm going to ride my bike for awhile" or "I'm going to look for the ice-cream man."

Grandfather saw the three of us talking to Grandmother on the porch. I asked Grandfather, who was working in his shed, if he would take two of the bigger flat inner tubes to the filling station and fill them up using the big air tank because it took too long to use our hand pump. I told him we had permission to go to the back river for Bessie's birthday party. He wasn't privy to the full conversation and assumed we

128

obtained permission from Grandmother to do so. As always, he complied with my sweet request and asked one of the boys to ride to the filling station with him. He needed someone to hold the inner tubes so they wouldn't fly out the back of the truck. I took my inner tube out of the shed and noted his soft tire. I asked Benji to pump air into it, using my bicycle pump while I theatrically tapped it and squeezed it until satisfied the optimal amount of air had prepared it for the perfect float. When he finished, just as he started to put the cap back on the tube's nozzle, I stopped him and authoritatively said, "You have to spit in the cap before you put it back on; don't you even know that?"

He didn't acknowledge me; however he brought the cap back up to his mouth, spit in it, and then screwed it back on. I doubled checked the cap to make sure he didn't purposefully leave it loose so my air pressure would leak. I surely didn't need a flat tube while outsmarting them.

Grandfather returned from the gas station with Ben holding inner-tubes in the truck bed. Our journey down 5th Avenue to the boat landing began. Once we knew the coast was clear, we darted to the right at the fork in the road and back-tracked towards the marshland. The incoming tide would take less than an hour or so to climax, then the alternating tides would pull the currents in the opposite direction—which meant we would paddle against its flow while trying to get back home. Timing was crucial and my heart pounded really fast as I never, ever, navigated the creeks without Grandfather. I felt confident I knew the hidden landmarks. I had the advantage over the boys; but I didn't understand the real danger facing the three of us.

It all started out great. The first few turns seemed pretty straight forward. We could see the shore and the landing area where we boarded our inner tubes. After a few more turns we went deep into the marsh and couldn't see above the grass. We remained okay because the water moved slowly and, for the most part, we floated without our tubes turning around and facing us backwards. We paddled with our arms until we got close enough to anchor our feet in the mud. Then we pulled ourselves closer into the soggy wetlands by holding onto large clumps of marsh grass.

Once our footing became stable we stood up and looked far into the distance. We saw miles of marshland, but we couldn't see the waterways traveling throughout them. I knew our exact position because we had passed two of Grandfather's markers; GR (go right), GL (go left), and I knew how many more markers we would have to pass before we reached the river's outlet; DR100 (danger river 100 yards). I knew better than to go that far because Grandfather was cautious and wouldn't let me stay in my inner tube even with it tied to the boat when we came within a hundred yards. The currents and undertows could be very strong in some areas and were considered "death-traps."

Small dark clouds formed overhead and my keen senses picked up the smell of rain in the far distance. Once again, nature silently warned me with its gentle breeze rustling through the marsh grasses. *Be wary of the Storm*, the wind echoed. I knew we

must begin our return journey earlier than I hoped, but I also knew the boys enjoyed their time exploring and I didn't want to ruin their fun.

The boys really liked their freedom and tried to look like nothing was new or amazing—and they ignored me when I said we needed to return because a thunderstorm brewed. I knew they were experiencing everything for the first time by their facial communiqué towards each other; they were having a blast! I sort of felt sorry for them, but it only lasted for a moment because I overheard their whispered words interrupting my niceness. They planned to leave me behind while they journeyed off by themselves. I continued digging up a conch and acted like I hadn't hear them.

All the while I felt such a deep sadness for having brought them to the special place Grandfather and I shared. My tears trickled in the mud. *Why am I digging up the conch? I'm disrupting its quiet home just to show it to two ill-willed boys.* Then I saw a fiddler crab raising his one large claw high in a respectful manner, telling me it's time to leave the marshes.

Ben and Benji tried to leave the mud-soaked marshland without paying attention to their footing. They ignored my previous instruction on how to wander around the soggy terrain by positioning their feet atop some of the larger clumps of grass. They quickly lost balance as their feet sank deep into the mud. Before long they stood almost knee deep in mud, still sinking a little at a time—not realizing that maybe they were really caught in the quick sand that smelt like bait shrimp left in a tackle box overnight.

"I told you there is quick sand in the marshes and you didn't believe me. I told you to keep your feet grounded on the larger grass clumps. I told you, you idiots! The quick sand is going to suck you all the way in and you will die; you will die and I'm not going to pull you out!" I ranted on and on and then thought I would just leave them there to figure their own way out and their own way home.

Carefully balancing, I grasped as much grass as I could with both hands, bending sections downward to the soggy surface in an effort to stabilize my own descent. I securely positioned myself in the inner tube and pushed off with my skinny long legs. I began floating in the same direction as the outgoing tide, noticing the currents seemed much faster than I ever remembered. I had never felt the full forces of the currents before since I always remained tied to Grandfather's boat. Now uneasy, I still told myself to enjoy the ride. I passed a few more of Grandfather's markers and realized that only a few more markers remained before reaching the river.

The smell of rain became more profound and the wind shifted in zigzag directions. I wasn't sure what this meant but felt frightened by the swiftness of the current and felt unable to control my inner tube as it twirled me around and around. For the first time, I knew I was in trouble, or should I say *up a creek without a paddle*, because literally none of us had paddles; a detail I didn't take into consideration because Grandfather

paddled the boat and I just drifted along. Part of me chuckled as I wondered if the boys remained stuck in the mud while fiddler crabs pinched their legs.

The currents pulled me to a perfect marsh landing. I extended my long lanky arms, reaching for marsh grass to secure my position. Once secured, I waited for the boys to drift down to meet me. Then I thought, *how can they, they don't know the markers; they don't know how to navigate.* With an escalating fear, I frantically grabbed the grass to pull myself along the edges—making it faster than trying to walk in the mud and carry the inner tube.

My arms felt so very tired, but just about the time I wanted to give up and climb into the marsh I heard Ben and Benji cry out for help. They couldn't see me and I couldn't see them, yet when I made the turn I still couldn't see them and felt like giving up once again because they didn't respond to my operatic overtures. Soon their cries no longer reached my ears. The eerie clouds became darker and darker. Just when I thought all hope was lost, I heard a little putter from a small fishing boat engine around the creek's bend. As soon as the boat became visible, I saw Ben and Benji sitting inside their inner tubes with their hands clinging onto the sides of the boat for dear life. I couldn't help but feel sorry for them and realized they didn't even hear me call out to them. Oh well, enough woe; I let go of the grass and began acting like I was having the time of my life. Waving my arms I called out, "Hi guys, where have you been? Stuck in the mud this whole time?"

"Found 'em lost, probably goin' in circles," the fisherman said. "They're sure glad I came along before the storm got them." Then he added; "And as for you young lady, just where do you think you're going and what business do you have out here in the creeks alone?"

"I know everything about these parts of the creeks because my grandpa taught me."

"And did your grandpa teach you about getting a good whoopin' if you ever dared to go out into the marshes alone?"

"No Sir," I replied with a haughty air. "And he wouldn't spank me anyway because I'm his Little Darlin'." My inner tube turned around once again, sort of like an attitude turn. The fisherman could not see my facial expressions change from haughty to panicky.

The rain hit the creek and produced rippled patterns, quickly removed by the strength of the currents pulling the tidal creeks faster and faster. I became frightened but tried to look cool and calm. My inner tube rotated. Now I could see the fisherman's brow scowl with concern. Nervously laughing and trying to hide my fears, deep down I knew I would be rescued and I wouldn't be pulled to the depths of the ocean's floor in the death-trap undertows. The fisherman threw out a rope with a buoy attached, and it landed within my arms reach.

"Here ya go, grab on and I'll pull ya aboard." The boat tilted from side-to-side and began floating out of control while the frantic twins became even more frightened that the boat would tip over and they would drown. Once I got my chest in the boat I looked up and gave a bratty smirk and an insincere smile.

The fisherman restarted his boat and we journeyed back to the boat ramp. The twins gave me their respective looks of disapproval while I rolled my eyes and said, "The two of you are hopelessly pathetic and disgusting to look at!"

"I can just see the Tybee News headlines: Frail Little Girl Sinks Boat with Two Muscular Teenage Boys Clinging on for Dear Life. The article would read, Fifteen year old twins, new to the Island, were unprepared when the boat they were clinging to tipped over ten yards from the boat landing in three feet of water. The two boys, each almost six feet tall, continued in fear as they slipped and fell into the muddy river banks while clinging onto their inner tubes. Their fears were put to rest when Deborah Elizabeth, a ten-year-old Island girl, extended her arms and offered her hands, helping them safely to shore." Hmmm, I thought that would be a very good article if I may say so myself. After all, isn't the news full of embellishments?

Unfortunately, the three of us had to walk back home together. We didn't speak a word; just three kids with soggy shorts hanging low on our butts, carrying inner tubes and hoping to get home before lightning struck us down.

All in all, we weren't really gone terribly long, but needless to say I got into so much trouble. Grandmother noticed the Spahos family returning home and walked over to give Bessie a little something for her birthday from all of us. Well, of course she found out Bessie didn't even have a birthday. I also got into trouble with Grandfather because he felt responsible for the boys' disappearance and didn't know what to say to their frantic parents.

Grandfather didn't invite me to swing in the hammock with him that evening. He and Grandmother whispered their conversations. Grandfather went to bed angry about the day's events and didn't say good night to me. Grandmother sat and talked to me on my foldout bed for a good length of time. She didn't talk out of anger, but she worried her new husband might wish he'd never married her because I was a troublemaker.

"What were you thinking when you took those boys to the marshes without your grandfather?"

"Well, Grandmother, you see it's like this. The boys made mean comments to me. They called me skinny and ugly. They made fun of me because I don't have parents. I just wanted to prove to them that I wasn't afraid to go with them to the marshes. Grandmother, they bragged they knew the marshes better than me or my *old* grandfather."

I told Grandmother I was sorry and I would apologize again to Grandfather in the morning. After my grandparents fell asleep, I took one of my nightly capers to the back river. The glorious displays of stars in the darkened skies, bejeweled by an occasional falling star, symbolized nature's changing forces, just like the cyclical tides going in and out, and like my living arrangements when the front doors opened to greet me, then closed behind me as I left.

Off to another journey we shall go...

FREEDOM

Authentic fulfillment
 never remains steadfast

The reality of fulfillment
 exists with a degree of conflict

Conflict within fulfillment
 is necessary to gain wisdom

Wisdom is accumulated
 within the stirring whispers of our mind

Freedom from self-destruction
 perhaps a celestial light

CHAPTER TWENTY-ONE
— *The Paddy Wagon* —

My father completed his Navy assignments and reclassified as a civilian. I had not seen my father, Mama Jo, my step-sister, nor my half-brother in almost five years. Suddenly they all moved to Savannah, just as my life had become more stable. By age ten I felt confident I would return to my grandparents' home after holiday breaks and their annual summer breaks. I figured the older I became, the more likely I would live with them until I completed high school.

In some ways Grandmother seemed happy I was rejoining Father, but in other ways she felt sad because we had just begun bonding, and I was almost eleven which meant I was more helpful than problematic. Grandfather worried the beatings would resume, and he never did like my father or Jo very much. As for me, I feared Mama Jo, but was excited to live with my father and siblings. Our East 32nd Street home was only about two miles from my grandparents' house–a perfect walk or bicycle caper. Fortunately I was able to stay in the same school and was about to enter the fifth grade.

During this time the Cuban Missile Crisis brought fear into our classrooms. Reels of mushroom clouds and the earth destroyed by atomic bombs replaced Disney films. Most of us heard our parents speak of war and the destruction and loss of lives during WWII. We became the baby boomers, the children who brought hope and joy to the new beginnings within our suffering nation. Well, most children brought joy, but of course I was created in the devil's workshop and only brought more suffering to the world.

Teachers' lessons were interrupted by the blasting sounds of air raid sirens, which posed an eerie sensation that the world was coming to an end. Laughter on the playground immediately hushed, without prompting from the teachers. They trained us to react to the sirens without hesitation and with the utmost respect for the imminent dangers which could destroy parts of our world. Many drills prepared us for

our mass exodus from the school building to the nearest railroad tracks. With a buddy system established, quietly and orderly we would begin our journey to safety.

We were taught that we became wards of the government when the sirens blared. Military men with guns quickly joined the ranks of our evacuation. An ambulance with a red-cross emblem slowly followed alongside our procession. Parents were not allowed to take their children out of the line, but could walk the evacuation route at the end of the student line. The government was responsible for our safety and we remained with our teachers as a group.

Our evacuation route trailed from the school yard to an intersection where railroad lines crossed. Sometimes box cars stood stationed on the lines with military personnel standing alongside the rail lines and inside the large box car openings. We never knew if the sirens blasted for a drill or if the evacuation was going to take us on a journey far away from our school and homes. Of course I wanted to take the journey and go far away, never to return to East 32nd Street ever again. War seemed less threatening to me than the turmoil I knew awaited me upon my return home from school.

Home life wasn't much better than when I lived with Mama Jo years before. Time apart had not healed the wounds of Father and Mama Jo's past differences, nor did time provide a change in Mama Jo's heart towards me—the unlovely, evil stepdaughter who came from Hell. She constantly reminded my father I was disturbed, couldn't be trusted, and instigated friction within the home. I probably provoked Mama Jo in some ways as I challenged her irrational authority and manic controlling ways— repetitive chores, vacuuming the same rug for thirty minutes, cleaning one toilet for thirty minutes with a toothbrush, folding sheets over and over until each corner lined up perfectly. I understood discipline and organization, but why was I the only child in the home performing domestic duties while the others stayed in their rooms?

From time to time Mama Jo and I worked pleasantly on the house projects. She complimented me on my eagerness to get on my hands and knees and clean the wooden floors without missing a corner. I scrubbed the bathroom tile completely free of mold until the bleach and ammonia mixture took my breath away and the whole house became toxic with fumes. Once again, Mama Jo labeled me an evil child for trying to kill everyone in the house with toxic fumes because of my jealousy towards my half-brother and step-sister. Truthfully, I just wanted to clean everything perfectly. I did not know about toxic mixtures, and no one had ever forewarned me of the dangers.

"Where is your common sense?" Mama Jo would ask. The short-lived pleasantries between us disappeared after I tried to kill everyone, and the distance between the other siblings and me once again broadened. "Keep away from Deborah. She is trying to kill us all. She is sick, we should never have moved back to Savannah. I don't know what I was thinking."

When Father came home from work the first thing he heard was how I tried to kill everyone. He began drinking and did not respond to her displeasure. By remaining quiet, he fueled her anger even more. He drank straight vodka in a glass filled with ice. One, two, three, and now he poured his fourth glass. I watched him try to walk to the bathroom in his drunken state. He stopped at the corner of the living room and relieved himself, thinking he had reached the toilet.

Mama Jo yelled at him, and then he threw a vase from the mantle in her direction. I'm not sure who called the police, but as they yelled and threw things about the house, police sirens could be heard in the distance—a good sign help was on its way. As the police reached our residential area, the sirens silenced and the emergency blue flashing lights flickered through our neighbors' windows. Before too long the sirens from the fire trucks blared in the distance. Two very distinctive sounds. Soon the fire truck sirens stopped and their red flashing lights lit up the whole neighborhood. Out of concern, but mostly out of curiosity, the neighbors opened their curtains to get a glimpse of yet another dramatic situation unfolding.

The neighbors were accustomed to the paddy wagon stopping in front of our house. A sweet elderly couple lived next door to us on the right and the Kessler family lived three houses down on the left. Families would venture onto their front lawns, walk to edge of their driveways, and appear non-obtrusive. However, they were genuinely concerned about our family situation. Oftentimes one of the neighbors welcomed me into their home when the fights between Daddy and Mama Jo became too unbearable.

Although their rage truly frightened me, on the other hand I used this time to expose some of my theatrical abilities. I engaged in conversation with the officers and could tell that they were saddened a small child fell in the midst of such turmoil. "Oh, sir. Oh, sir," I would say. "What will happen to my daddy, sir?"

That day the officer asked if I had any brothers or sisters in the house.

"Mama Jo makes my brother and sister stay locked in their bedrooms during these ever-so-frightful arguments, and she tells them to keep me locked *out* of their rooms!"

Day after day, Mama Jo greeted Daddy with angry words as he approached the front door after work. She apprised him of our daily unlovely interactions, and expected him to do something with *his child*.

Daddy did not condone corporal punishment, and he didn't know how to handle all the so-called problems. He attentively listened to Mama Jo rage about my behavior, my lack of respect, and my inability to perform my chores in the manner she instructed.

Daddy distanced himself from me and drank every night. I caused his alcoholism—me, his most unlovely daughter who wished she was never born. Daddy

could never be happy with me in the picture. History had proved that already. *Get rid of Deborah Elizabeth and everyone lives happily*, I thought.

On one particular evening, several police cars came to the house along with the paddy wagon. One officer stood at the front door while another officer walked around to the back door. I'm sure they heard glass breaking during the tirade, with a lot of shouting and threats. While Mama Jo spanked me, I pitifully screamed, "She's killing me, Daddy. She's killing me." I hoped the officer's ears would perk up with my overly theatrical pleas.

Daddy opened the front door to the officers. Mama Jo pushed me into my bedroom, like that was really going to shut me up. I whimpered ever so loudly. Mama Jo returned to the living room ranting and raving, barely taking a breath of air between sentences. The officers repeatedly asked her to remain quiet in an effort to hear Daddy's comments, to no avail. I poked my head out from my room to gain attention. "Oh sir, oh sir, I'm over here." I longed to tell the officers the real story!

After further dialogue between the officers and my parents, the officers determined the judge needed to decide the outcome of the situation. Mama Jo and Daddy were escorted to the paddy wagon by the officers. Oh Lordy, Lordy, the words coming out of Mama Jo's mouth scared the officers. They felt sorry for Daddy and apologized for having to put him in the same paddy wagon as that crazy woman. Fortunately, our next door neighbor offered her assistance to care for us children until one of our parents returned home. She adored me. I didn't care if Mama Jo never came home again and feared that Daddy might never come home again.

The paddy wagon, crude in appearance, looked just like the ones seen in cartoons. It was black with no windows in the containment area. A little window on the back door with bars provided fresh air to the prisoners. The paddy wagon turned around at the end of our cul-de-sac and headed back up our street. As it passed our home, I could see Daddy and Mama Jo fussing up a storm. I yelled out, "I'm sorry, Daddy. I'm sorry, Daddy. I didn't do anything bad. I promise I didn't do anything bad."

I wanted to burst out and sing, *Ding, dong the witch is gone*, and dance on the front lawn, but I didn't because this would prove to Daddy I was a bad girl and I really did things deliberately to infuriate Mama Jo.

It seemed like the paddy wagon faded away in slow motion and life stood still. There was no sound to be heard; no movement in the air nor a dog's bark—inert and cold.

Within four or five hours Mama Jo arrived back home but without Daddy. I'm not sure if Daddy had to stay at the police station because he was intoxicated, or if he went to Grandmother's house. All I knew was Daddy did not come home.

Several days passed before my father returned home. He went to work, came home, stayed in his own drunken world, and slept most of the time. Mama Jo remained aloof

towards me until she needed my help to sew tiny sequins on one of my stepsister's ball gowns. The hoop-skirted gown contained so many yards of material that she oftentimes required my help. Mama Jo seemed happiest when she sewed. Because she was so attentive to extreme detail, Jo's creations looked more attractive than anything store bought.

I loved sewing on the sequins, one little sequin at a time, and it made Jo happy, too. She seemed to enjoy my company when we worked on sewing projects. She complimented me by saying, "You are the best sequin sewer, ever. You sew better than your sister. You are the best little helper."

Mama Jo never looked upon herself as my stepmother. "I am your mother," she told me one day. "I am the one raising you." Mama Jo put her sewing needle down and reached for the dictionary. She always had a book and a dictionary close at hand—an avid reader, Mama Jo looked up every word she questioned. That day she opened the dictionary to the tabbed MN section. Then she turned the pages until she reached "Mos... " on the top upper left corner of the page, and "Mot... " on the top upper right corner of the page. Scrolling downward with her index finger she stopped on the word—Mother.

"Deborah," she said. "This is the definition of Mother, as quoted from Webster's Dictionary." She read with authority, "Mother: a woman having authority or dignity like that of a mother; one that has produced or nurtured something; one related to another in a way paralleling or suggesting the relation of mother to child." Later I noted that she left out the part that defined mother as "a women who has given birth to a child," or "to give birth to."

Well, I can say Jo had the authority but lacked the ability to nourish a child with tenderness. Perhaps her own upbringing by her German father's harsh words and corporal punishment were the only teachings she knew how to pass along. It was apparent that she did not house an understanding of softer words or actions and seemed unable to empathize with others' feelings. She lacked the ability to value others, to provide warmth and tenderness, or to exemplify motherly gentleness. Her view on mothering seemed based on the utilization of power, paralyzing any independent thinking by her children.

As early as four I had possessed nurturing and gentle motherly instincts. All of nature, including its tiniest little creatures, I deemed important and meaningful. Therefore, having a mother with such foreign habits disturbed me.

My young motherly instincts opened my heart to nature and caring for wounded or lost animals. However, if I found a bird with a broken wing I wasn't allowed to help it because I would get mites. If I wanted to put a piece of leftover meat on the porch for our neighbor's dog, then we would attract rats.

Jo perceived me as rebellious when I tried to offer a positive approach to her concerns. Helping a bird with a broken wing could be easily achieved by putting on a pair of garden gloves. Even if another animal preyed on the hurt bird, at least I could put it under a bush and away from the elements, provide it with a little bit of water and bread crumbs and hope it would fall asleep and slip into its slumberous death. As for the dog food, I could have discarded it if the dog didn't retrieve it before nightfall. A stray cat meowed for days in our backyard until finally one night I put her in our garage and gave her some food. Throughout the night more and more cats gathered around the garage until we had a yard full of cats. They meowed so loudly Mama Jo woke up.

The next thing I knew I was being pulled from my bed by my arms and dropped to the floor beside my bed. "Get up, you insolent thing." I wasn't even a child, I was a *thing*. "What have you done to attract all these cats into our yard?"

"Nothing, Mother." I really didn't know because it didn't dawn on me that the little cat I put in the garage caused all the commotion—she was in heat. I didn't know about those things.

Pushing me forward into our kitchen, Jo told me to unlatch the main door which opened inward. I opened the screened door. It squeaked so loudly, it quickly scared the cats away. Jo switched on the outside porch light and only a few brave cats remained sitting in front of the garage side door. Shooing them away, she opened the garage door and discovered the calico cat I had sheltered and fed. I grabbed the switches out of the large urn in the dining room and ran quickly to my bed. I hid the switches under my bed and pulled the covers tightly over my head.

It wasn't long before the porch light turned off, the back door was locked and Jo entered my room with the belt in her hands. I kept my face buried deep within my pillow so Daddy wouldn't hear my screams—like hide and seek. I hid my cries from him, but still wanted to seek out my daddy for protection. I knew if he heard me, there would be another fight between them and the police would return. I was afraid the police would take me away to another foster home, and I would never see Daddy again.

Having been brave really didn't help though. The next day he saw the red belt marks on my body from the beating. When he asked me, I first told him I had a bicycle wreck. Then he started putting the events of the evening into place with the noises outside, the back porch light shining through the window, the noisy kitchen screen door, and the voices. And, he knew I had taken a beating. The other two children went to school. I remained home and Daddy stayed home from work. The arguing and the violence continued all day, and I stayed in my room knowing everything was my fault.

I wanted to return to the shores of Tybee Island, *my* island, where I could live amongst the mysteries of the ocean, essential to the nurturing of my soul. I had no further resources to exhaust. I lived in an icy prison with Jo as the mother-warden with

no warmth to melt away her frozen exterior. Oddly enough, I believed Mama Jo was a strong, principle-oriented individual. Sadly, however, she was insane and her best efforts sequestered us from the natural elements of happiness. Our lives became exhausted by her abstract principles and great teachings taken out of context. The affirmative response "Yes, Mother" to her demands and commands eliminated my needs for logical sentence structures as I became more and more robotic.

Retreating to my pirate princess world brought me the happiness I needed to create new poems and imaginary stories.

Off to another journey we shall go...

DARKNESS PASSES

One's soul need not suffer from
Inherent weaknesses
Needless or meaningless
Carelessly strewn about

Perils cannot reconcile
if inoculated with repetitions of unkind acts
filtering through the veins of your spirit
repeatedly brutalizing your creative imagination

Identify yourself!
Let your artistic warmth traverse within
the synapses of your mind
surpassing in virtue

Begin the day when the new moon is first seen
Without yielding to meaningless qualities
Bring out the harmonic emotional and intellectual qualities
Unknowingly suppressed, yet dwell and stir amid the chaos

As darkness passes with the perils from the past
The new moon becomes full of new beginnings
Nature never dwells in one place for long
For without change, life is stagnant.

CHAPTER TWENTY-TWO
— *Cathedral of St. John the Baptist* —

My first memorable Catholic experience was at the Cathedral. The larger than life statues carved with passion for the Holy Trinity and the Church took hold of my soul. I loved being in the church. I felt ever-so-small within the massive holy structure and close to God in an inexplicable way. I cried because I felt unholy. I knew God lived everywhere, but I felt his presence there more than ever. The Stations of the Cross lined both side walls depicting Jesus suffering for our sins and ultimately dying for them. An evil sinner, I came from the devil's workshop. I wanted to live inside the church so that I could feel holy and protected.

Incense lingered in the air from an earlier service. The Mass spoken in Latin made the service seem holier to me. If my soul and spirit felt something, then I felt worthy. I liked the pomp and circumstance. Each ritual took me to a different world, a world away from my hurtful daily rituals.

I thought the priest talked too much about money. The Catholic sermon wasn't as animated as the revival; falling asleep seemed easy to do. Then a single note filtering through the massive organ pipes quickly awakened sermon sleepers. What glorious music! Never before had I heard such beautiful music.

During this time I lived with Mama Jo and Daddy. Jo was Catholic and agreed to Grandmother paying my Cathedral Day School tuition. Nuns from the Sister of Mercy Order taught at my school. They walked slowly, wearing the traditional habit. Long black rosary beads hung from their waists with Jesus attached, nailed to a silver cross.

Some of the nuns appeared almost manly with their stronger, deeper voices. I learned to look out for them because they used the rulers. Although they didn't seem very holy, they were firm disciplinarians and presented dictator personae over the other nuns. I respected their authority but didn't respect how they used the name of the Lord to shame and degrade a student who spoke out of line or refused to do an assignment in a timely manner.

Punishments for any wrong doing varied. Usually we had to write a chapter out of our religion book or write pages from the Bible. I never took to heart or mind what I wrote. The works just represented letters and more letters. The final period ended with the blessing. It would have been more affective and a better use of time to sit in a room and read out loud to a blind person at the nursing home. I didn't think teaching by intimidation was very effective, at least it wasn't for me. I drew far more strength and awareness in wanting to be a better person by watching the quieter and more solemn nuns.

The best part of the day was chorus. We were taught Gregorian chants along with catechism: Kyrie Eleison: Kyrie eléison. Kyrie eléison. Kyrie eléison. Christe eléison. Christe eléison. Christe eléison. Kyrie eléison. Kyrie eléison. Kyrie eléison; Agnus Dei: Agnus Dei, qui tollis peccata mundi: miserere nobis. Agnus Dei, qui tollis peccata mundi: miserere nobis. Agnus Dei, qui tollis peccata mundi: dona nobis pacem.

During mass, the priest would chant and the choir and congregation would respond back in chant.

Many of the churches in Savannah kept their doors open twenty-four hours a day for all to come and worship, morning or evening. The church was a sanctuary to all who wanted to talk and be near God and the Saints. Oh, and I can't forget the Virgin Mary. She was prayed to more than the saints. *Hail Mary full of grace, the Lord is with thee. Blessed art thou amongst women and blessed is the fruit of thy womb Jesus. Holy Mary, Mother of God, pray for us sinners now and at our hour of death.* I didn't understand why people felt the need to pray to the saints and to Mary.

"Why not go to the top and pray to God directly," I asked the sisters one day.

Sister Mary Margaret and Sister Mary Hope embraced the questions I asked. I didn't ask questions in class because from past experience I feared ridicule and judgment. However the nuns actually thought I asked good questions.

"It is important for all of us to pray for one another," Sister Mary Margaret gently explained. "The more prayers lifted to God, the more we bond together as we struggle through the temptations on earth. God wants us to draw strength from the saints and Mary because they sacrificed their lives honoring his teachings."

Sister Mary Hope looked at me calmly and added, "God hears all prayers. We should ask Mary to pray for us just like we would ask a friend or a priest. Mary and the Saints aren't gods; they are God's messengers."

I still thought it best just to talk to God one-on-one. I didn't really get the "holy" feeling when talking to statues.

On two occasions I successfully entered the upstairs choir loft unnoticed. I felt closer to heaven, just like sitting high-up in the oak and magnolia trees. The side altars,

ornamented with statues, and the church's main altar, gilded in gold with tall arched stained glass windows, commanded reverence. The outside sunlight beaming through the upstairs choir loft's stained glass window presenting sparkling prisms of holiness.

I wanted to be a nun. I wanted to be a soloist in the choir. I wanted to be holy and not perceived as evil. The second time I sneaked into the choir loft, the pews sat empty. I started to sing in a gentle soprano voice, "Laudamus te. Benedicimus te. Adoramus te. Glorificamus te." These phrases I repeated several times and then continued the chant, "Domine Deus, Agnus Dei, Filius Patris Domine Deus Domine Deus Agnus Dei, Filius Patris, Qui tollis peccata mundi, miserere nobis. Qui tollis peccata mundi, Qui sedes ad dexteram Patris, miserere nobis. Qui sedes ad dexteram Patris, miserere nobis. miserere nobis."

Unbeknownst to me, a priest had walked from the vestry to the front of the main altar, genuflected and performed the sign of the cross, then went down the steps lining the communion rail. His presence went unnoticed while I sang because my eyes were fixed on the stained glass windows and the beautifully painted ceiling. Suddenly my eyes met with his. I quickly stopped singing and ducked behind the choir loft's railing. I listened to his steps echo throughout the church, my heart beating faster and louder. I didn't want to get into trouble, not here in the church. *Oh, please God, don't let me get into trouble for singing.*

The granite steps leading to the choir loft were no longer a passageway between me and the downstairs. Father found me. "My child of God, you do not need to fear me. Please make yourself known." He must have been an important priest because his jeweled ring appeared really large, just like the Mafia man's ring.

The priest must have sent one of his messengers to the chapel to tell on me. Sister Mary Fidelis, the principal of the school, arrived. I had only left the downstairs chapel for a few minutes. I'd believed I would go unnoticed because all the fifth and sixth graders who had not been confirmed were taking special classes to prepare for our confirmation test.

I showed my temper off by yelling, "God wanted me to sing and not at your stupid confirmation. God hates you." I yelled so disrespectfully in the holiness of the church, Father and Sister Mary Fidelis both looked stunned. After sashaying to another row in the choir loft with my nose high in the air, I began singing once again, this time louder and louder without the spirit of the Lord in my soul. As I began calming down, my singing and chants turned angelic. I knew God was no longer upset with me. I felt him inside me.

God said, "Lift up your voice to sing praises and I will forgive you." That is exactly what I did, but I still had to write passages from the Bible the rest of that day.

More times than I can remember Mama Jo would wake me up at one o'clock in the morning, even on school days. Her voice would penetrate through my dreams and I'd hear, "Deborah, Deborah, get out of bed. Come into the living room."

Each day Mama Jo's delusional revelations would be articulated differently. A single sentence could have many variations depending upon her frame of mind. I could never memorize her interpretations because they constantly changed.

When she wasn't in a delusional frame of mind, the teachings seemed interesting. Sometimes we would each read a paragraph from the Bible and discuss it. Instantly she could snap, and her hand would slap my face—reminding me I was the devil and that my rationale was nonsense. "God will certainly rebuke you, Deborah."

How could I even begin to mirror Jo's delusional behavior, especially when I felt groggy? I liked my thoughts. They were with me when I felt alone and afraid, and with me on the jetties and when I hid high in the trees. No one could destroy who I was. No one!

I feared Mama Jo when her eyes changed into a strange stare-like trance. Her face contorted and became hardened as the muscles in her face changed. She looked completely different. With these outward appearances, I knew that anything I said would ultimately lead to a beating with the belt as the devil required banishment from me and from the house.

The more she talked and the more she read, the more I realized I needed to pay very close attention. I needed to learn how to avoid saying simple phrases that would lead her into her manic world and dialogue. One phrase I learned through trial and error—*Yes Mother, your thinking is correct.* It was as if she herself were trying to receive approval from God and she was using me to be a witness that God passed his Words to her—for her to teach me.

Another phrase I would use when she became uncontrollable was, *God is with you tonight, Mother.* As long as I could deflect questions with a turnaround approach, she began pontificating again which bought me some time. After much practice and many beatings, I finally mastered the perfect body language and little phrases. Eventually the beatings stopped, but she continued waking me up in the early morning hours to pontificate.

I was doomed in her world. She kept emphasizing that she was my mother, the only mother I would ever have, and that God had sent me to her. God had sent me to her so she could take the devil out of me and be rewarded. She referred to my biological mother as the womb of evil. She emphasized that female mammals can give birth and that giving birth had nothing to do with mothering.

Off to another journey we shall go...

146

VALUES

My years go by relentlessly

with values

protected and not affected

by transitory standards and other men's dreams

Centered by my own self core

not by philosophies of man or lore

perplexed by diverse and unsure trends

simplicity transcends

CHAPTER TWENTY-THREE

— *Cathedral Day School* —

Father and Mama Jo continued their arguments over petty issues and of course over my daily unlovely interactions with Mama Jo. Our modest home contained one bathroom. If someone needed to use the toilet while another bathed, the shower curtain must be closed to afford the respective privacy each person required, and too, our private parts would not be seen.

I entered the bathroom while Bobby bathed in the tub, and of course he quickly drew the shower curtain closed. Being a bratty sister, I very gently pulled the shower curtain open—just enough to quickly pour cold water over his head. He was startled when the cold water hit him and was equally stunned by my sneaky maneuver. His natural response hit a high note; "Aaahhhh, Mama, Mama." The discomfited screaming hastened the attention of Mama Jo who quickly snatched me out of the bathroom. My laughter quickly turned to dread.

Mama Jo, unable to contain her anger, screamed over and over again, "You just molested your brother. Oh my God, Bobby's been molested! Bobby's been molested." Instead of taking Bobby out of the bathtub, she flew to her bedroom to retrieve the belt. Her anger heightened to such an uncontrollable rage that she herself didn't realize her own strength behind the belt as she repeatedly lashed her leather weapon.

This beating lasted longer and was by far the most severe whipping I had ever received. Each time the belt struck my body I screamed for my daddy. "Daddy, help me. Daddy, help me. Heeeeelpppp Meeeeeeee. Please help me. Make her stop, Daddy. Make her stop."

He just walked to his bedroom and closed the door.

The beating continued as I thrashed my body against tables and chairs hoping the belt would hit one of them instead of me. I don't know what finally made Mama Jo stop hitting me. Perhaps she herself became exhausted. I just remember limping to bed, followed by my bloody trails.

I simply played a joke on my brother. Cold water had been poured on me before and no one received a spanking. What made it so horrific this time?

The following morning, the family dynamics remained somber with no mention of the bath tub incident. Therefore, as the molester, I started the new day with the understanding Mama Jo could bring forth harsh words at any given moment, yet in order to show respect without mocking or disturbing her superior nature, I survived the morning without uttering one word to anyone.

Father drove me to the Cathedral Day School on his way to work. I remained unusually quiet and reserved in class and had difficulty sitting for long periods of time. Each time my back barely touched my desk chair I flexed in pain. If I pressed my chest too close to the desk, I softly muffled sounds of pain. My ribs were bruised from thrashing myself against the furniture.

Mama Jo called the school and informed the Sisters of Mercy I molested my little brother. I wasn't allowed to play with the other children during recess and was required to stand next to Sister Mary Margaret while she supervised recess. Even though embarrassment took over my usual smiles, I did not bow my head in shame. Instead, I mimicked the nuns each time they instructed one of the children to behave. From time to time I would give an eye of disapproval to a group of children even if they weren't doing anything wrong. Ha, they responded to my evil eye and became less aggressive with their playful antics. I waved my hand as if to orchestrate their movements with a bippity boppity boo fairy godmother impression.

Sister Mary Margaret popped me on the shoulder as a gesture for me to stand still and to cease drawing attention to myself. I cried aloud in pain. Sister Mary Margaret thought I was being my usual dramatic self and popped me once again. My new cries overlapped my first cries as I sat on the ground and sobbed in pain. After Sister Mary Margaret sensed I wasn't being a drama princess, she compassionately helped me up and we walked back inside the school together.

After having resisted her embrace with a yelp, she began to question my reactions and my cries. I told her about the bathtub incident. She took me to the infirmary nurse. This was the first time I realized my beatings were not something God wanted to happen to me. The nuns were compassionate and overwrought with sadness when they examined my wounds and bruises. Some of the wounds required medical attention. I spent several nights at the Abbey under very loving supervision.

I felt a holiness I will never forget for as long as I live. Chants from the nuns' evening prayers filtered the halls and became sweet lullabies to my ears. I wasn't allowed to join them in their sacred prayerful chambers, but I felt their holiness. I felt, most assuredly, that all their prayers being lifted up to God were on my behalf. A certain kind of gratification overcame me that God was displeased with Mama Jo because she had overstepped her parental duties in His eyes.

I was placed in a group home for girls for a few weeks and then reunited with the family. I didn't interact with my brother for fear I would be accused of doing something vile. My father's walking away from me as if he pathetically feared Mama Jo seemed unforgivable. I dreaded the repercussions of the belt but not her words. I knew in my heart she possessed an unnatural view of the world. She was predisposed to seeing the world as problematic, evil underlying sinfulness lurked behind every act of human kindness.

Mama Jo didn't see the world as I saw it. She didn't understand that simplicity has merit. She over-shadowed others' thoughts and actions with her preconceived convictions.

Fortunately, within these tumultuous times I tuned out my surroundings and once again escaped to my pirate princess world on Tybee Island. Mama Jo's words did not penetrate through my mind to my heart. I played a wooden puppet and performed a theatrical role to please her—if for nothing more than another moment of peace. I became her little puppet child as she manipulated my strings to do and say what she required of me, but she never controlled my thoughts nor did she break the strings of my soul which remained attached to my heart.

Off to another journey we shall go...

DARK SHADOWS

My body is fragile with human frailty
I weep for enclosing myself in a sphere
Of which only I can enter.

I thus shall barricade my secrets
From surfacing in this world
My innocence lost in the shadows of time

What one may perceive as sunshine
I perceive as darkness
The rays do not bring life, but
A sweltering death

Yet the spring bulbs are blooming
While the winter leaves are decaying
Where do I fit into this cycle?

Perhaps I am the dark shadow
Emerging into sunshine, therefore
Punishment of death itself will not
Take over my physical frame and
My soul will not dwell in shame eternally.

CHAPTER TWENTY-FOUR

— *Thickets and Roaches* —

Our family moved from East 37th Street into a much larger and nicer home just outside of the Gordonston Subdivision. Once again, we all thought the new home would bring us closer, and our lives would be better.

Carole got accepted into an out-of-state college. Bobby studied beginner drum lessons at school and showed an immediate talent. Mama Jo took a part time job working as a receptionist in a doctor's office, and Daddy worked at Lindsey and Morgan Furniture Store in downtime Savannah. Much to my displeasure, I was instructed to do yard work every afternoon after school. Mama Jo hated the side yard hedge, a thicket of bamboo where thousands of huge palmetto bugs bedded. She determined to make the yard more attractive by having me dig it out.

One hot summer afternoon Mama Jo instructed me to place her lounge chair in the center of the back yard, underneath the pecan tree. I placed the few books she had selected earlier on the chair and her tall glass of iced tea on a serving platter. She was rarely seen without a book in her hand. *Idle hands are the devil's workshop!* She wore a plain scarf to cover her fading red hair, over-the-calf pedal pushers to modestly cover her shapely legs, and a sheer long-sleeved white cotton blouse to protect her fair-skinned arms from the sun—the perfect apparel to be worn while supervising the removal of bamboo hedges. As soon as she felt situated in her chair, she told me to bring her several long switches and place them beside her iced tea glass. After I provided her with her weapons, I began my daily afternoon bamboo removal project.

Absorbed in her reading, Mama Jo became distracted by sounds within the bamboo hedge. As she removed her large black sunglasses while uncoiling upward from her reclined position, her angered voice escalated with scolding words. "Deborah, stop screaming and jumping! What will the neighbors think? I will not condone such behavior. Keep digging and without your theatrics." She waved the switches I had placed by her chair and warned me without words I must silence myself.

Palmetto beetles crawled on me, and I couldn't control my screams and my involuntary jumping reactions. Mind over matter didn't work this time, I felt petrified. Brownish black legs became entangled in my hair, which trapped the roaches while their wings fluttered in their efforts to escape. Helplessly, I couldn't slap them off my face like a mosquito invasion because their creamy puss-like insides would splatter. Brushing the roaches away irritated them more. They banned together and crawled over every part of my body. I'm sure the insects wanted to leave their tortured frenzied environment as much as I wanted them to do so. The roaches had better luck than I because Mama Jo headed towards the bamboo hedge with the switches while they fled to safety.

Long grassy switches stung across my legs and arms, cutting my flesh into thin slices. "You are pathetic. Your crying won't get you anywhere. You make me sick. Only God knows the hell you've put me through." Small gnats fed upon the droplets of blood from my open wounds along with my tears. Suddenly, a profound silence of fear and shock hushed my world.

Trembling with an irrepressible impulse, I quietly sang. *"Everybody's got a laughin' place, a laughin' place to go, to go. Everybody's got a laughin' place, a laughin' place to go."* The lyrics I recalled from an Uncle Remus tale when Brer Fox entered into the briar patch.

Day after day, I dug bamboo while smarting from the bladelike switches. Oddly, my reactions to physical pain silenced—a skill mastered while digging the bamboo. My tears never flowed again as I dug the bamboo while the roaches in the hedged clicked and crawled.

After many months, the yard once hidden by the bamboo thicket became adorned by a flowering pink and white dogwood tree, a small fig tree, azaleas and camellias blooming in shades of lavender and pink, and most of all by the complete absence of bamboo.

The day's lesson at school focused on nutrition and the colors associated with the basic food groups. Colorful food was not important to Mama Jo nor the embellishments I needed to make our mundane food look edible. In that our pantry was undersupplied I improvising with thought-provoking enthusiasm, coloring our mashed potatoes green while the deviled eggs became a brighter yellow and the baked chicken gravy a vibrant purple. I helped in the kitchen because Mama Jo didn't like to cook and I did, especially with my new ingredient—food coloring.

Proudly placing the food on the table, my excitement vanished as Mama Jo pronounced, "You have ruined a perfectly good dinner. You have made our food look rotten and uneatable. No one in their right mind would eat food that looks so disgusting."

Quickly, a thoughtfully planned supper turned into disarray when she pulled the table cloth over the beautiful display of colorful food. I didn't understand how she could take a set of circumstances and verbalize my intentions as rebellious and disrespectful. One of Jo's famous phrases came to mind: *Your thinking is ridiculous. I never taught you to think like this.*

What had I done to provoke this type of anger?

Mama Jo may not have taught me how to make a plain dinner look visually appealing, but to mirror her perceptions of my thoughts would destroy my creative urges. *Why would my colorful food accents bring out her demons?*

She continued her harsh words. "Get out of my sight; I'll deal with you later!" A selection of bamboo switches filled a tall vase awaiting Jo's personal selection. She would choose her weapon by length, thickness, and with or without grassy blades. She grabbed several switches in her hand and began swinging them in the air. I ran around the table, through the kitchen, and then out the back door, slamming it behind me and crying, "I just wanted to add color to our food, just like my teacher said."

Sadly, I ran outside and hoped she wouldn't follow. My depressing thoughts instantly turned into excitement filled with unlovely thoughts when I came across several of my creepy crawling enemies. Swiftly, I scooped up the largest two-inch roaches I had ever seen and folded them into the bottom of my shirt. Hurriedly, I took the repulsive insects indoors and put them inside of Mama Jo's toilet. I closed the lid and felt happy again. Later, her screams almost shattered the windows—*oh my, how could that have happened? Perhaps I am hopelessly flawed.*

Later that same evening, I awoke to the Bible hitting my head, controlled by the momentum of Mama Jo's hand. "Deborah, get up and go to the living room. I'll be waiting for you there." I supposed Mama Jo processed the toilet event and knew I was the culprit.

I never understood Mama Jo's complete unhappiness, even if she, too, had been dealt an unfavorable childhood. Her bitterness overpowered her ability to have an understanding heart. Her brothers and sisters didn't act like her. I oftentimes thought she feared me because of my inner happiness and carefree spirit. Constitutionally, and sometimes defiantly, I challenged her authority. Perhaps her frustrations stemmed from her inability to accept how she wronged people when she, in her own mind, thought herself godly and omnipotent in her teachings.

Mama Jo's lecture lasted for hours and then she said, "You know why you are standing here, don't you?"

"No Mama," I replied, motionless, with my eyes fixed on hers. I felt trapped in her confusion of truth and spiritual obsession, and she didn't realize her presence brought fear, sadness, and discord to the entire family.

154

Jo believed in God and the spiritual healings promised in the spoken Word, but she could never apply these beliefs to daily life, and if a situation deserved forgiveness she was unable to extrapolate this emotion. Her relationship with God did not illuminate the family but instead acquainted our daily lives with grief and destruction. We felt poisoned with despair and lacked self-confidence. Thus said, her intentions appeared very different than the outcomes; she must have felt unfulfilled in God's eyes because I seemed so flawed and unlovely. In her mind, my behavior reflected on her ability to teach her children right from wrong. These perceived failures must have been tremendously frustrating and haunting to her and frequently pushed her into self-destructive modes of thinking.

I stood quietly and attentively in front of Jo while exhaustion overtook my physical frame. When I wavered, she hit my feet with a switch saying, "Stand up straight and give me the respect I deserve."

Where was her God and where were my guardian angels?

"You can return to your room now. I am tired and your presence indisputably annoys me." Finally, after several hours of interrogation, I stumbled to my bedroom.

So be it, I was free to go back to my fairy fantasies and compose my own prayers. They required no memorization or dissection from Jo because she never listened to my prayers. She wouldn't believe I had the aptitude to make them up all on my own; she would have accused me of stealing them from someone.

Dearest Angel of Faith:

My prayers are carried on angles wings. I'm constantly moving to places untold, so please guide my spirit so it may rest within my life's ugly mess.

Off to another journey we shall go...

PITIFUL PITY

I have foresworn farewell to pity
The circumstances of my youth's ungentleness

Dark sunken holes filled with lies, replaced my eyes
Speech resting upon my ears, provided fear

Oh enemies of mine own, faults as they are
Take thy soft mercy upon the pulse of life
Transforming eternal shame into painless scars

Oh humble messenger
Elaboration becomes the motif placed upon my faults
As they were for now –

My eyes jeweled with crystallized tears - no longer fear
My speech, no longer utterances of indifference have become
Oral proclamations disavowing suffering and unhappiness

I've returned to nature, observing the seasons,
Realizing decay fertilizes, just as
Hardships strengthen the soul
Pity me no more – the abundant reasons have seen their seasons

CHAPTER TWENTY-FIVE
— *Bright Lights and Smoke* —

President John F. Kennedy was assassinated. Media footage of his children saddened me as they, too, became lost children without their father. *How sad it must be, I thought, to see your father and mother on television and your father's blood on your mother's pink suit. How cruel, how horrible the world treated them.* I remembered the blood splattered walls from the killer-shower-man and thought these children would never forget the last images of their father alive. I didn't even know the dead man who'd been lying next to me, but I had sensed remorse for his life to have ended in such a tragic set of circumstances.

I wanted to befriend the two new lost children. I wanted to make their world full of fairy tale wonderments and take them on adventures to Tybee Island, and be a big sister to them. I could take little Carolyn and John John into my secret hiding places where the media couldn't find them. No one would find them in my sand forts and no one could take the stars away from their darkened nights.

I suppose the most memorable fun times in junior high were the times spent with Daddy when he worked on stage props for the local Little Theatre. The theatre stood a few blocks down from our home on One Kenzie Avenue. Daddy and I worked together on the set for Camelot and I also sang in the chorus. My vocal talents were well received within the theatre community and the school chorus. I became a soloist and participated in the young people's symphony. Of course, Mama Jo forbade me to attend rehearsals after school.

Once again, I became the object of Jo's displeasure, my voice now scrutinized by her majestic authority. It didn't matter what my chorus teacher said, nor did it matter what the director of the orchestra expressed about my unusual talent. I possessed a naturally perfect pitch, rejected however by Mama Jo's tone-deaf ears.

A strange and most disturbing occurrence took place that year. Mama Jo and Father had one of their arguments while Mama Jo's deceased husband's mother, Grandmother Sigman, was visiting us in Savannah. Mama Jo planned an outing with her to include Carole and Bobby. I'm not sure why I didn't attend the outing, but I didn't. While they were away from the house, Father's intoxicated mind took an unusually violent turn. He forced me into the bathroom and closed the door, leaving me alone. He instructed me to stay inside, and no matter what I heard I was not to open the door. I thought he was going to kill himself.

Before long I smelled smoke and then it began drifting under the bathroom door from the adjoining bedroom. I opened the door and saw him partially clothed on the bed. "Daddy, Daddy, are you okay? What's happening? The house is on fire!"

Because he was unresponsive to my pleas, I wondered if my Father had just given up and wanted me dead. Mama Jo had often said the only way to kill a demon was to burn it alive! My little girl fantasies about my father suffocated.

In a panic, I climbed out of the bedroom window, reentered with a garden hose and put the fire out. I remember Mama Jo had made new curtains and repainted the walls.

Mama Jo and Father divorced shortly after this incident. Since Mama Jo had adopted me at age twelve, she was entitled to receive child support for my care. I remember feeling petrified when I was called in front of the judge to tell him which parent I wanted to receive my custodial rights. I froze on the stand while she stared me down. Prior to the hearing, she told me I would never see my brother or my sister again if I didn't live with her, and God would punish me by taking my voice away.

I believed her. I have no idea what made my brain so stupid that day. The reality of the court decision sent me back home without my father ever coming back to live with us. But, did it really matter? Had my father tried to burn the two of us alive, or did he drop his cigarette too close to the curtains because he was drunk? I have to believe the latter.

Off to another journey we shall go...

DIFFERENT DIFFERENCES DIFFER

Different colors of people and landscapes
Different religious beliefs and doctrines
Different values and dreams
Different interests and vocations
Different sexual orientations and passions
Different opinions and motives
Differences not listed
 So
What difference do different differences make
 If
Differences you differ
Differ differences you don't differ, just to differ
Don't differ differences with indifference
 Because
Indifference lacks imagination
 And
Without imagination
Your differs will never make a difference
 If
That makes a difference
 If not
Why differ just to have different differences?

CHAPTER TWENTY-SIX

— *Emancipation* —

My first two years of high school I experienced academic difficulty. I attended St. Vincent's Academy, an all girls' Catholic school. The education was geared toward college with a focus on academic excellence and stringent spiritual guidelines. Both disciplines seemed advantageous for me because my hours away from the house increased, and I typically had four hours of homework to complete before the next school day.

Physically ill, Mama Jo didn't have the energy to take her aggressions out on me. She tried to work but was fired or quit due to disagreements with her bosses and co-workers. She showed pleasure towards my academic enthusiasm and exhibited less agitation with me. I didn't receive the belt anymore; however, the emotional maltreatment continued as part of her daily dialogue and mode of thinking.

I enjoyed my times at St. Vincent's even though the nuns could be a bit over-zealous in their opinions of good and evil. The nuns deemed a popular pizza parlor on Broughton Street as evil and off limits to all students because a cigarette vending machine was installed. Of course, the few times we girls did go inside the pizza parlor, one of the nuns would mysteriously show up and make a scene while escorting us out. We went for the pizza slices only, but the mere presence of the devil's smokes seemed reason enough for the nuns to remove us from the restaurant. As the nuns escorted us out of the restaurant, we girls would balance our books while unfolding the material around our waistbands. We'd folded them up to shorten our skirts.

The nuns scrutinized us to the point that the bows in our hair could only be black or navy blue. We were not allowed to wear perfume, lipstick, makeup, silk hosiery or carry a purse that wasn't black or navy blue. We had to line up on the outdoor stage for the nuns to measure the length of our skirts which had to be precisely the required uniform length. I didn't mind the rules within the structured walls of St. Vincent's. I felt safe within this sacred place while other students felt imprisoned. I hoped I was

destined to become a nun and prove I didn't come from the devil and that he wasn't my eternal father. I would never wear tampons because Mama Jo called them the "devil's fingers."

In an attempt to bond with Mama Jo, I began talking to her about my religion classes and what I had learned in school. This didn't go over too well, as her opinions oftentimes weren't in sync with my teachers' views, and they were nuns.

One evening, I suppose she was processing one of my earlier conversations while she tried to sleep. The next thing I knew I was abruptly awakened sometime after midnight by her screeching voice. "Deborah! Deborah! Get out of bed this very instant. Follow me, now, I said! Don't give me that look or you will be sorry. Who do you think you are, looking at me like that?"

I knew better than to reply and kept my sleepy eyes glued to the floor.

"Look at me! I said, look at me! Go stand in the corner. I didn't say prop up against the corner, I said stand up next to it. Get that look off your face. Did you hear me? Answer me. Do you hear me? Answer me."

I didn't know what to say other than, "Yes Mama, I hear you."

I looked directly into her eyes, unafraid of her wrath. I knew it would come to pass after a few minutes—no matter what I did, or said, or how I looked at her.

Jo suffered many years trapped in her mind which did not embrace nor give credit to the opinions and ideas of others. Well versed in the philosophies and ideologies of ancient times, Jo read the entire Bible at least two times. Each day her delusional revelations would be articulated differently. A single sentence could have many variations of meaning, depending upon her frame of mind. I never memorized her interpretations because they constantly changed.

When she wasn't in a manic delusional frame of mind, the teachings seemed interesting. Sometimes we would each read a paragraph and talk about it. Instantly she could snap and her hand would slap my face, reminding me I was the devil and my rationale nonsense. God would certainly rebuke me.

During my junior year in high school, Jo became hospitalized several times with diagnoses of mental exhaustion coupled by a nervous breakdown. She depended completely on me as Carole attended college in Washington, D.C. I received my driver's license and drove her back and forth to the hospital. One of Jo's sisters, Aunt Deloris, came to stay with Bobby and me.

On one occasion, I drove Jo to the Cathedral of St. John the Baptist for counseling. We arrived early for her appointment and the secretary asked us to wait in the lobby. Unfortunately, Father McMillan and Father Fitzpatrick didn't know their voices carried to the lobby.

"It's been such a long day. My next session is with a woman who's nuttier than a fruitcake. I'll be surprised if there are enough prayers in the prayer book to save her."

Jo sprang from her chair and promptly walked towards the voices and confronted the two priests by saying, "Were you talking about me? Are you insulting my intelligence by saying I am nuttier than a fruitcake?"

"Oh, no, no, no," Father McMillan stuttered. "Mrs. Merriman, you took our conversation out of context. We were discussing something else entirely."

"Please excuse me, Father McMillan. Mrs. Merriman, it was so nice to see you, again," Father Fitzpatrick said as he cowardly exited the room.

I felt sorry for Jo because we both knew the priests lied. Perhaps for the first time I looked at her as a human being rather than as a dictator. I saw a frailty consume Jo, but her defenselessness didn't veil her unkindness. Instead, she continued to deny her own self- destructiveness which defeated any chance of her regaining some semblance of cognitive thinking. She seemed unable to form thoughts and began disassociating the hospital's efforts to help her as some kind of plot to kill her. She stood at an emotional and physical standstill. She lost faith in the church, her most sacred "hiding place."

I began wondering again if Jo had been abused as a child. Maybe internally she was fighting herself or acting out against her own childhood abuses when she hit me. Was I her mirrored image? Satisfying my own question with the answer 'yes,' I then started to see her as a very flawed human being with her own demons controlling her mind. She tore herself apart one thought at a time. Nothing seemed simple, and nothing appeared joyous. Did her German father cause her to be a lost child, and if so, perhaps she didn't have the ability to enter a fantasy world filled with dreams like I did; a place where nature guided my fears into playful fairy tales.

I began to understand her life would never have peace, nor would mine as long as I lived with her. I longed to escape and to feel more like my friends at school who seemed to have happier homes. Their parents took them to the football games and allowed them to participate in after school activities. I so wanted to be normal.

After the divorce, Jo had declined Grandmother's offer to continue sending me to St. Vincent's Academy. I was enrolled in a public school for my last two years of high school. When I entered the halls of Savannah High School, I instantly loved my new surroundings. First of all, there were boys and more boys in the school, unlike the all-girls Catholic school. Suddenly I was popular and my long blond hair, big blue eyes, and long legs attracted the boys.

Academically, I didn't take school seriously because my education at St. Vincent's had offered most of the requirements for a basic four year curriculum. I enjoyed receiving attention from my chorus teacher and praises from students as well as other

teachers for having the best voice for two consecutive years in our chorus group. I joined the drama club and instantly hammed up my parts to the pleasures and laughter of the students.

I was selected as the lead soprano for our school's chorus and for the young people's symphony chorus. Mr. Thigpen, my school counselor, had faith I would receive a hardship scholarship to college. He and my chorus teacher sent tapes of my singing to various college recruiters and on my behalf set up interviews for the recruiters to talk with me during school hours. Mr. Thigpen encouraged me to take school more seriously. However, studying or going to college played second fiddle to my love of socializing.

I attended Sunday school at St. Mary's on the corner of Victory Drive and Waters Avenue. Jo attended women's devotionals where she met Mrs. Burke. Although I was forbidden to date, Jo allowed me to attend a church sponsored New Year's dance. Being a devout Catholic and after talking with Mrs. Burke, another devout Catholic, it was agreed for Mr. Burke and their son Chuck to drive me to the event. Little did Jo know, Chuck had become smitten when my eyes flittered in his direction during Sunday School. Of course, I didn't play on his emotions, not one tiny bit. It wasn't my fault he melted when I smiled ever-so-sweetly with a giggle when he looked my way. We were in Sunday school with the purest of intentions, I dare say.

I was so proud to enter the church's auditorium with Chuck, the lead guitar player for The Tragedies, a rock 'n roll band. Why, every girl looked at me with envy. I was on a date with a rock 'n' roll player, and this was my first date!

My newfound popularity oftentimes provoked untruthful rumors from jealous girls, especially when I went to Chuck's house. Well, the real reason I went to Chuck's house was because he had the worst case of mumps, and I worried about him. He sat propped up in bed with ice packs between his legs, and kept the sheets pulled up to his chin during my visits. He was out of school for weeks and I visited him often, bringing him handmade cards.

The Vietnam War took our friends into the battlegrounds of despair, death, drugs, and the fear of coming home with missing limbs and altered minds. The following year, Chuck enlisted in the Air Force shortly before his draft date. His unit went to Pleiku, an area in the mountains on the border of Cambodia, Laos, and Viet Nam. The enemy fired a 122 rocket on his post at Camp Enari. He sustained serious injury and returned home.

In a conversation with Chuck I told him, "You are my war hero. Thank you for serving our country."

"Don't call me a war hero," he said. "The heroes are on The Wall."

The baby boomers became war heroes to many, but nothing had prepared them for a war.

Our country stood divided about the purpose of the war and the expected outcomes. All we knew was young men our age were dying on battlefields in a foreign land every day and were praised in the media as dying for an honorable cause.

In contrast, our friends and other young men came home with their minds forever demonized by horrific memories, various body parts dismembered from their torsos, shrapnel imbedded deep within the flesh of their battered bodies, and then were given only a moment's praise for serving our country. They then left feeling less than heroic as their sacrifices were labeled as duty to our country and were soon forgotten by many. Yet they will be forever remembered by many of us who continue to value their sacrifices and appreciate the soldiers from past wars.

The soldiers carried precious memories of their high school dream girls into the battle fields. Their minds held onto single acts of kindness like the most important moments of their lives. They took the memory of a smile and wept alone at night hoping they would see that smile once again. I felt ashamed for harboring on any hardships I endured at home. The war took a serious toll on many families, and their losses far surpassed any battles I tried to defuse at home. I think many of the soldiers coming home from war felt guilty for surviving.

As Mama Jo's physical strength increased, her nightly interrogations worsened. It wasn't long before she rarely slept at night nor allowed me to sleep. I had to remain standing while she continued her frenzied biblical readings. She persistently asked me questions in hopes of tripping me up, attempting to find fault in my answers and justify her continued madness until the sun rose. She chained smoked and drank coffee one cup after another which helped her stay awake. I slept in the school counselor's office during study hall and chorus class. Sometimes I didn't go to class at all, and the teachers gave me make up work to take home.

I finally broke down one night during Jo's biblical drillings. I cried and slumped down to the floor from exhaustion. I realized the necessity to say something that would draw me closer to her, so I could come within reach of her thinking and perhaps speak to her with some sort of kindness. I wanted to run, to run as far and as fast as I could. I longed to be alone in the night and sit on the jetty. I wanted to climb in a fort or sit on the dock at the back river. I couldn't take another sleepless night of interrogation.

As I slumped to the floor she immediately sprang from her chair and began pulling my arms upward. She spewed harsh words with a soft yell so my brother wouldn't wake up and cry. I looked straight into her eyes and said, "Mother, God loves us. He is with us right now in this room. I can feel him and it is because you reached Him through your readings. He has blessed you by coming into my heart. Mother, please forgive me for all of my transgressions. I am overwhelmed with joy and He has cleansed me. Can't you see the difference in my eyes? Can't you see His reflection in my eyes? You put God first and he has rewarded you. Mother! Look into my eyes. You have to look into my eyes because God told you to."

Jo's delusional behavior lessened and we sat calmly on the couch together until we both fell asleep with Fritz, our family dog, sleeping under the couch.

The following evening seemed unusually quiet while Mama Jo prepared dinner. Jo rarely cooked and was never a good cook. I didn't think about anyone but myself that night and how I needed to escape.

I selfishly thought about my own needs. I should have talked to my little brother more often. I became disconnected from his needs because I feared Jo's reactions if I looked at him with a certain look or if I made a comment to him that met with her disapproval. I didn't want Bobby to feel he must come to my defense. His physical safety seemed intact, and I didn't understand that he, too, was affected by his mother's mental state and needed me.

I didn't plan my escape. The evening seemed quiet and Jo let me do my homework in my room without interrupting me with a Bible reading. I closed my bedroom door and quickly placed Gerber, some of my clothes, and special possessions in pillow cases. I left the house through my bedroom window and left the packed pillow cases in the alleyway. I ran for hours into the darkness of night. I feared the police would spot me darting between the azaleas lining the median on Victory Drive.

If the police caught me, I would most assuredly be taken to the psychiatric ward in Milledgeville, Georgia. Mama Jo had that threatened the Milledgeville Mental Institution would be my final destination; my last home should I continue disrupting her world.

Assuredly, society would never burden itself with the likes of me and everyone concerned would benefit from my admittance. Rather than have this happen, I decided to run away and hopefully find my way to a classmate's home. I knew running to Grandmother's house was not an option because she would scoot me out and tell me to go back to Jo's house. Grandmother would tell me not to bother her about my continued disruptions at home when I'd had my chance to live with my father. I deserved her comments and knew how hurt she felt because I had disgraced her and disappointed her and Grandfather Fraser.

Jo heard Father had remarried and, of course, was beside herself with anger. How dare he take on a new wife and not support her and the family he left behind! He now lived with his new wife, but I didn't have their address. I was sure if I reached one of my classmates' homes I could call Grandmother and apprise her of my situation and ask her for Father's telephone number.

Grandmother responded matter-of-factly to my call and would not give me Father's telephone number. Instead she took the number I called from and said if he wanted to contact me he could. It was up to him, not to her.

Father called and shortly thereafter he came to my friend's house and took me to his new home to meet his wife, Lillian, and her mother. He quickly told me he

couldn't guarantee I would be allowed to stay with him until we all had a chance to talk things over.

When we arrived at his house I saw both ladies peeking out of the sunroom windows, anticipating my arrival. They greeted me with heartfelt hugs, as if I were one of their relatives returning home from an extended trip. I supposed they were well informed of my situation living with Jo, as they had predisposed opinions of her based upon Grandmother Fraser's and Father's comments. I felt so happy to have made it to their home, and I wasn't going to ruin the happiness by dwelling on my past transgressions. I wanted to leave those thoughts at One Kenzie Avenue and never return. I had my Gerber, that's all I needed.

Fortunately, Father's new family invited me to live with them and assured me that we would all take care of each other as hardships arose. Grandmother Kessler was dying and the toll of her illness and subsequent death affected Lillian tremendously. Lillian never felt like a stepmother to me. Her warmth and kindness to Father and to me felt natural, and by age seventeen I supposed titles didn't matter other than when making formal introductions.

Father experienced happiness during this time, and Grandmother and Grandfather Fraser approved of his new marriage. Sadly, it had taken seventeen years for me to feel I wasn't an undue burden to anyone. Too many years of uncertainties had passed, shielding me from emotional attachments to anyone and thus too late for me to have a little girl's relationship with my father.

Living with Father in our warm home provided me a sense of happiness and security. We didn't spend a lot of time together because he and Lillian encouraged me to stay busy with school activities and friends, and to experience being a normal teenager doing what teenagers do—hanging out with friends. Permission was granted to go with my friends to the annual bon-fires at Daffin Park and Tybee Island. Shoney's Big Boy Drive-in Restaurant and the XXX Drive-in Restaurant provided popular date night eating spots. School events provided the biggest social gatherings, especially the football games and sock hops.

I knew my time with Father and his wife was going to last only until I graduated from high school with college on the horizon; however I felt my life had finally turned around for the betterment. Father's promise to me finally did come true, just like in a fairy tale ending.

Off to another journey we shall go...

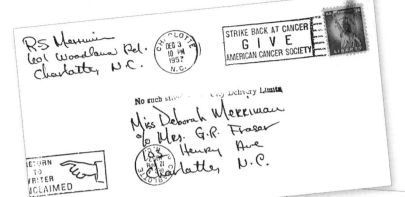

RS Merriman
601 Woodlawn Rd.
Charlotte, N.C.

CHARLOTTE
DEC 3
10 PM
1957
N.C.

STRIKE BACK AT CANCER
GIVE
AMERICAN CANCER SOCIETY

No such st.... ..ly Delivery Limit..

Miss Deborah Merriman
℅ Mrs. G.R. Fraser
Henry Ave
Charlotte, N.C.

RETURN
TO
WRITER
UCLAIMED

December 2, 1957

Dearest Debby,

Hows my little girl getting along. I hope you are getting along fine in school and doing real well. Are you listening to your teacher? That is very important Debby. Listen and learn from Grandmother and Granddaddy as they will not tell you wrong. I miss you very much and maybe someday you will be with me and ~~will~~ we will have a wonderful time

Darling take real good care of yourself and write to me. Daddy thinks of you always and loves you very much.

Your Daddy

Entryway to the Heart

The sweetest sleep within the shadows tonight
beckons the calls of nature within the night
and with a heightened awareness casts out
the quarrels and dissentions of the day
preparing the heart to pray

I, who serv'st thy master – the god of nature,
wait as nocturnal magic overthrows damnable forces
hauntingly lingering within the twilight hours
trying to take control of my dreams.

I will not let my dreams be frightened away with false fright
within a poisonous garden of thoughts and lasting strife
For within this night, I ask myself, "What dost thou profess?"

Within the rivers of my blood I am no longer hindered
by the imminent dangers of fear, and therefore, I reply:
I have come to know my destiny outside of the wounding
shames and dismemberment of childhood.

I no longer ache nor wisely suffer the wrongs that once quarreled
and labored within my head. I banish mockery as I have no more
to reckon and prepare the new day without fearful scouring

I will forever remain a pixie with my dearest friends alongside me,
the crickets and frogs, as I melodiously drift into a slumberous state
of mind.

I embrace the richness inside me, and from that place confined
deeply within, I accept my past as stepping stones which lead me
to a miraculous entryway:

That of my heart

CHAPTER TWENTY-SEVEN
— *Reflection* —

Reflection is difficult. Reflection means quiet time, pausing the rat race, and digging inward— bringing forward and reprocessing memories and the emotions associated with those recollections. Sometimes I forget what images, smells, music, and sounds made a profound impact on my life until, out of the blue, a particular event— maybe the changing of seasons with distinctive colors and fragrances, or the smell of leather and old books, black tar used on pine pilings at the beach, or fragrances from a pipe, the smell of ivory soap—each processing through my brain while giving its own unique impact on my memories. When I look at the clouds, I remember the important role they played in my childhood. They carried me on many adventures.

Every day sounds—melodious, serene, loud bass vibrating from a passing car— whatever changes my internal track; once again, emotional memories associated with each passing event take over. When I began the reflection process, good and bad images appeared—some images horrifying, bloody, contorted and confusing. Yet, they made me who I am today, and also deterred me from who and what I didn't want to be.

I have tried to push the memories aside, or alter them when they creep up. I try to convince myself that I can control a feeling, yet sometimes it just takes over at the most bizarre moments. Sometimes I just want to say "stop it," other times I embrace a memory. The events, memories, and emotions define me. Emotional intelligence and a strong inner constitutional drive from within guided me—an English virtue, I'm sure.

Most of us have experienced a lost soul at some point in our lives. I continue to draw upon my experiences and believe in myself. I don't stand alone with the scars from my childhood world of confusion, yet the scars remain strong enough to hold all the joys I experience now that I have found sanctuary in the arms of my husband.

The world holds so many lost children amongst the living and the dead. The lost soul continues until it finds its sanctuary; for some the soul may remain lost through eternity. For others, the journey has only begun.

I began a journey, looking at the world through the eyes of the principal players who influenced my childhood development the most.

Robert Merriman, my father, grew up in boarding schools. Upon graduation he joined the military. With most of his life under a microscope within a male military environment, he became inept at making his own decisions and usually followed orders. When trouble between Grandmother and Norma Jean took place, he avoided the conflict by returning to his naval duties. This doesn't mean he lacked caring and love, he put himself into his world of work. When he remarried, he married a lonely woman with a strong little girl, Carole, a reliable and very pretty child.

Father misunderstood Mama Jo's depression, as he did truly lack knowledge of the needs of young children. I do believe he honestly cared about the family, but alcohol became the route he took to numb his feelings when the responsibilities became unmanageable. His mother continually blocked his growth as an independent man, a man of authority and self assurance. Each time he attempted the role of the man of the family, Jo belittled and mocked him as being pathetic. He gave up, and they divorced. His third marriage was the first time he received the kind of nurturing he always wanted from a mother and from a wife. Lillian Kessler and her mother were wonderful to him and to me. He and Lillian remained married until her death.

On my father's death bed he said he loved me and apologized. I sang the Lord's Prayer to him the last few minutes of his life. Carole, Bobby, and I saw the good in Father, but never truly understood his weaknesses and why he didn't try harder during the times we all needed him the most.

Grandmother and Grandfather Fraser, now deceased, were in their late fifties when I was born, my troubled years took a toll on their senior years. Grandfather Fraser didn't have any children of his own, and Grandmother's children were raised in boarding schools. Neither had known what to do with a child during their golden years. I always cared deeply for my grandparents and felt they had my best interest at heart. I treasure my adventurous capers and wouldn't trade those experiences for anything.

Mama Jo, of course, was the most complicated of all the characters in my life. I think she tried to instill religion, morals, good hygiene, and education. She just didn't know how to accept the imperfections facing her daily life, nor could she take in the needs of others. She lived in a confusing world, one which she herself never understood because her way of thinking was hard coded into her brain.

During the nineteen-fifties, corporal punishment was a socially acceptable means of discipline. She took it too far, and I could tell in her eyes her anger controlled her instead of her controlling her anger. I describe her character in life as a tortured soul. As she became involved in the excessive need to control, she lost the her softer side and

became someone she herself couldn't understand. At times I recall her words and extrapolate the simplicities within them.

Although a dictator, Jo provided many valuable lessons, although they were taught with fear instead of compassion. I look back at her as a remarkable woman who needed a strong educated man to show her the softer side of life. She never experienced stability. Life forced her to take on too many roles which she could not mentally or physically equalize. In my adult life, I feel she coped poorly with mental illness and today's medication would have afforded her a more neutral life in which, perhaps, she could have found happiness.

Jo is deceased and buried in Arlington National Cemetery next to her first husband, her true love. Perhaps she no longer suffers. I love her in a very unique way, somewhat like loving the unlovely while it's difficult to see the good in their efforts, whereas loving the lovely feels easy and uncomplicated. I remember many of her teachings, oftentimes filled with meaningful insights, however delivered with cruelty and bewilderment.

Norma Jean and I met for the first time when I was thirty-seven years old. Explaining my feelings about the day I met Norma Jean is difficult. I received a phone call at my work from a girl who introduced herself as my half-sister, Donna. She went on to say our mother had been looking for me for many years. Donna hoped I would not be upset with Lillian, who gave her my work number.

During our conversation I discovered I had another half-sister named Carol. Norma Jean and my two grown half-sisters all lived in Lexington Park, Maryland. Without hesitation, I told Donna I would come to Maryland within the next few days.

As a child I always held Norma Jean in my heart, but I also used her as a crutch when I wanted to make playmates feel badly. I would say, "I'm going to tell my mama on you... when I meet her!"

When Norma Jean and I met, her spunky personality danced and her blue eyes sparkled. She and I shared our love of life and adventure. My mother and two half-sisters impressed upon me how Norma Jean suffered trying to locate me all those years or even discover if I was alive. I was told I was always part of their family in spirit, not a hidden dark secret from our mother's past. My half-sisters showed me a video of their childhood. Norma Jean's two young girls, well dressed and nourished children, played happily. Mother's beauty showed in her eyes which communicated how much she cherished her daughters. They assured me if Mother had ever known my whereabouts I'd have been in the video right next to them playing. I couldn't watch the entire film. I only imagined my mother until that point, and now I saw her fulfilling my childhood dreams—with other children. Years later I did watch the full version and lovingly appreciated it.

171

I visited Norma Jean several times and on one occasion she came to Atlanta and stayed with me for a week. The years of separation did not break the natural bond between us, however I had survived without her most of my life and had developed a loving but guarded relationship in my heart. My mother and I vowed we would never lose each other again. She died several years ago at home after a long illness.

I have some funny stories to tell about Norma Jean. A real hoot, playing bingo became her favorite pastime. Sometimes she had ten bingo cards going at once. I managed looking at two cards per game. She cherished her independence and never met a stranger. She never judged others and loved animals.

She is buried in Arlington National Cemetery with her second husband.

My siblings, a brother Bob, step-sister Carole and half-sister Carol are living, and each has a very special place in my heart. We each have a unique bond with one another. My half-sister Donna died from cancer in the summer of 2010. While on her death bed, Norma Jean admitted birthing a son prior to my birth. My half-sister and I are looking for our older half-brother.

There will forever be a lost part of childhood innocence within my reflections, however I look to the future with the same enthusiasm I did as the pirate princess dancing on Tybee Island's shores as the wind echoed, "Deborah Elizabeth, you are special".

As a lost child I experienced internal exhaustion. I now experience self-worth just as much as the beauty I've always seen in all of nature's wonders. I just didn't see it in myself until now. To some I may not have achieved worldly greatness, but I do have a compassionate heart for those who struggle from within and suffer from feelings of worthlessness. I only hope that if one suffers from low self-esteem and depression, he or she can draw strength from my writings.

Charm and character linger on in Tybee Island's local lore. Experiencing quiet times on Tybee's beaches still inspires and rejuvenates my soul. As the sun rises my senses awaken with the natural wonders surrounding the eastern shore of the barrier island. Being a lost girl at such a young age, I remained principled and possessed an appreciation for life, not bound to any particular doctrine or teaching. Nature was and is my teacher. The drones of human existence did not turn me to the forbidden acts of drugs, alcohol, prostitution, or suicide. Predisposed to failure by others, and my brain branded with "the devil's workshop," I would not allow my destiny to be guided by others' words, but from my internal forces–the core of myself.

Possessing an enduring affinity for the less fortunate children in the foster homes in which I lived, I, often the youngest of the children, used nervous theatrical energy to perform Tra La's, silly body contortions, and clever antics, providing the children with distractions and laughter. The other children did not seem to possess, as I did, the internal ability to rouse themselves from their depressing living conditions and look forward to the possibilities of a better life. I felt a responsibility to nourish them.

A profound lesson should be impressed upon all of us: touch, hold, kiss, sing to, and play with children—and perhaps they will do the same with the children in their lives. And if you have no children to play with, then hold your partner's hand, and if you have no partner, embrace every detail of nature's goodness.

My aim is not political; it is to help us find peace within the confines of self in spite of the oppressive complexities of everyday life. We do not have to suffocate under the negativity and pessimism that shower down upon us daily. We do not have to remain under these burdens until they leave no breath in us for the passion of life and joyfulness. We have to acknowledge the existence in ourselves of cluttered and unquiet thoughts before we can practice the art of healing—the healing of every abandoned or unwanted thought or deed that lingers within our minds. Each of us needs self-reconciliation from within as well as self-love.

We, all of us, feel at one time or another that we just can't take something anymore. That's why long ago I copied down the following statement by Eleanor Roosevelt: "Every time you meet a situation, though you think at the time it is an impossibility and you go through the tortures of the damned, once you have met it and lived through it you find that forever after you are freer than you were before."

And I am freer now; I enjoy life's slower and calmer journey. I am at peace with myself, and at every turn I appreciate the simple pleasures of life, just as I did as a lost child. When I see an elderly person serenely rocking on a porch or strolling along the beach, I imagine that they have reached the wisdom phase of their life and are absorbing the beauty around them. They have learned from life's experiences that they simply cannot fix everyone and everything. They have begun to decompress their minds and open their craniums for calmness and less fretting.

I hope to begin the wisdom phase earlier rather than later in my life. I will not destroy myself for the sake of becoming perfect in the eyes of others for I have seen how destructive that journey has been for so many people. When we are bound by conscience to be one-for-all and less-for-self we become puppets performing our daily duties of work and family. The balance between health, mind, and daily duties becomes difficult to achieve, compromising our creative self and causing us to lose our inherent uniqueness.

My imperfections provide me with an approachable means of communication with others who themselves realize their own imperfections.

Being *perfectly imperfect*, my journey through life continues...

Fondly, Deborah Elizabeth

EPILOGUE

The Epilogue was written because so many people have asked me, *"Why did you live in so many homes?" "Where were your parents during this time in your life?"* I will never fully know the answers as they are with the dead; however, I decided to write a story based upon the various scenarios I heard over the years. I tried to incorporate the personalities of each character as I perceived them to be from their stories to me. The following writing is dedicated to my parents, Robert and Norma Jean, and to my grandmother Gladys Elizabeth and step-grandfather Gibby.

OUTGOING TIDE

Norma Jean Dye and Robert Slater Merriman

In 1949 my father, Robert Merriman, served in the U.S. Navy on the U.S.S. Siboney. Time constraints did not afford him the necessary hours to travel from Norfolk, Virginia to Savannah, Georgia to visit his mother, Gladys Elizabeth. Grandmother continued her vigil for her deceased family members and spent hours writing letters asking the government to assign her only surviving son to a desk job.

The Navy finally granted Father authorized annual leave for nine days from the U.S. Naval Amphibious Base, Little Creek, Norfolk, Virginia from 0800 12 OCT 1949 to 0745 22 Oct 1949.

Grandmother stayed busy with volunteer services and work. Filled with emotional pain, Gladys Elizabeth needed the comfort of her son whom she, for the first time, reached out to for affection. She rarely displayed her emotions in public, nor has it been said she overtly exemplified motherly concerns for her two sons as they grew. She came from a family with strong English virtues, and attended school under the strict rules and discipline administered by the nuns at St. Mary's Catholic School. My father and his brother were both educated in out-of-state military boarding schools beginning with elementary studies. Education was paramount and in her mind the academies afforded her sons the best education.

The day finally came for my father's arrival in Savannah. I'm sure Grandmother prepared a list of special cleaning instructions for the housekeeper.

Tidy-up everything nicely

Polish the sterling silverware

Put fresh linens on the *single bed*

Place a magnolia bloom in the small round cut crystal bowl and put it on the dining room table in the middle.

Place white candles in the crystal candle holders on either side of the magnolia.

Starch and press the white linen napkins with the silk monogrammed 'M'.

Starch and press the white table cloth with the eyelet corners.

She also wrote instructions for the housekeeper about how to prepare and serve her festive meal for Robert's most anticipated homecoming. Of course the table would be set with her mother's beautiful crystal and china, traditionally used when special guests came to her home. I can visualize the table as if I were sitting next to them, but the table was set for only two and I would have to rearrange everything in my mind to accommodate a third person. To this day, I use the same china and crystal when I set the table for my own family's celebrations.

After Gladys Elizabeth critiqued the preparations, she took off her apron, double checked her hair and makeup, and posed in front of her dresser mirror to fine tune the lines of her garments covering her dainty frame. Knowing Grandmother, she paced back and forth at the front windows, awaiting the much needed visit from her son. As soon as the cab arrived, she would vigorously wave her laced handkerchief to draw his attention.

Father stepped out of the cab onto the road and handed the cabby a modest tip. With a sheepish look on his face, he purposively ignored his mother's signals.

Grandmother's heart must have suffered emotional paralysis as she watched my father walking from one side of the cab to the passenger back door of the cab, all the while keeping his eyes downward, but without compromising the regal appearance of a man proudly wearing his Naval uniform. I can appreciate how Grandmother felt betrayed when she saw Robert opening the cab's passenger side back door and extend his white gloved hand to a girl sitting in the backseat.

My biological mother, Norma Jean, told me Grandmother stared right though her. Grandmother turned as pale as a white marble statue, but without the warmth and solitude a beautiful statue possessed. After the initial shock, her emotions took a 180 degree turn which frigidly froze her like a statuette in the Bonaventure Cemetery, but with the contorted face of a gargoyle.

Like Father, Norma Jean immediately sensed the reserved and emotionless figure awaiting them at the top of the staircase. Grandmother had absolutely no prior knowledge my father was even remotely involved with someone and was aghast at what she saw.

I'm not sure who my father deceived more, my mother or my grandmother. Maybe in his own mind he wasn't trying to deceive anyone. Both women unequivocally needed his immediate attention; one no more than the other. I don't think he maliciously wanted to hurt his mother. He probably wanted to avoid conflict until the very last

possible moment, and that is just what he did. There was no time left to stall the inevitable. He couldn't undo the fruit of his January romance.

What should have been a joyous occasion for Norma Jean and Gladys Elizabeth was just the beginning of my unfortunate misadventures. The next few days were met with questions and emotional recriminations for everyone.

Nine months pregnant and past her expectant due date, Norma Jean felt isolated and overwhelmed with hormonal fluctuations. During Father's brief visit to the states, Norma Jean needed her new husband's devoted attention. Her pregnancy seriously overdue, her primary concern was for her baby and not for her new husband's mother. However, having made that statement, and after having met Norma Jean in my thirties, I think she would have unselfishly stayed in the background with an understanding and compassion towards his mother's grief over the loss of so many family members. She understood Gladys Elizabeth's feelings of despair about the responsibilities that were placed upon her as a single woman trying to support herself in the late 1940's.

Enduring months of anticipating Father's visit home, after all the family tragedies she was dealt without a husband by her side, and she must have felt betrayed by my father. Bobby didn't have the wherewithal to inform her beforehand that he married and they expected a baby soon. No calls. No letters.

Father probably didn't know what else to do with his wife and unborn child, especially since he had to return to the U.S.S. Siboney and wouldn't be home for several months. In my mind, he knew in advance if he called and asked Grandmother if Norma Jean could stay with her for the duration of the pregnancy until he returned to the states, she would scold him with a definitive NO! How dare him! Then he brought home a pregnant port whore with no proof that 'it' was even his child.

At five years old, I remember overhearing Grandmother refer to Norma Jean as a port whore to her bridge club friends. Grandmother became more and more agitated and would raise her voice as she spoke about the port whore invading her home. "She ate my food. She lived under my roof without paying a dime and expected maid and childcare services."

Father felt burdened with the immediate discord between the two women. More importantly, he was faced with remembering connections and schedules which posed uncertainties; he had to report to duty October 22nd or he would be AWOL.

Having spent only a few childhood years living with my father, I realized that he didn't seem to be the kind of man who harbored ill-will towards anyone, nor did he seem to premeditate deceitful schemes. Having been predominately raised in an *all male* boarding school then enlisting into the regiment and control of the military, he became inept at making decisions about his own personal conflicts.

I seriously doubt the above events would have turned out much differently, even if Father had apprised Grandmother of his real intentions visiting her in Savannah. My personal theory is Norma Jean informed Father many months into the pregnancy that the girl he had the romantic tryst with in January of 1949 expected his child. As soon as he returned to the states, the base chaplain performed the marriage ceremony and off to Savannah they traveled. He hoped his new wife would deliver the baby during his leave. He could go back to his assignment while his mother would dutifully care for his wife and child until he could make other arrangements. Having endured all the drama surrounding his mother and his new wife as well as the reality of the upcoming birth of his first child, I'm sure he was ready to return to the U.S.S. Siboney with its structured and predictable environment.

When Father started his journey back to his home base on October 20th, 1949, he left Norma Jean confined to bed rest, despondent and lonely.

On October 22, 1949, Norma Jean gave birth to me. This was the same day the U.S.S. Siboney was scheduled to embark port in Norfolk, Virginia. Norma Jean felt frightened. She had no family beside her while going through labor in a sterile room with bright lights. Why hadn't Father ask for extended emergency leave; what was he thinking? Did he really trust his mother to be loving and supportive of his wife and baby during this vulnerable time?

Three days passed and Norma Jean remained in the hospital without a visitor. She wasn't even certain if my father had been notified of my birth. However she knew The American Red Cross was good about informing military men of birth and death events, but someone had to tell them first!

Grandmother arrived at Candler Telfair Woman's Hospital four days after I was born. When she entered the room she was cordial, yet with an air of condescension said, "Hello Norma Jean, I trust you are doing well."

Mother respectfully replied, "Yes, very well thank you."

Without a reply to the cordial mode of Mother's voice, Grandmother voiced her next sentence with a degree of sarcasm. "I understand from my conversation with the doctor you are being released from the hospital later this afternoon?"

With a nervous quiver in her voice mother replied; "Yes Ma'am, sometime after the doctor makes his afternoon rounds."

Mother told me it surprised her to see Grandmother at the hospital during the noon hour. At this time she was told arrangements had been made for my care and she would hear more details later.

The tension between the two women broke when a nurse unexpectedly entered the room with me in her arms. Since the timing was close to lunch time, my mother

thought the nurse brought me to her for a bottle feeding. Norma Jean had no idea Grandmother had pre-arranged, through her hospital connections, my release to her personal care at the noon hour. Grandmother also failed to inform Norma Jean she made arrangements for her to be picked up later in the day upon her release.

The nurse handed me to my mother. Grandmother extended her arms, gesturing she wanted to hold me, and began humming a few notes from a lullaby. She asked if she could hold me. As she took me from my mother's arms, the lullaby quickly turned into a question. "I suppose you have chosen a name?"

Mother knew Gladys Elizabeth had been informed of my name and birth statistics and thought for a moment that maybe the question indicated she wanted a civil conversation. Still doubtful of grandmother's plans for our arrival home, my mother answered the question with emphasis on certain words–a bit unlovely–but perhaps deservingly so. "Yes, *Robert and I* decided that if we had a girl we would name her Deborah Elizabeth; Elizabeth, in your family's honor."

Without acknowledging the honor, Grandmother walked towards the hospital room door, tucking the baby blanket corners around my tiny pink legs. Pausing, she looked over her shoulder towards Mother as if about to say something, but didn't. Grandmother unrepentantly hurried her pace through the door. Mother immediately eased herself out of bed and gingerly walked to the door of her room. When she looked down the hospital hallway, she witnessed Grandmother picking up her pace as she neared the hospital foyer. Cautiously, trying to catch up to Grandmother, Mother became unable to continue her run-walk pace in her weakened state and slowed down to a shuffle-walk. By the time she reached the foyer, Grandmother was seen turning the corner from the hospital balcony landing.

At the entrance of Telfair Women's Hospital, a 1949 black Studebaker remained idle, awaiting the arrival of the lady-of-the-house. Grandmother's driver stood close to the car while attentively keeping his eyes focused on the hospital balcony platform. As soon as he got a glimpse of Grandmother approaching the top of the balcony, he rushed up the steps to help support her arms in an effort to cautiously guide her down the steps. With a sense of urgency, Grandmother coaxed him to "hurry-up." Grandmother was on a mission, and dawdling would not be part of her planned escape. The driver helped Grandmother into the back seat with me in her arms.

Just before mother reached the top stairs of the balcony landing, she heard a car's engine accelerate. She felt a nauseated feeling and a knot in her stomach. She always did when something terrible was about to happen. A few more seconds passed before she reached the top step of the balcony where she saw Grandmother's Studebaker turn left onto Drayton Street.

When Mother was released from the hospital she walked to the East Huntington Street row house, alone, bewildered and defenseless. Confused, Norma Jean couldn't understand how her mother-in-law could perpetuate such an ill-fated act against her. Mother could not fathom why Gladys Elizabeth vehemently disliked her, especially after she had sacrificed all of her time with her husband so his mother would have him exclusively to herself, in hopes that her honorable actions would bridge the gap between them.

A port whore, that's what everyone thinks I am, she thought while crying as she walked up the steps in pain. I asked her why she didn't call for the driver to take her home. She said she feared the phone was spitefully unplugged, and she didn't want any favors from anyone. She said she didn't want to feel the rejection in Grandmother's voice if she called and the time was inconvenient. In her mind, it was just best to leave well enough alone, look at the colors of fall, and enjoy the crisp cool air before becoming a prisoner in her husband's mother's home.

Undoubtedly, the unfolding events were insurmountable for any young mother and even more so for Norma Jean whose own childhood was traumatized by her mother's abandoning her at age three. A very kind man named Mr. Buck, employed by the Washington Post, found Norma Jean standing alone on the steps of the Washington, D.C. State Capitol Building. Through the appropriate channels the Bucks raised her as their child.

Mother's experience living with Grandmother unfortunately met with resistance. Grandmother usurped Mother's natural bond with me by supplanting a nanny, and eliminating mother's role entirely.

Unsure of her future living arrangements and continued rejection, Mother took a low paying job to gain independence. With meager financial means she rented a little house with scanty furnishings. It was located on the block of East 37th Street and Waters Avenue and on the bus line. Angry altercations ensued over the move and my immediate care. Feeling powerless and earning little money Norma Jean distrustfully agreed to Grandmothers' conditions for my care. Grandmother allowed Norma Jean to pick me up on Friday after work and return me Monday morning on her way to work. Six months passed and the disparity between Mother and Grandmother remained with no reconciliation in sight.

During one of Norma Jeans' times to pick me up, Grandmother continued her terse remarks, "You are nothing but a port whore who latched onto my son. You thought he would support you. You sure convinced him Deborah is *his* child, didn't you? It's just a matter of time before I'll have you out of this town."

Norma Jean tried to be respectful towards Grandmother by remaining silent during the verbal rampage. When a silent pause afforded itself, Norma Jean sheepishly replied,

but with the same emphasis on key words. "I'm sorry you feel this way about me and about *Robert's* child."

When she saw no act of kindness in Gladys Elizabeth's eyes, she retaliated by once again placing emphasis on certain words. "When *my husband* comes home, I'm sure *he* will know just what to do to protect *his* daughter from *you*."

Grandmother was not one to change her opinion, nor compromise her authority. Once she, in her own mind, became convinced a situation warranted her disapproval, she refused to change her course of action. She remained poised and stayed in control. I don't ever remember Grandmother deviating from her words once she had spoken them.

Each household began their unique plot to rid one from the other. Norma Jean and Gladys Elizabeth each orchestrated their own carefully planned courses of action to gain complete control over the one possession that would bind them to Robert—me.

This made perfect sense. Father was granted leave and he most assuredly would spend all his time with his little girl. Grandmother and Mother, each with her own agenda, prepared for my first Easter. Both were excited because it would be the first time Father had been to Savannah since before my birth.

Mother excitedly arrived at Grandmother's house at her usual scheduled time after work; however this was a special day, Good Friday. It was on this day Grandmother stood stolidly outside the front entranceway waiting for Mother's arrival. In the most recent months Grandmother remained distant from Mother when she picked me up for the weekend. Mother looked into Grandmother's eyes with the same glaring determination an animal in the wild possesses while protecting its cub.

Stopping midway up the row house steps, Mother once again listened to more coldhearted ranting from Grandmother. "Why don't you go back to your sailors in Virginia where you belong? I had a reliable source tell me you already have a son by some other sailor and you abandoned his child, God only knows where. You won't get a dime of my money. If you're scheming for money, your thinking is terribly misguided."

Mother wanted to challenge her accuser, but she had more important things to accomplish than arguing for naught. She didn't understand why Gladys Elizabeth seemed adamant about Robert not being my father, yet at the same time she took control of me and wouldn't allow Norma Jean to take me away.

When Mother took another step upward she saw Grandmother's hand slowly taking something out of her apron pocket. A gun, once hidden within the apron's pockets, was now in plain view.

With controlled retaliation, Mother pleaded to Grandmother in a soft but stern voice. "There is no truth in your allegations about my having another child. There are no legitimate grounds upon which I should be accused of being a port-whore. The only reason I am here is to pick up my daughter. Why are you doing this to your son? Why can't you be happy for us?"

While steadily aiming the gun at Mother, Grandmother reiterated some of the same harsh words she had used many times before, however this time her words were life threatening. "I have many connections in this town and every turn you take could be your last."

Backing down from Grandmother was not an option. Norma Jean wanted to stand up to her by keeping her silence. She hoped her calm personae would influence Grandmother's act of desperation and the hurtful dialogue would eventually cease due to exhaustion. Grandmother had warned Mother on numerous occasions to leave town, but this time the verbal threats along with the presence of a gun made her fear for her life. Then Mother's fear heightened when Grandmother aimed the gun directly at her and said, "I'll see to it that you aren't in this town when my son arrives."

As carefully as Grandmother had taken the gun out of her pocket, she placed it back inside her pocket. When she removed her hand the second time it contained a very large sum of money. With harsh, hateful words, Grandmother told Norma Jean to leave Savannah.

"Here, take the money and leave town immediately. There is more than enough for you to live on until you latch onto another sailor. I'm sure you will find your sailor victim before the next ship leaves Savannah's port. Whores don't waste time, do they?"

Now, with the large sum of money, Norma Jean felt confident she possessed the monetary means to go forward with her own plans. She accepted the money without uttering a word. She kept her head tilted upward and began walking down the steps feeling she had just been given the biggest gift she needed to comfortably take care of me without anyone's help. When she reached the last step, she picked up her pace so she could catch the bus making its turn around the park.

With nervous anticipation, Mother prepared for our Savannah exodus. She packed the meager necessities for the two of us to travel. She doubled checked Father's itinerary and bought a Greyhound Bus ticket to Norfolk—he would be unexpectedly surprised to see his two girls in Virginia. Lastly, she made herself even more beautiful by wearing his favorite dress; a black and white polka-dot dress puffed-out by a crinoline slip. Her delicate but hard working hands were fashioned with matching polka-dot gloves perfumed with the scent of gardenia hand lotion.

Mother's timing was crucial. All of her plans had to be executed with little time for unexpected distractions. Everything depended on times surrounding Grandmother's departure to the church, the city transit bus and Greyhound bus schedules, and Father's

incoming flight into Virginia—he was scheduled to take the Nancy Hanks train from Atlanta to Savannah the following day. Missing one scheduled time would terminate her planned escape.

Gladys Elizabeth always felt honored when she was chosen to serve on the Altar Guild for the Holy Saturday Midnight Mass Communion Service at Christ Episcopal Church. The sanctuary, the most sacred part of the church, required special attention to the Holy Table and the Table of Preparation which required changing during the service from dark colors to bright, as did the veil of the Altar. Most of the preparations were completed earlier in the day; however she wanted to arrive at the church by 8:15 p.m. to allow time to double check her preparations and to finish up the last minute details before she met with fellow choir members in the choir room at 9:00 p.m.

Norma Jean arrived at the East Huntington Street alleyway around 8:00 p.m. She hid between courtyards and waited pensively for the driver to pull the Studebaker out of the alley driveway. As soon as Grandmother's driver drove the car to the end of the alley, Mother started walking to the corner of East Huntington Street. It was very important for her to remain hidden from the driver's view as his loyalties were to the lady-of-the-house. Mother watched the driver help Grandmother down the front steps and then into the backseat of the Studebaker. The car stopped at the end of East Huntington Street before crossing East Broad Street. She remained in her same position until the car crossed the intersection and was out of view. She wanted to insure the driver wouldn't return before she had time to execute her plan.

Leaving our few packed belongings at the base of the steps and behind a large azalea bush full of magenta blooms, Mother began her walk up the steps to the front door. She took in a deep breath before courageously pushing the doorbell. Attentively, she listened, making sure she heard the doorbell chimes ring inside the house. She heard the Westminster Chimes from the Seth Thomas clock on the living room mantle ring on the half-hour.

The nanny wasn't too surprised when the doorbell rang and assumed Mrs. Gladys Elizabeth must have left something behind. She looked through the front window. Her eyes met with Norma Jean's eyes as she stood on the front porch landing. Norma Jean saw the nanny through the sheer curtains with me in her arms. Norma Jean tried to ease her nervousness by thinking how beautiful the walk through Forsyth Park would be with the azaleas in bloom. She assured herself no one would ever come between her and her husband again. She couldn't wait to surprise him in Norfolk with me in her arms.

The ringing of the front door bell signaled the nanny to execute the plan *her superior* had prearranged. The nanny's directives were sternly instilled upon her—if Norma Jean ever came to the house unannounced she was to call the neighbor immediately and then go to the neighbor's house by way of the back stairs. The nanny glanced towards Norma Jean with hesitation and sorrow.

With an immediate troubling awareness, Norma Jean watched the shadowed images of the nanny walking towards the kitchen. The evening was still. Echoes rang from sounds being made as someone went down the metal fire stairs which led to the alley. Immediately Norma Jean felt terrified. She stopped breathing as her mind pleaded, *Oh God. No! No!* The words reverberated as her nostrils expanded bringing air into her lungs. She continued looking through the window, and watched for any signs the Nanny would return to the front door with me in her arms. Maybe the metal echoes were coming from an adjoining home and not Grandmother's back stairs, after all.

Reliving the panic stricken moments she felt when Grandmother took me away from her at the hospital, and with a deep heave, she expanded her chest and then let the air flow out of her body before taking in another deep breath. Norma Jean promised herself she would never live without her daughter again, even if it took drastic measures. She anticipated retaliation, even if it meant losing her life. She vowed to herself she would never fear Gladys Elizabeth again.

Running down the front stairs, turning right off East Huntington Street, circling around to the alleyway, Norma Jean helplessly watched the last fading images of me disappear into the fog hovering over the dark alleyway. Mother watched the nanny dart into an alcove which led to a small private wrought iron gated courtyard. Motionless, a freeze-frame image was impressed upon Mother's mind. White apron sashes tied with a perfect bow contrasting against the back of the nanny's black uniform. A white eyelet bonnet covered my head and a pink baby blanket flowed downward almost hitting the ground. The most profound memory was the eerie emptiness and the musty smell of the evening's fog in the alleyway and her feelings of hopelessness.

Mother's cries and screams went unheard. She continued to run the distance of the alley, unsure of the exact cul-de-sac the nanny had escaped through. At each gate stop she was greeted by the coldness of a closed locked wrought iron gate. Once again she was too late; she didn't reach me in time. With an unimaginable sadness, Norma Jean turned away from the last gate. She paused and then looked back once again to see if the nanny, or if anyone, would respond to her pleas.

She began her walk back through the lonely, musty smelling, dark alley. She briefly paused when she reached the metal stairwell leading up to the row house. She knew no one was home and wanted to go inside. She thought about hiding inside a closet until the nanny returned home with me. She would wait until everyone slept and then move slowly until she carried me safely out of the house. She wouldn't look back. The sound of her own heart beat jarred her thinking from such a plan. It was more important for her to continue her journey to meet Robert than to try and calculate what she could not see.

Norma Jean walked in a catatonic state through Forsyth Park. Her numb body did not feel the misty spray from the historic fountain, nor did she notice any of spring's

colors within the darkened park. She boarded Transit Bus #70 on Forsyth Street and Abercorn. She sat motionless until the bus driver called out twice. "East Bay Street Extension, Greyhound Bus Terminal, East Bay Street Extension, Greyhound Bus Terminal."

Once in the bus station, Mother sat on a wooden bench next to another passenger going to Norfolk. With both of our meager belongings in her lap, she silently cried with tears softly touching her face. Several announcements to board the Norfolk bus were made and Mother remained seated, motionless. A passenger tapped her on the shoulder informing her that the final call to board the bus had been announced.

Boarding the Greyhound bus, off to her surprise journey to greet Father alone and unannounced, Mother slept knowing everything would be wonderful the next day in her husband's arms. They would travel back to Savannah together to reclaim their child and the three of us would move far away from Gladys Elizabeth.

Norma Jean greeted every flight at the naval station with anticipation. She made sure between arriving flights her hair was in place, stocking seams straight, and fluffed her petticoat just enough for her skirt to have a perfect twirl. Mother was determined to be as beautiful as the morning's sunrise upon Father's arrival. After waiting all day, the last flight of the evening finally arrived. Her heart beat extra fast. Father wasn't on this flight, either. Placing her hands over her face, she cried out loud, drawing attention from other families greeting loved ones arriving home. Being comforted by onlookers, she was told flights oftentimes were rerouted and it was up to the government when seamen were transported into the states. She listened to the encouraging words and was told she could contact the Naval Family Services and they would be able to assist her. With this bit of hopeful information she sought out the proper contacts.

Back in Savannah, Gladys Elizabeth arrived at the terminal right on time: Easter Sunday afternoon, 2:45 p.m., Platform 10 - Arrival City, Savannah, Georgia. Grandmother had received a call from her son informing her of his itinerary change; which of course was never shared with Mother.

I feel sure Father anxiously awaited his return home and seeing his three girls. His direct flight into Atlanta, Georgia, which bypassed Virginia entirely, facilitated a more expedient arrival home. From the Atlanta airport he took a cab to the train station where he boarded the Nancy Hanks. Ironically, he arrived one hour and forty-five minutes after Norma Jean's bus arrived in Norfolk, Virginia—ships passing in the sea.

Grandmother began telling Father the tragic ordeals of the last six months concerning Norma Jean. She explained how she fulfilled her dutiful role as grandmother and mother to his daughter, Little Debby. Grandmother's caring voice reiterated more than once how she did the best she could do under the most unusual circumstances, as well as the extra burden of a full time job. Father, unable to decipher

which part of the story was fact based or fictional, didn't understand why the nanny and the driver looked as though they had just seen a ghost.

Grandmother continued with her dialogue. "And, can you believe Norma Jean's actions—no warning—she just wanted to go back to her friends in Virginia, you know, where you met her in that U.S.O. Club. She told me more times than I can count, 'I'm just not ready to be a mother and wife with all the responsibilities and no husband to help.' Son, can you believe she abandoned us like that? Well, at least we have our little girl, that's the most important thing. Now, isn't that right, son?"

Instead of replying to his mother's question, he slowly took in a deep sigh.

His mother didn't miss a beat to rectify her actions by saying; "And furthermore son, don't you remember correcting me by saying this was Norma Jean's second child? You mentioned she had a child by some sailor in Florida. Sounds to me she just drops her babies out like hen eggs and trots off along her merry way. A port whore, that's what she is, a port whore. We are all better off without her."

Father questioned his own judgment of Norma Jean. In his heart he knew something must have gone terribly wrong. Many disturbing questions entered his mind and heart. Would he have time to look for Norma Jean, or should he spend his few short days of leave with his little girl? He was sure Norma Jean would call for him at his mother's house. He never thought to check the phone connection to the wall outlet, nor did he think to ask the people who shared the telephone party-line if they would request her telephone number. Father, faced with many unanswered questions relating to Norma Jean, felt an immediate concern for my care. He had not procured a commitment from Grandmother that she would care for me until he finished his Navy duties, and the likelihood of her doing so seemed slim as he and his brother had spent their childhood days in boarding schools.

Father left Savannah saddened by the ordeals and his gut feelings for Mother were confused with doubt. He returned to active duty on the U.S.S. Siboney. As for me, no one has ever told me what happened to me before the American Red Cross found me abandoned, and no one has told me about the homes I lived in before age 4 1/2.

And so dear readers, the "story before my story" has been told with the best intentions for the people who made my story possible...

Off to your own journey you shall go...

ABOUT THE AUTHOR

Born in Savannah, Georgia, in 1949, Deborah Elizabeth exemplifies courage, perseverance and imagination as she travels into various homes as a very young girl. Uplifted by Deborah Elizabeth's powerful story, filled with enchantment within tragedy, the reader has the ability to see life through not only a child's eyes, but also as a survivor that finds happiness in the most unexpected places. Her ability to connect the simplicities of nature surrounding her into the complexities of her traumatic story compels the reader to continue. Her unifying theme of hope over despair is filled with witty antics, bicycle capers, and a tad of unlovely behavior, perhaps warranted, but nonetheless, unlovely.

Although her immediate biological family placed her into less than favorable living arrangements in an effort to hide her from her mother, and too, to live their own lives unencumbered by a small child, Deborah Elizabeth's carefree spirit carried her along her journeys as though all children moved hither- to and hither- fro.

By the very young age of five, Deborah Elizabeth inspired other children who were also displaced from their families with her storytelling. Her small stature couldn't keep up with her tall tales being a pirate princess. She migrated in and out of nineteen homes before her fifth birthday. Once she was able to ride a bicycle, her adventurous capers took her travels to journeys off limits.

Her passion for children extends into her adult life. She has been a housemother to twenty-six boys at Bethesda Home for Boys in Savannah, Georgia during the early 1970s. She later became a housemother to fifteen girls at Thornwell Home and School for Children in Clinton, South Carolina. She later returned to Savannah, Georgia and then moved to Atlanta, Georgia with her three sons. She now resides in Smyrna, Georgia.

Deborah Elizabeth also has a passion for music and in the past participated in the Armstrong State College Chorus and the Savannah Symphony Chorus. Her poetry has been published in various anthologies for The National Library of Poetry.

Deborah Elizabeth comes from a family background of literary excellence. In 1954 Merriman Smith wrote *Meet Mister Eisenhower* humanizing General Eisenhower's life as President. In 1964 he received the Pulitzer Prize in the award category - National Reporting. Citation: For his outstanding coverage of the assassination of President John F. Kennedy. Publisher: United Press International.

Deborah Elizabeth has been recognized for her participation in community service through the American Red Cross Flood Reliefs; The Salvation Army Flood Relief of North Dakota; Habitat for Humanity-Partners in Homes for Habitat Atlanta; Jaycees Empty Stocking Fund; Hands-On-Atlanta; and Center for Puppetry Arts. During her employment she received the Lee Burge Excellence in Outstanding Achievements and Contributions to the Atlanta Community.

Dedicated to my children

Trey, Jamie, and Doyle

and

my grandson Joshua

In loving memory of

Donna, my half-sister who found me

and

Amber, my step-daughter who was also a lost girl

With special love for

Robert Merriman, Jr., my half-brother

Carole Seitz, my step-sister

Carol Cogar, my half-sister

My older half-brother that I haven't found

PUBLISHED BY MERRIMAN PUBLISHING, LLC.

First Edition 2011

ISBN 978-0-9849016-0-9

Author photograph © Alex Neely
Cover design by Carolyn Otness Benton
Edited by Victoria Hobbs Olsen

www.deborahelizabeth.com

Printed in the United States of America.